CW00646626

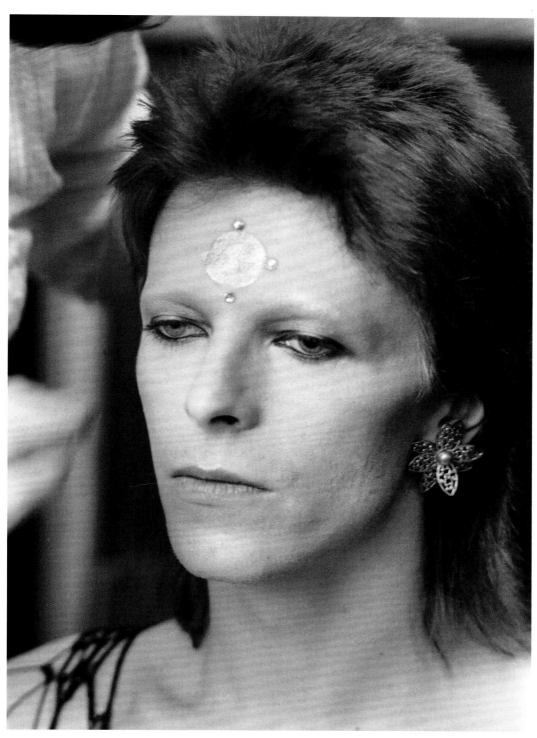

David Bowie. 8 January 1947–10 January 2016

David Bowie

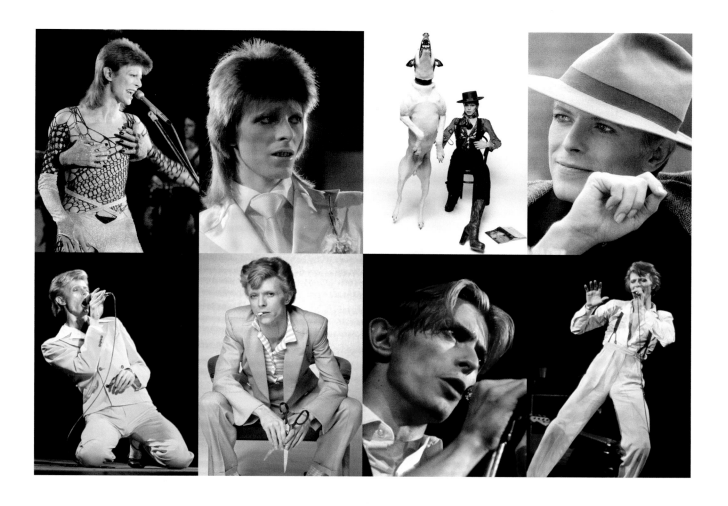

A photographic memoir.
Through the lens of
Terry O'Neill

Creative Direction Red Engine Media

CASSELL
ILLUSTRATED

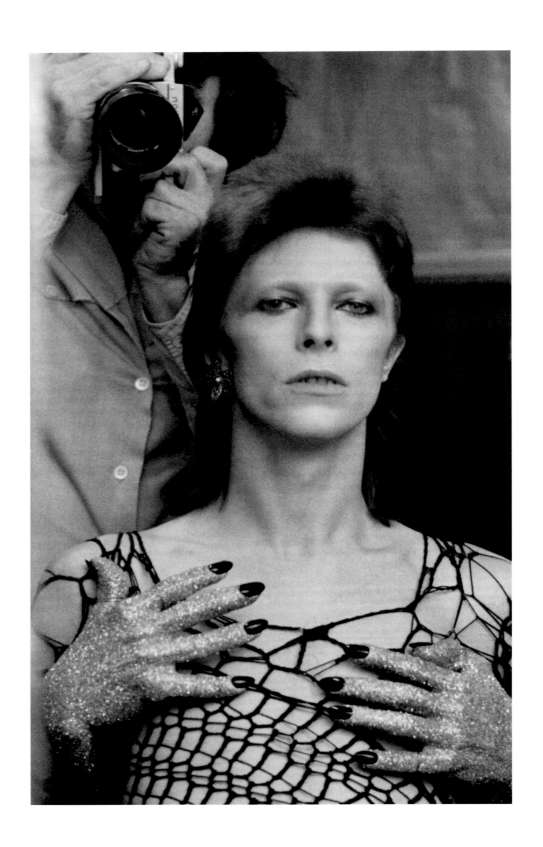

"I was lucky enough to receive the call to photograph David Bowie. And I was smart enough to know to say yes.

If I had to name the most talented, enigmatic and audacious star I ever photographed, it would have to be David Bowie. He was a cerebral and searching soul who was always looking to push the boundaries of his art.

Even a simple portrait was not simple. David always chose his own direction. It was our choice if we wanted to follow or not – it's a testament to his talent that we did."

Terry O'Neill

CONTENTS

WHEN ZIGGY PLAYED THE MARQUEE

My Memories of Working with an Icon

TERRY O'NEILL

It started off the same as how these things would typically happen: I got a call from a manager asking me to come and shoot photos of their star. The star, in this case, happened to be one of the brightest that ever shone.

I was lucky enough to receive that call to photograph David Bowie. And I was smart enough to say yes. If I had to name the most talented, enigmatic and audacious star I ever photographed, it would have to be him. He was a cerebral and searching soul who was always looking to push the boundaries of his art. Even a simple portrait was not simple. David always chose his own direction; it was our choice if we wanted to follow or not. It's a testament to his talent that we did.

I wanted to be a jazz drummer. Although I studied to be a priest for about a year, it didn't work out. The rector pulled me aside one day. "Terry, I don't think you will make a good priest," he confessed. "You have too many questions."

I didn't question my love of music. I'd play at as many jazz clubs as 1950s' London had to offer, but I knew if I was going to have a real go at it, I'd have to get to New York City. Someone told me about the new, glamorous world of working as a steward on transatlantic flights. That sounded great: work for a few days, New York layover, then back to London. But BOAC – British Overseas Airways Corporation, a predecessor of today's British Airways – didn't have any steward jobs going. I was offered work in their photographic unit, and I'd be placed on the candidate list when a steward job opened up.

After a few weeks Peter Campion, who headed the unit, took an interest in me and was very encouraging about my budding photography work. The assignments at BOAC were to capture moments in the airport. Flying was a big, new industry and no longer just affordable to the mega rich, and the airlines used "reunion" photos and the like to attract travellers: hugging, crying, laughing – how wonderful flying was, how it would bring people together. I was being trained,

essentially, as a photojournalist and it was this idea that led Peter and me to discuss, at length, the work of photographers such as Henri Cartier-Bresson and W Eugene Smith. Peter would bring in these photography books and annuals to show me. This was my introduction to "the decisive moment", as Cartier-Bresson would say. Peter would go on to tell me that Cartier-Bresson would work for months, travelling the world, in search of capturing a single image. I wasn't too certain about that for my own work: music was still very much in my blood.

Everything changed for me when, one day at the airport, I came across a very dapper gentleman, fast asleep amid a crowd of African dignitaries in full regalia. After I took a few photos a guy approached me and said, "Mind if I take your film and show it to my editor?" No problem. A few days later, I got a call. Turned out the gentleman I took a photo of was a famous British politician, the then home secretary Rab Butler, and the paper wanted to run my photos in the next issue. And I would be paid for it. I suddenly went from photographing at the airport to being offered a job covering events for one of the newspapers on Fleet Street. I was off and running.

The papers at that time all thought that the youth culture – music, fashion, film and whatnot – was going to be big in the 1960s, and they wanted a younger photographer to cover this new phenomenon. Plus, I was a musician, so they figured I'd relate to the music. "We want you to go down to Abbey Road and photograph this new band." That band was the Beatles. The pictures ran the next day and the paper sold out. I worked with the Beatles quite often in 1963 and 1964, following them to press conferences, award ceremonies, and television and stage rehearsals – even photos of the Beatles with Laurence Olivier, or the Beatles with prime minister Harold Wilson would run in the papers. And the papers would rightly sell out. The men who owned the papers knew they had a new powerful selling tool

on their hands, and I was quickly assigned to follow bands such as the Dave Clark Five, the Animals and the Searchers. Then I got a call from Andrew Loog Oldham. He was the young manager of a new band and asked if I would take some photos and "do for them what I was doing for the Beatles". I was pretty busy and told Andrew that if they came into Soho, I'd meet them. Days later, this group of five lads showed up and I took them to Tin Pan Alley (London's Denmark Street). The band was the Rolling Stones, who went on to become one of the greatest bands of all time. I loved every second that I was working with them, and the other new celebrities just entering the scene.

But after four long years at the paper, I was growing very tired of the other assignments I'd be called for. The papers were the papers, after all, and I was one of their photographers, so when I was assigned to cover an event it was my job to do so. The assignment that finally ended my career as a newspaper photographer was a horrific plane crash that claimed the lives of dozens of people, young people, from Croydon, London. I was sent to cover some of the funerals and the aftermath of this tragic event and how it affected this small community. It felt so intrusive, trying to capture the personal and private emotions of the events, that I decided right then and there I had had enough of newspaper reporting. I told my editor the next day and he implied that, without that paper, my career was finished.

The next day, scared to death I had just made a horrible mistake, I called everyone I knew and hustled for work. And once the word got out that I was now freelance, I started to get calls from other big publications. Then movie studios started to ring, looking for special photographers to go on set for a few days to grab some stills for the media. It was a terrific opportunity for me and I found myself working with icons such as Audrey Hepburn, Michael Caine, Terence Stamp, Elizabeth Taylor, Ava Gardner, Brigitte Bardot, Raquel Welch and Peter Sellers. I worked on several

of the early James Bond movies, having a great time off set with first Sean Connery and then Roger Moore. These encounters led to close friendships – some I hold close to me to this day. The 1960s brought me the opportunity to work with musicians such as Tom Jones, who in turn introduced me to Elvis Presley, and models such as Twiggy and Jean "the Shrimp" Shrimpton. Then I was asked to meet with Frank Sinatra, the icon of icons. Nervously I went along, and that job would lead me to a collaboration of nearly thirty years with the great man. I was in the middle of what cultural historians would label the "Swinging Sixties" – and it really was.

The 1970s ushered in a new wave of film and music. Elton John – with whom I started to work quite frequently in the early years of his incredible career – and others like him launched a whole new set of visuals that the magazines and papers loved. Elton, like Sinatra, would become a good friend of mine and our working partnership has lasted decades. Although, truth be told, I was more likely to be found working on the set of a film than front row at a gig, I still knew enough to answer the call when the phone rang. I never took work for granted, never assumed a job would be just around the corner, so when an offer came I was likely to say yes. And this time it was a new manager asking me to come along to a closed-set performance of Ziggy Stardust.

Marianne Faithfull was going to be one of the guest stars at the performance, and I already knew Marianne; a decade or so earlier, it was Oldham, the Stones' manager, who asked me to take some photos of the new singer he was working with. Marianne and I would work together a few times in the 1960s, and I always found her very charming and incredibly easy to work with.

The Marquee Club was located on Wardour Street in Soho and was one of the places musicians would perform. The club held about 150–300 people, so it was the perfect place to record for television: small enough to handle all the equipment needed, and probably

easier to produce a show that would involve several costume changes, various performers and multiple takes. The special performance was going to be taped for an American television programme called *The Midnight Special* and the singer, David Bowie, was calling the show "The 1980 Floor Show". I was told the show would be a mixture of modern dance, mimes, a few duets (with Marianne) and then performances by Ziggy Stardust and the Spiders from Mars. At the end of one of the songs, David Bowie was going to strip off his costume and unveil a new character – this was the final performance David would ever give as Ziggy, after he'd publicly "retired" the character onstage earlier that year. That's when I realized what he was doing. From my experience working on film sets, watching actors transform themselves for the camera, I saw that David was acting. He was using the television platform as so many great performers would (the Beatles, the Rolling Stones and so forth) to help launch himself and to achieve what he was aiming for: a transformation.

I was asked to arrive in the morning and I could see straight away this was going to be a different type of television recording. You could tell by the fans who had started to gather, many winning tickets through the David Bowie fan club. The kids were dressed outlandishly. The club itself was packed with lights, television equipment, record industry people and close friends.

Because I was there to take photos, I was allowed full access, including backstage. When I went back to introduce myself, I was met by this tall, lanky, pale boy with shockingly red short hair. "I'm David Bowie," he said. "Pleased to meet you."

David was a complete professional and very generously allowed me into his dressing room to take photos of his transformation into the characters he'd play onstage. I got photos of him being dressed by his then wife Angie, and his stylist Suzi (who would go on to marry guitarist Mick Ronson). I liked Angie

a lot and could tell she had a major influence on the overall visuals of the band – which was something different, I won't lie! Gone were the days of the Beatles' suits and tuxes worn so frequently by the musicians who ruled the 1960s; here were the looks that would dominate the next revolution. But as electric as his look was, it didn't come near to matching how electric he was onstage – the energy and presence he had. Marianne performed two songs the day I was there. A solo, during which I found myself watching a casual David in a T-shirt, encouraging and directing her from the sidelines. A few hours later she appeared next to David onstage. David was dressed in a strange devil-like ensemble and she came out wearing a nun's habit. They sang "I Got You Babe", a song made famous a few years prior by the American duo Sonny & Cher. In retrospect, the show he was recording would be instrumental in breaking him into the American market, and performing to a select crowd of his most dedicated fans was the right decision. Those cheering boys and girls, and girls who looked like boys, and boys who looked like girls gave him so much love and adoration. I hadn't seen that sort of reaction since the Beatles or the Rolling Stones. And watching him perform a song over and over and over – just to get the lighting right, the best camera angles, or so that Ken Scott, his long time sound engineer, was happy with the quality – I knew he was going to go on to become one of the most significant artists of our time. He was meticulous, and he had a visual concept. He used the television medium to his full advantage. Even when he was rehearsing or doing a simple sound check, he'd come out dressed as strangely as I've ever seen. And he was great to his fans, those in the front rows, achingly outstretching their hands to touch this man; a man who would help define the next thirty years of music. A few of my images ran in the *Daily Mirror* the next day, under a headline that shouted: "Back in Stiletto Heels…David Bowie of Course."

David and I hit it off immediately and I sold the pictures. That day at The Marquee was the start of a relationship we would continue over the course of the next few decades.

Several months later I returned to Los Angeles, where I was spending more time. I didn't usually work the clubs in LA, such as the Whisky A Go-Go or the Troubadour. Instead, I chose to focus my career on shooting on movie sets and the occasional portrait session for publicity to help drive album or box-office sales, and so forth.

Bowie's manager rang again and asked if I was available to do some additional work with Bowie, this time in a studio environment. Everyone was quite happy with what I had done at The Marquee and David needed stills for his new album they were just finishing off, called *Diamond Dogs* (1974).

In the 1970s, as it turned out, I photographed several musicians for their album covers. A few for Elton John, most notably *Rock of the Westies* (1975), and even for the Who's album *Who Are You* (1978). For *Diamond Dogs*, at first I was asked to just shoot some reference photos of David – and a dog – on the ground, posing. These stills would be used to help guide the Belgian artist Guy Peellaert when painting the portrait that ultimately became the album cover, complete with gatefold sleeve. It was easy enough and the shoot went without a hitch. I think this was the first – and only – time I did a few rolls of film of just a dog. The finished product, which I would only see a few months later, was excellent. Peellaert took my photos of Bowie and of the dog – taken separately but posed in the same position – and managed to merge them, creating a portrait of the artist as half-dog, half-man.

For the next session, following the same theme, the images were going to be used for publicity; possibly for the album interior, concert promos, that sort of thing. David was going to arrive with a great dane. On the scheduled day he walked in with a few assistants, one leading a giant dog. When David emerged from the back, now clothed in high-heeled boots and a sombrero Cordobés, he looked terrific. The dog was going to be placed at his feet. So far, so good. Bowie stretched out in his chair and I started to work, but at every snap of my camera the dog grew more and more agitated. The clicking of the camera matched with the popping of the lights must have set the dog off. At one point, the strobe that was hovering above the star and his canine companion encouraged the now barking dog to leap. People who were gathered around shrieked and took cover. I was safely behind my camera. And David? David didn't move an inch. That image, often referred to as "Jumping Dog", has been called one of the most iconic images in rock and roll.

By this time, we were friendly enough that David would just call me when the time arose. This was the case when the phone rang one day in London around the time of the *Diamond Dogs* promo shoot. We were both back and forth between the two cities so often back then. "Terry, come to our offices," he asked. "I want you to meet a good friend of mine."

When I arrived, camera at the ready, David introduced me to an older man. They were doing an interview together for the American edition of *Rolling Stone* magazine and I was asked to take a few portraits. I gave one of the test prints from that shoot to David so he could have a preview. I never minded sharing images with the people I worked with, and David would sometimes mark the contact sheets himself. On one occasion, I remember, he didn't like some particular images so he cut them in half. He loved the photos I took that day, though, so luckily nothing was chopped! Later, he showed me the print again, now fully enhanced by his own hand with colouring, markings and so forth. He titled the image "2 Wild Boys". The two wild boys, it turned out, were David Bowie and the writer William Burroughs, pre-eminent figure of the beat generation and author of *Naked Lunch* (1959). I was so embarrassed I hadn't recognized him! But no matter, those photos ran in *Rolling Stone*

as planned and the Bowie-enhanced test print he took from me that day was highlighted in the groundbreaking *David Bowie Is* exhibition that travelled worldwide from 2013 to 2018.

The next stage in our working relationship would turn out to be on the actual stage. Now, I did not and do not have a lot of experience working with musicians onstage. Sure, I shot the occasional show, but these were more in the Frank Sinatra, Judy Garland, Marlene Dietrich style, where grand curtains would unveil a solo singer with the full force of a backing orchestra and band. Usually audience members would be in tuxedos and evening gowns. I did work quite often with Tom Jones on the set of his television show, where he'd perform with acts such as Janis Joplin, Ray Charles and Cher. But Bowie's stage shows, in front of tens of thousands of fans in big auditoriums, would be some of my first live concert performances. I didn't realize the challenges I would face.

The thing about stage performances that is the opposite of working in the studio or on smaller television sets, first and foremost, is the availability of light. For this, the *Diamond Dogs* tour, I figured out quickly to follow David onstage as best I could, in order for the lighting to be spot on him, which allowed my photographs to have a real illuminated feel to them. Working with David again onstage reinforced my original thinking about him: that he treated the stage in the same way as an actor would. He had real command of it, from using props such as a skull for a very Hamlet-inspired moment, to reaching out to touch his adoring audience. I needed to be quick and stay out of the way, I could not be a distraction to anyone – the artist, the band or, most importantly, the audience. They were there to see David, not a man running around with a camera. I tried to find my moments and spent a lot of time running to the front, left and right. A year or so later I used my experience of working with David Bowie and applied that knowledge to photographing Elton John at his two-day concert series at Dodger Stadium in LA.

It seemed to me that the touring, recording, interviews and everything else David was doing was starting to take quite a toll on him. I thought it was visibly apparent when we scheduled a session that many would later dub the "Yellow Mustard Suit" series. Again, the shoot was in support of the *Diamond Dogs* album and now tour, and it was to be a simple studio session. When he arrived I thought he looked exhausted. His hair was bright orange with hints of red and yellow, framing his very tired complexion. He looked worn out to me; his eyes were half-closed and as bloodshot as I've ever seen. I had seen the effects of the rock and roll lifestyle up close before. There was one occasion when I ran into Brian Jones of the Rolling Stones at an airport in around 1968, only a year before his untimely death. Brian was slumped in his chair and, for an instant, I wondered whether I should get a picture of this, something I saw as a warning of what drugs and alcohol could do and where it would lead? But I didn't – I called for help instead. At this session, with David, I felt I could see the signs of someone running fast, day and night.

I didn't know what David was doing when we weren't working together. I would see him occasionally at a party – such as Peter Sellers' 50th birthday party, where he performed in a little makeshift group they dubbed Trading Faces, which included Joe Cocker, Bill Wyman and Keith Moon – but I certainly heard the rumours of late nights. Luckily I never got involved with all that, even in the 1960s. For the "Yellow Mustard Suit" session, I chose not to use a lot of colour film. Black and white hid some of the shadows and evened out the eyes. Even so, as tired and worn out as I thought David seemed that day, he was styled to the nines. That bright, bright suit, clashing with his shock of hair; posed with a slight slump of his shoulders; the cigarette dangling from his lips; the large silver scissors pointed down – they are great photos, even if I do say so myself. David is the one who absent-mindedly picked up the pair of scissors. He could still cut a brilliant image.

"Can you introduce me? I want to ask him about a role in the film I'm working on." When Elizabeth Taylor asked you to do something for her, I'm not sure there's a man alive who would have said no. When she called and asked me to introduce her to Davie Bowie, I did everything in my power to make it happen. She was working on a new film called *The Blue Bird* (1976) and thought this unusual singer would be perfect for one of the leading roles.

I knew Elizabeth and her husband Richard Burton from working with the couple in the 1960s and 1970s. Elizabeth and I were quite friendly; I liked her immensely, so I was happy to do what I could to introduce her to David. After a few calls, a time and date were set.

I headed out an hour or so ahead of the appointed time. We had agreed to meet at around one o'clock at the director George Cukor's house in Beverly Hills. I arrived a little earlier than scheduled, wanting to ensure everything was set up. I brought my camera with me, in the hope I'd be able to capture the moment with a few snaps of the stars together at this, their first meeting. Well, we were there, waiting for David. Two o'clock came and went, then three, four, five o'clock, and still no David. And you know, no one is ever late for Elizabeth Taylor. Finally, at six o'clock, he showed up. By then we hardly had any light left, so Elizabeth just took control of the moment, grabbed him in her arms, and I managed to capture a series of photos of the two icons meeting for the first time. They shared a cigarette, swapped hats, and the connection between them was instantly clear. While they had great chemistry, I think the fact that he kept her waiting for so many hours may have cost David a role in the film. However, although he didn't get the part, they did become very good, lifelong friends. She was really charmed by him. And he, of course, was cast under the spell of Elizabeth Taylor.

But David did move over to film, and quite successfully I might add. One of the first films he worked on was shot on location in Arizona, not far for me from Los Angeles. I went down to the set of *The Man Who Fell to Earth,* the 1976 Nicolas Roeg film, to grab a few candid photos of David preparing for the role. This time, though, he appeared to me much healthier; clean in a tailored suit, he was ready to work on what would become a new extension of his talents – the silver screen.

But his eventual success in movies didn't deter David from continuing to work on his music. This was very evident to me when I was called over to Philadelphia to capture some images of the recording session of David's latest album *Young Americans* (1975). Here, at Sigma Sound Studios, he was working and writing, and directing his back-up singers Ava Cherry, whom I'd met at The Marquee and on tour, and a young man named Luther Vandross, who would later become a very successful award-winning solo artist. David's longtime piano player Mike Garson was also there, and Tony Visconti – who is still a good mate – produced the album. I make a small cameo appearance in the 2013 BBC documentary *David Bowie: Five Years,* which focused on the five most important years in David's career. I'm seen as a reflection in the mirror, busily taking photos of the star at work. The funny thing is, for the life of me, I cannot locate the original negatives from this session. What exists in my archive are the original contact-sheet prints and only one or two sets of negatives.

My work with David ended around then, for no significant reason except that I was spending a great deal of time in Los Angeles and he was touring the world and releasing album after album of extraordinary music. I followed his career closely, and I was always happy to see David at the occasional event. By the time the 1980s rolled around, another decade was behind us and a new era of music, celebrity and fashion would once again usher in a fresh roster of talent. In the 1980s and 1990s I found myself working with stars such as Tina Turner, U2, the Police and the other emerging talents arriving on the scene. Digital

photography was just coming into fashion, but that really wasn't for me. And more managers started to insert themselves into the artistic process. While I fully appreciate and respect their roles – I mean, if it wasn't for managers I might not have received the calls that I did – I wasn't ready to give up rights; I didn't want to have my work retouched to the point of being unrecognizable from the subject, and I didn't particularly like being told what I was able to release and what I wasn't.

During the 1990s I received a call from an old friend. David wanted to know if I was available to take some portraits for a magazine interview. I hadn't seen him in years and was surprised when he walked into the room. Yes, we were both much older; it had been a bit more than twenty years, in fact, from the first time we met at The Marquee. He looked terrific. Still tall, a bit lanky, but no longer a pale boy – the person in front of me was now an award-winning musician, actor and activist, who had lived through, thrived and survived those heady days of the 1970s. He was really at ease with himself. I wasn't meeting with a character this time, there were no tricks to hide behind; it was just David, and he was happy with that. That polite boy I first met back in 1973 was still there. We laughed and shared a few memories of our time working together. He was married to a terrific woman, Iman, whom I would go on to work with as well. Things were good for him and he seemed very happy.

We all woke up in shock the morning that the news was announced. David was gone. He had released his final album only days prior; the outpouring of grief was instant and immense. People gathered at various sites that were meaningful to the legendary Bowie, candles in hand, singing. And the nation, the world, mourned the passing of a legend.

Since that day I've had the opportunity to meet some of his fans at different celebrations and events honouring his work. He has the most loyal fans I've ever seen. It shows you – it proved to me anyway – that he meant a great deal to

people, and created through his work a real, lasting impact. I was encouraged to share my photography archive with the world, having amassed hundreds of images and contact sheets over the years. His fans connected with him – whether they were in the audience at a concert or play, a viewer of one of his many films or a fan of his music. He captured something very special and made it – whatever it was – meaningful. He was an artist. And I was lucky enough to pick up that phone and answer yes all those years ago.

There is no way to express the impact David Bowie had on people – from teenage fans to backstage friends, to working partners and fellow musicians. I was recently with the brilliant photographer Masayoshi Sukita. Sukita, as he is best known, worked with Bowie, along with scores of other musicians and actors, in the 1970s – around the same time I started working with him. It is Sukita's portrait that graces the cover of the album *Heroes* (1977). In fact, Sukita worked with Bowie for nearly forty years – probably one of the closest and longest-lasting photographic relationships he had with anyone. I asked him why he thought Bowie had what he had, what made him different, and why his death had such a massive impact on so many people the world over. Sukita took his time and answered thoughtfully, "It is because he was curious."

These images, many never before seen, help us all visually add to our memory scrapbook – and encourage future generations to be inspired by a man who played The Marquee.

The contact sheets on the following pages were unearthed from Terry's collection. Some are being published here for the first time.

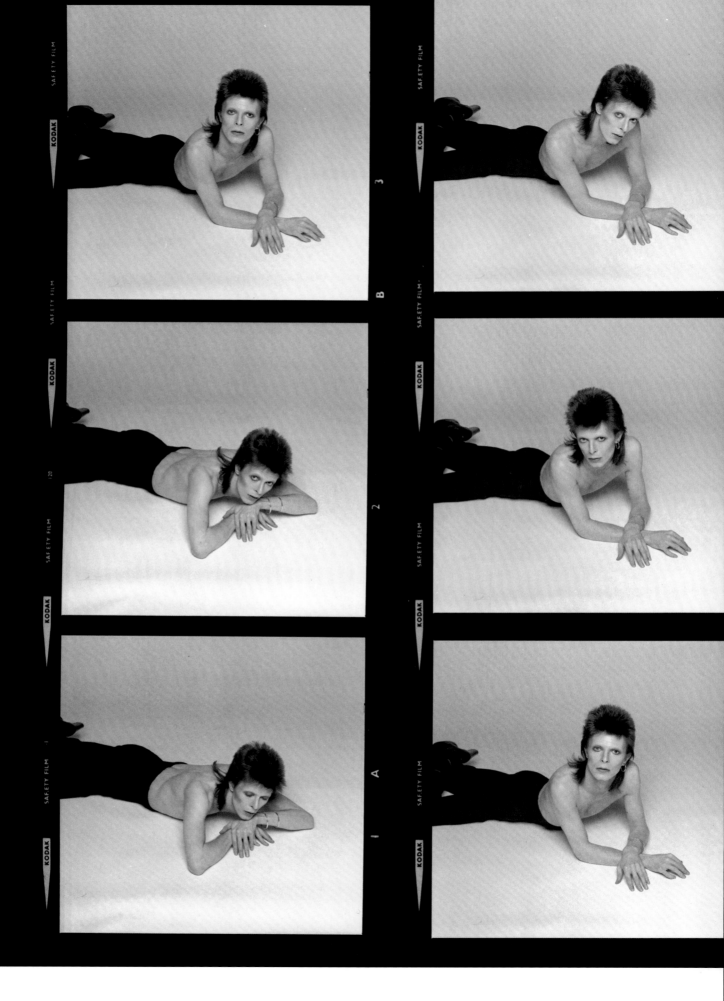

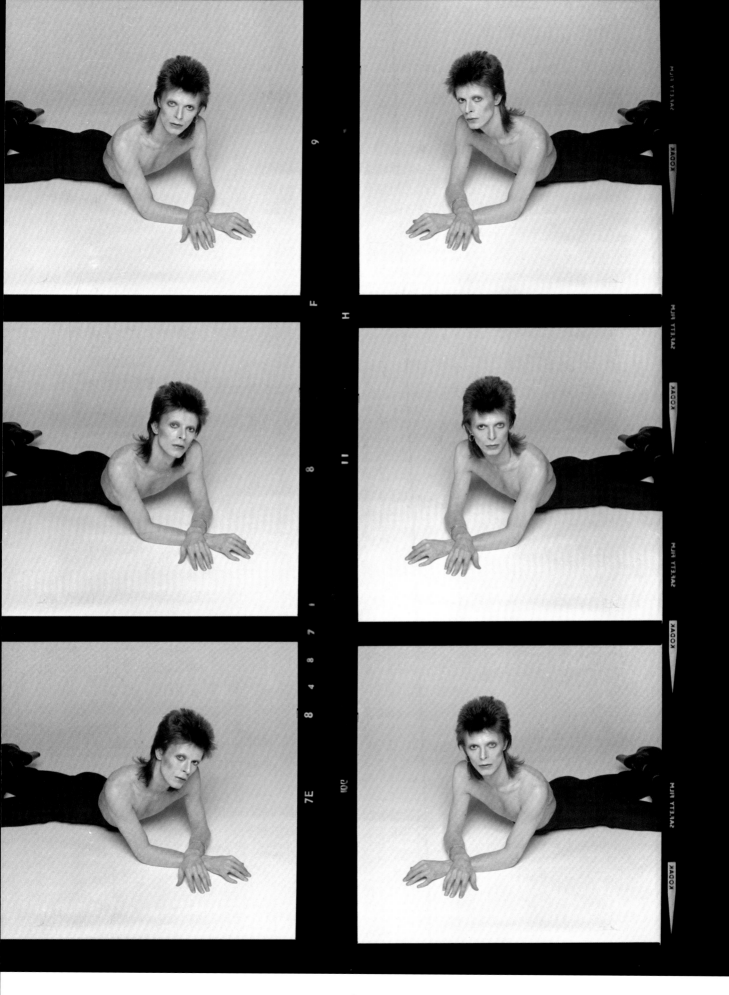

David Bowie posing as a dog, to be used as reference by the artist Guy Peellaert for the cover of the 1974 album *Diamond Dogs*. Terry laughs, "I even had to shoot the dog in the exact same pose as David."

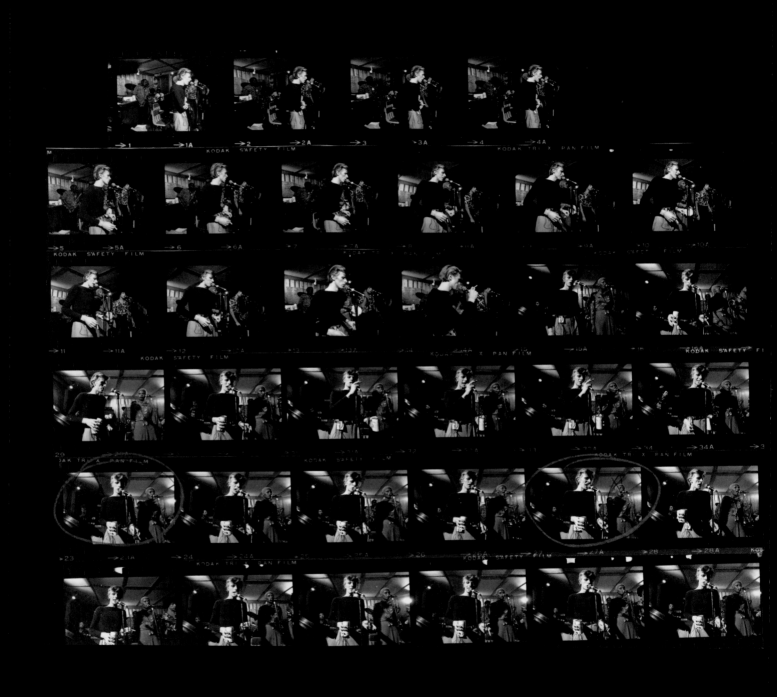

"All I have are a few printed contact sheets, not even the negatives," remembers O'Neill. "This was done in Philadelphia, at the Sigma Sound Studios, with Tony Visconti."

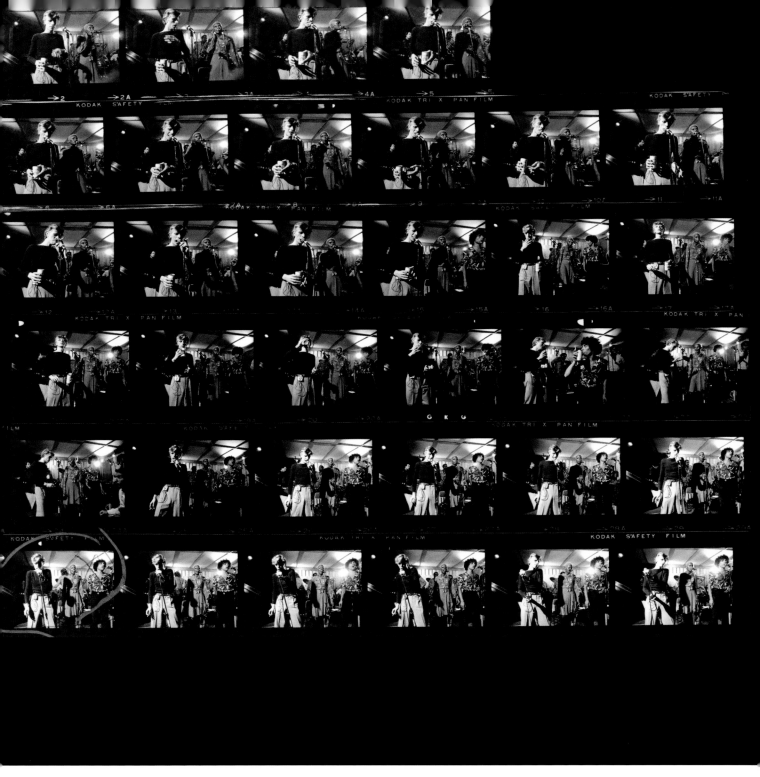

"Some of the recording sessions were filmed for the documentary *Cracked Actor* (1974). And yes, blink and you might miss my cameo in the documentary. I'm the one behind the camera."

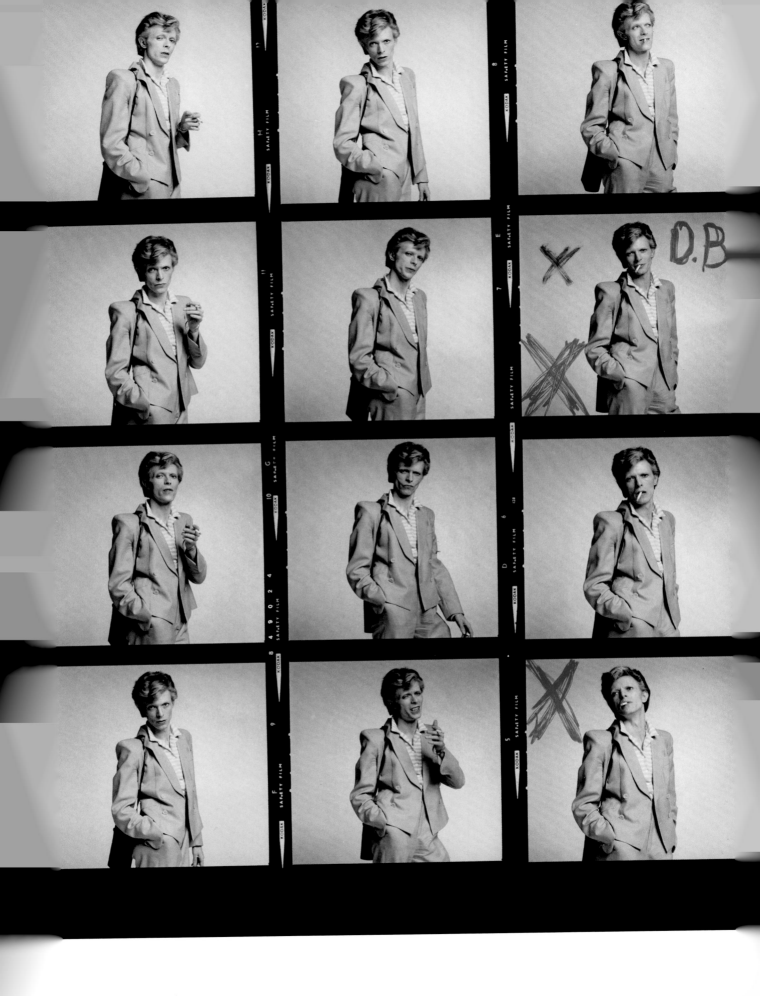

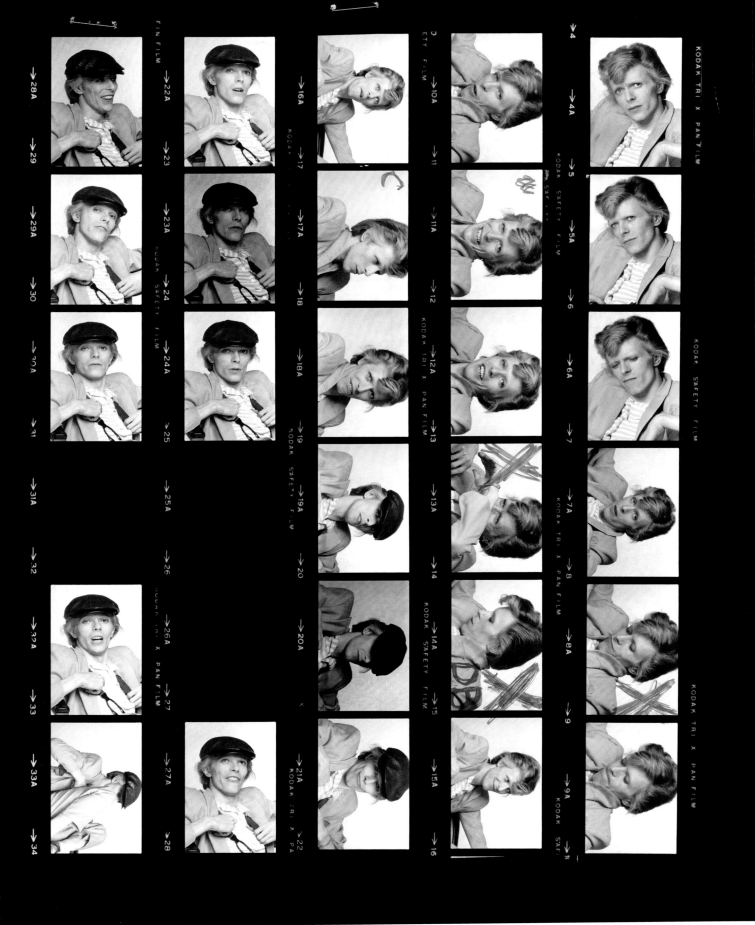

"Many people refer to this session as the 'Yellow Mustard Suit' series, but the truth is, I mainly shot in black and white. I only found these two original printed contact sheets this year. The markings are from David. I'd often share my work with him – I was curious to get his opinion. He'd 'X' the ones he liked and then initial DB on his preferred shot."

XIII

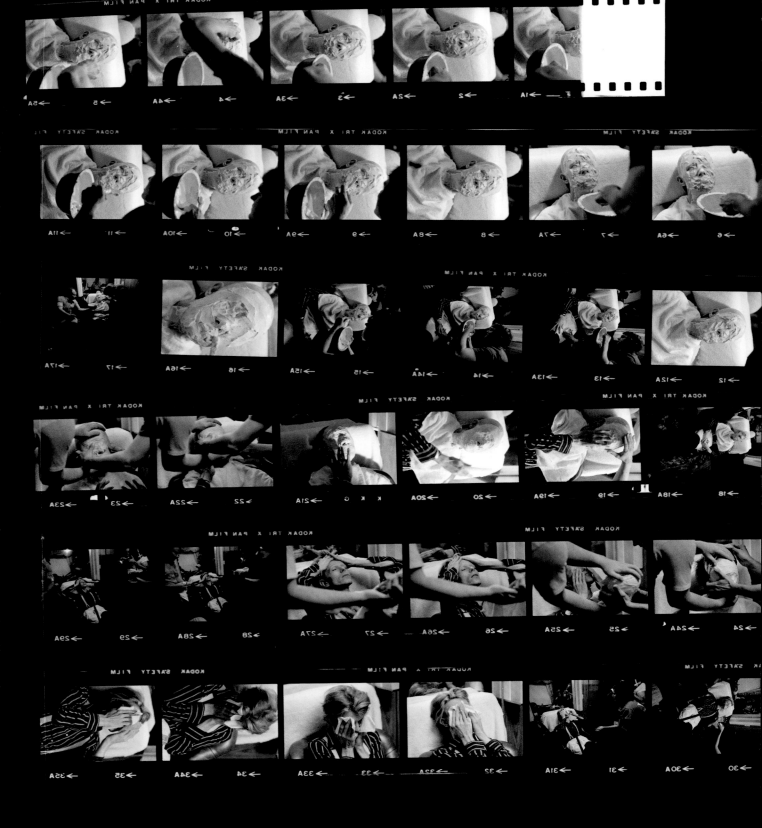

"A lot of people think the mask was done for *The Man Who Fell to Earth* (1976), but it was for the *Diamond Dogs* tour (1974). In the documentary *Cracked Actor* (1974), there's footage of the mask being applied."

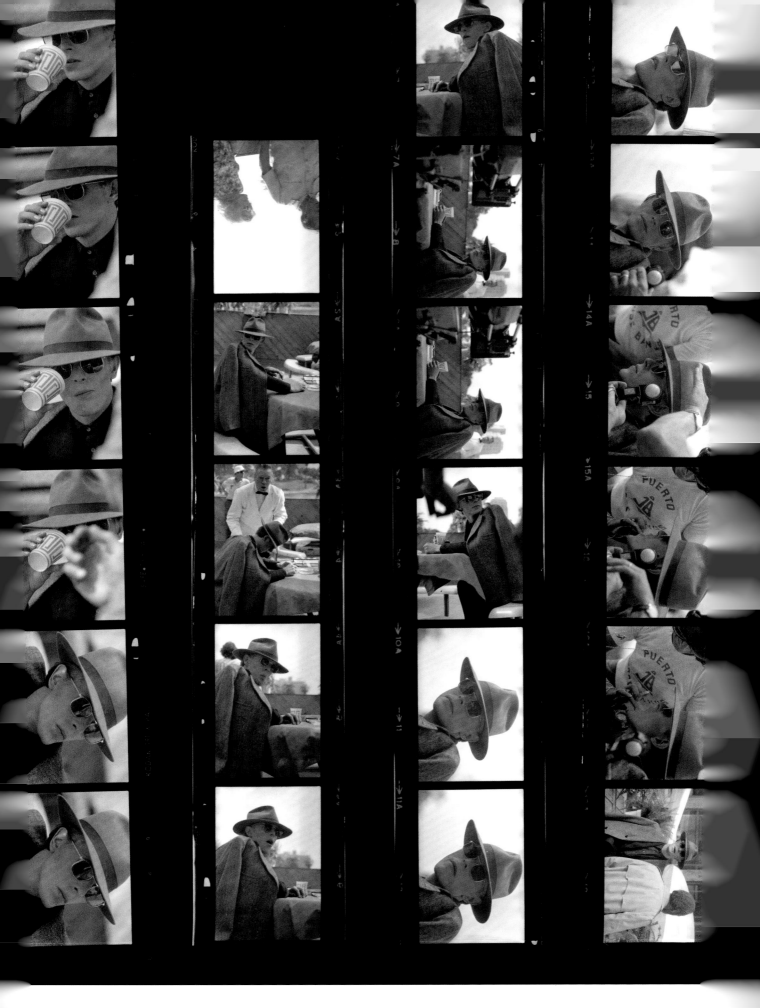

This contact sheet is from *The Man Who Fell to Earth* (1976), David's first starring role.
"I remember David being really happy to have another Brit on the set."

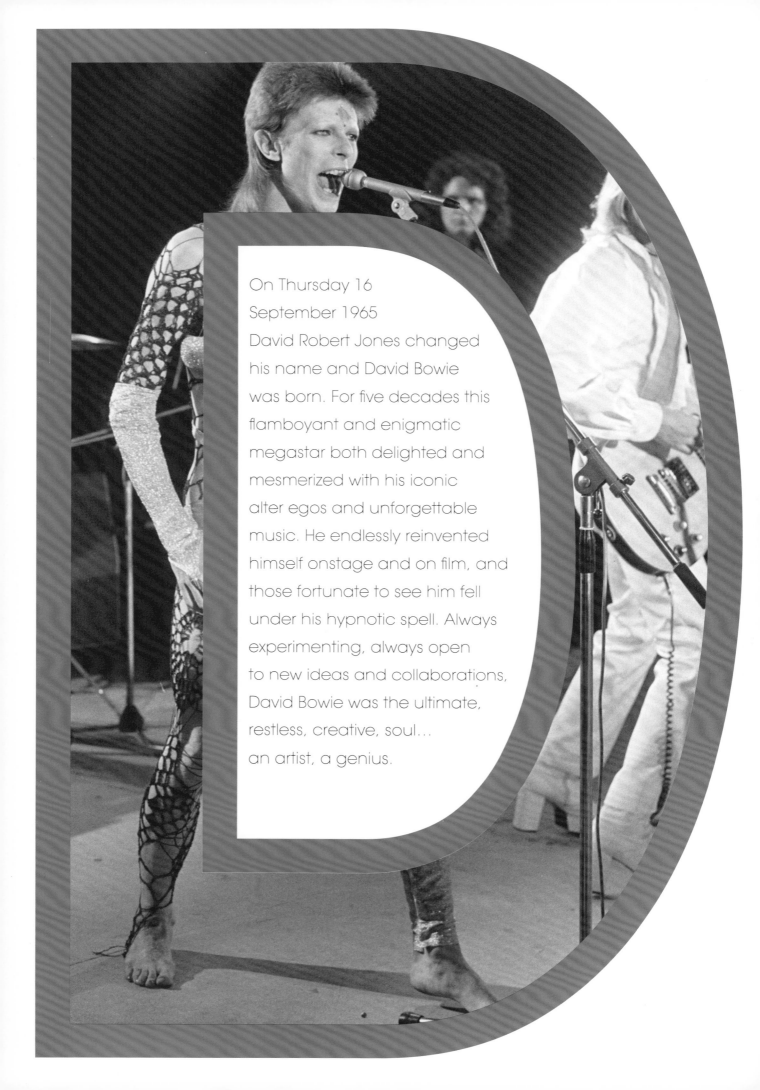

On Thursday 16 September 1965 David Robert Jones changed his name and David Bowie was born. For five decades this flamboyant and enigmatic megastar both delighted and mesmerized with his iconic alter egos and unforgettable music. He endlessly reinvented himself onstage and on film, and those fortunate to see him fell under his hypnotic spell. Always experimenting, always open to new ideas and collaborations, David Bowie was the ultimate, restless, creative, soul… an artist, a genius.

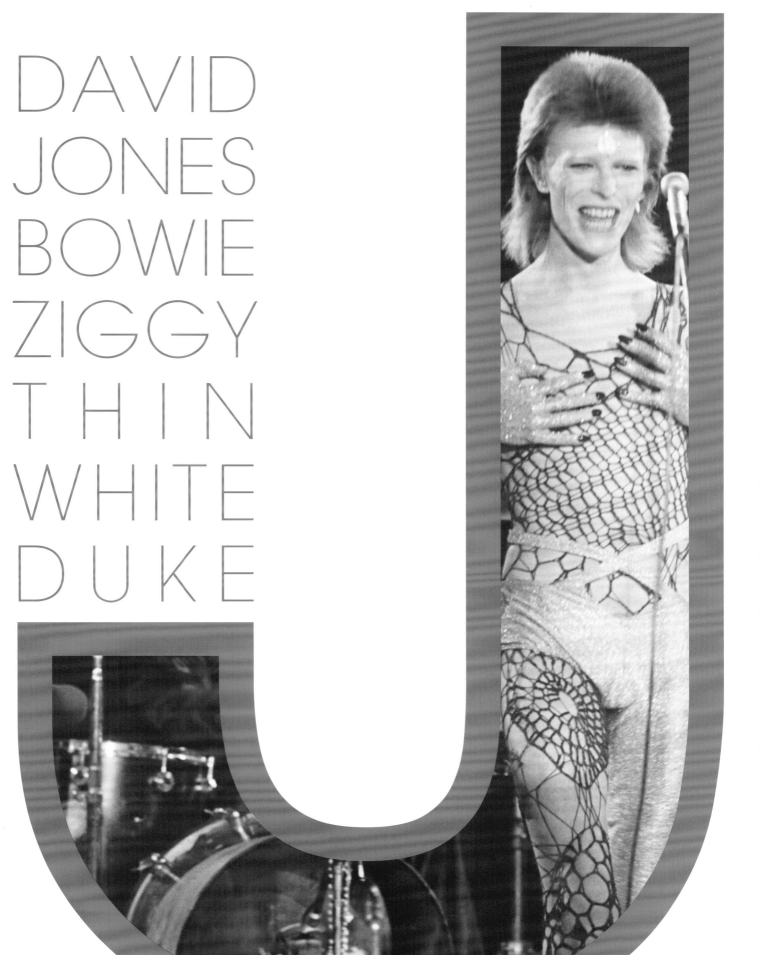

DAVID
JONES
BOWIE
ZIGGY
THIN
WHITE
DUKE

1973

ZIGGY STARDUST

THE 1980 FLOOR SHOW

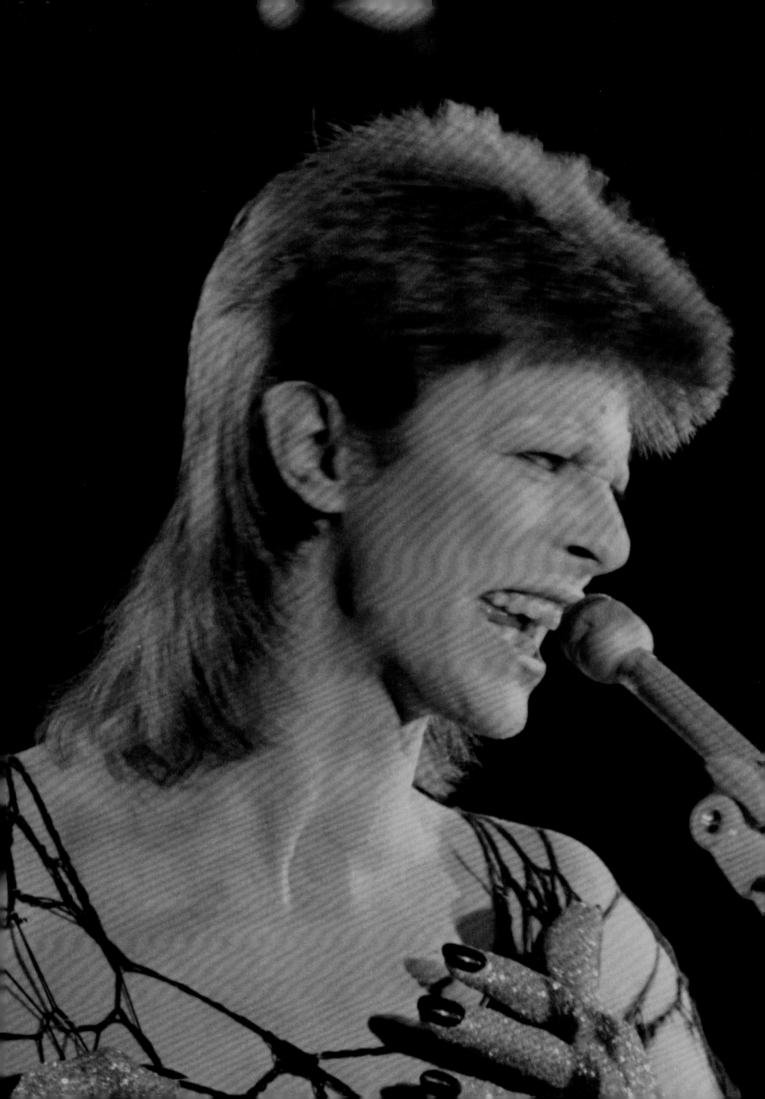

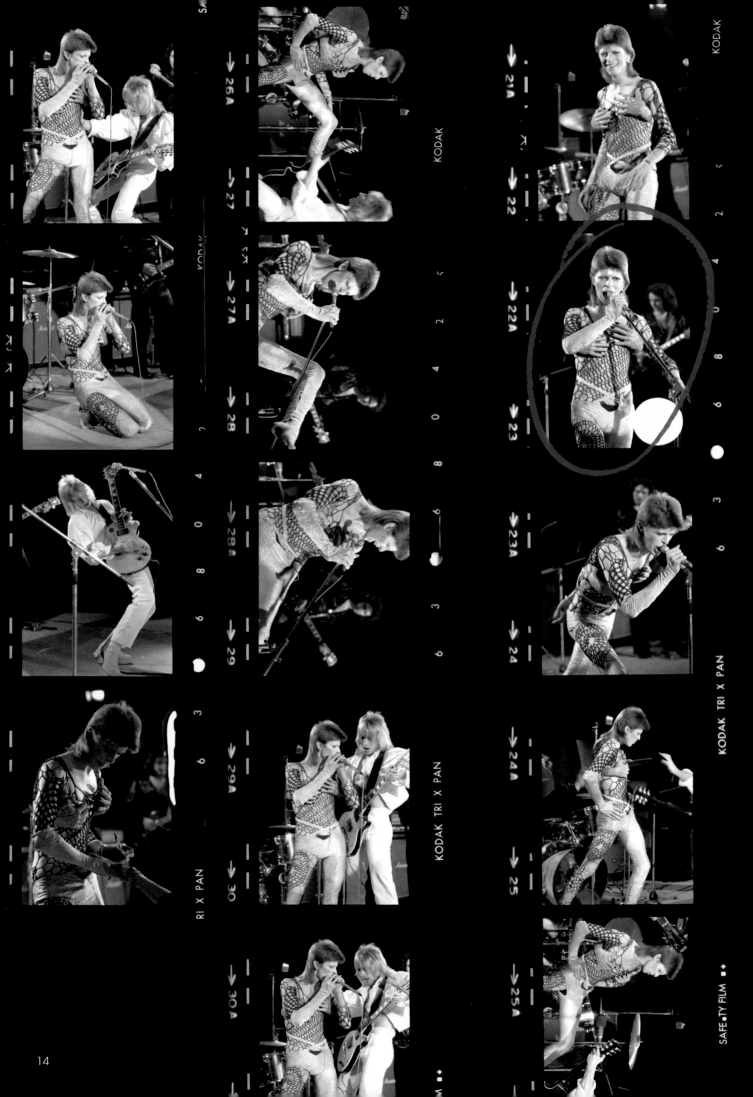



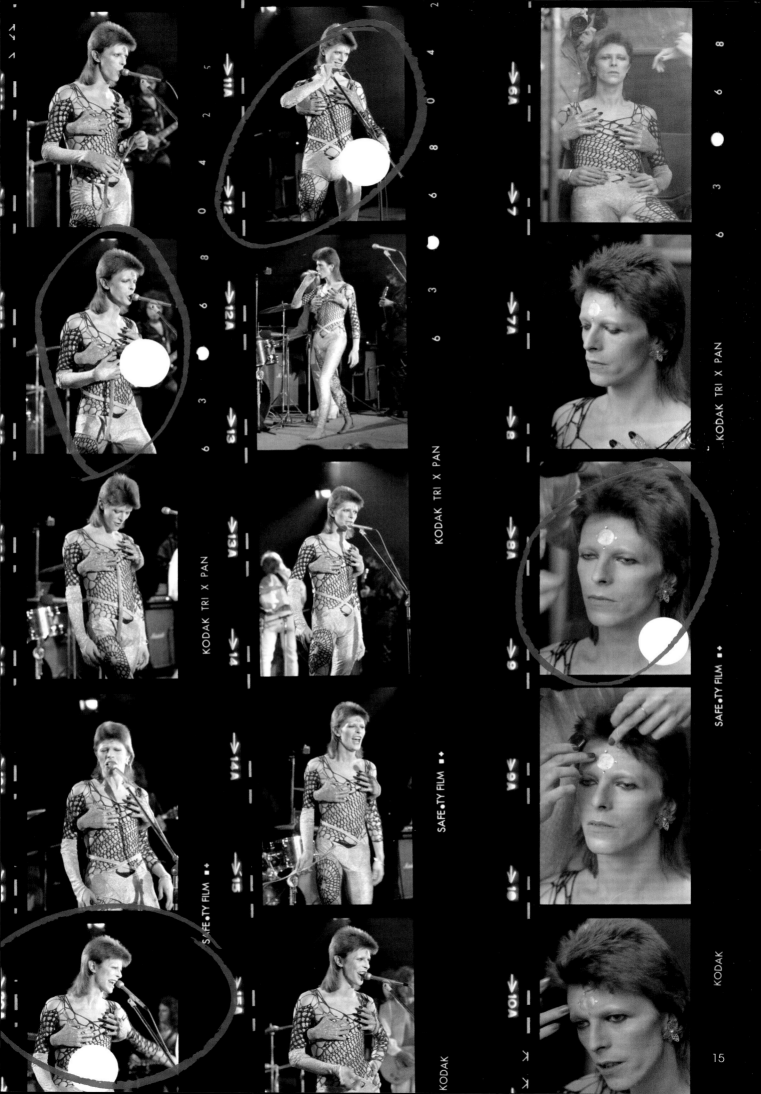

15

"Lucky for some…unlucky for many!"
The Marquee press release was right.
It was the very last appearance of
Bowie as the androgynous Ziggy
Stardust, and the audience was small
and specially invited. Terry O'Neill was
one of them and, in the pre-digital
age, he shot roll after roll: 432 frames.

Since the death of Ziggy had already
made headlines, this was it. This really
was the end. History, and O'Neill was
recording it.

Later, viewing contact sheets that
contained pure gold, he would
mark his chosen shots and Ziggy
would live forever.

Set list:

1984/Dodo (Bowie)

Sorrow (Bowie)

Bulerias (Carmen)

Everything's Alright (Bowie)

Space Oddity (Bowie)

I Can't Explain (Bowie)

As Tears Go By (Marianne Faithfull)

Time (Bowie)

Wild Thing (the Troggs)

The Jean Genie (Bowie)

Rock 'n' Roll Suicide (Bowie) – not broadcast

20th Century Blues (Marianne Faithfull)

I Got You Babe (Bowie/Marianne Faithfull)

"A huge cheer went up
as the musicians appeared
for a sound check."

Chris Welch, *Melody Maker*

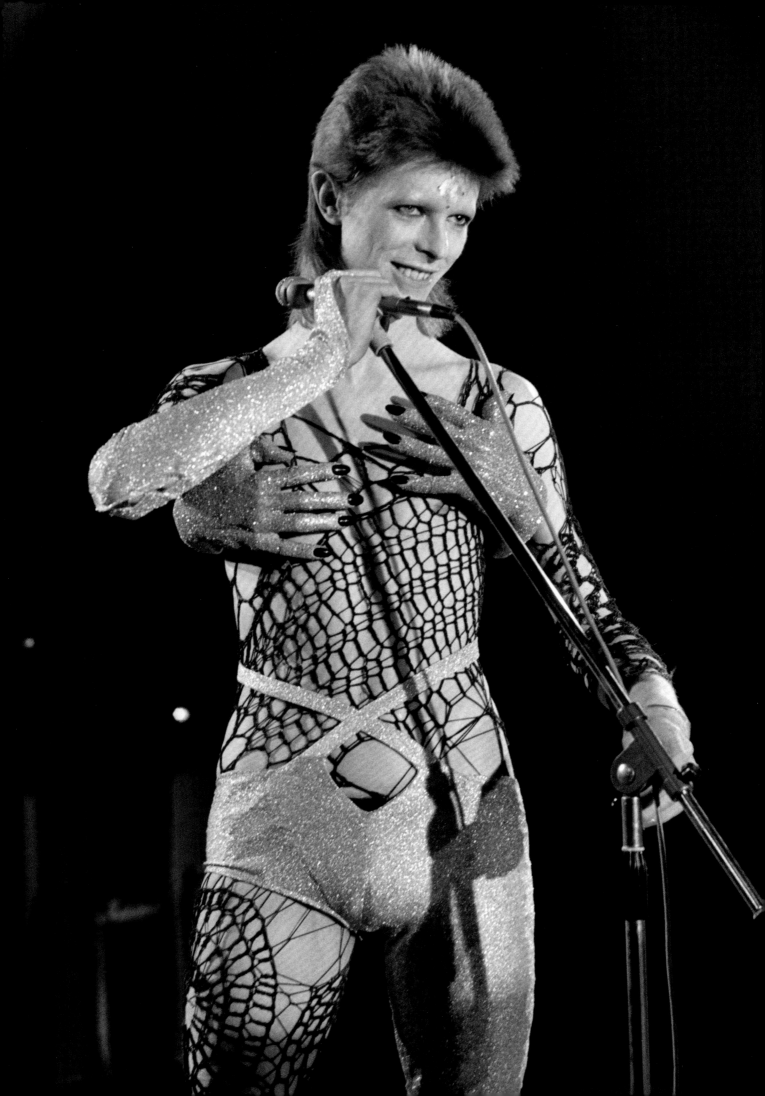

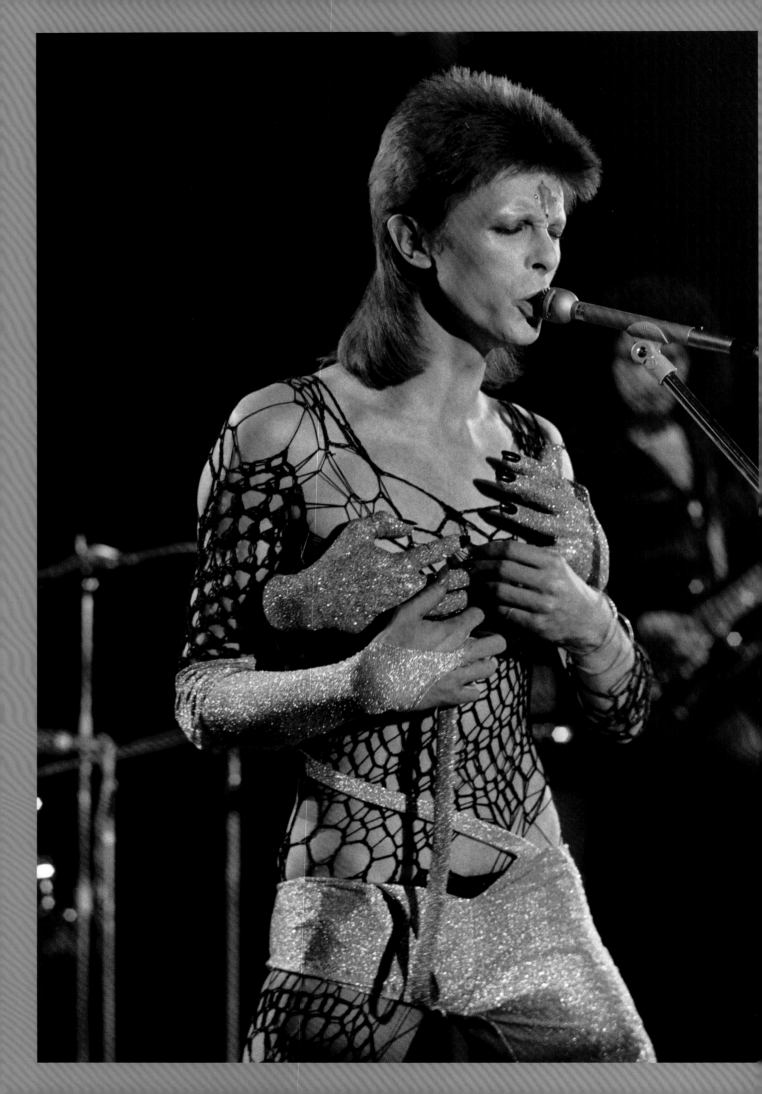

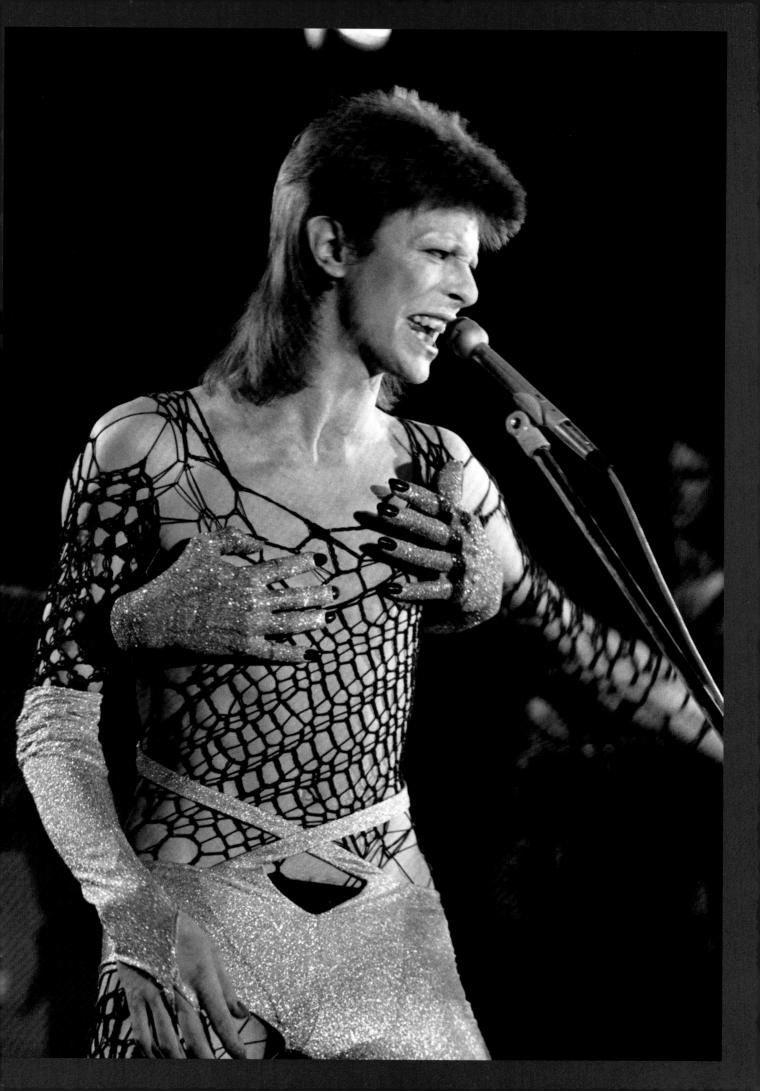

"Now he was attired in a fish net
of a type usually employed
in catching small whales
with disembodied gold hands
attached to his torso.
Apparently there had been a third hand.
But American television
would not stand for that."

Chris Welch, *Melody Maker*

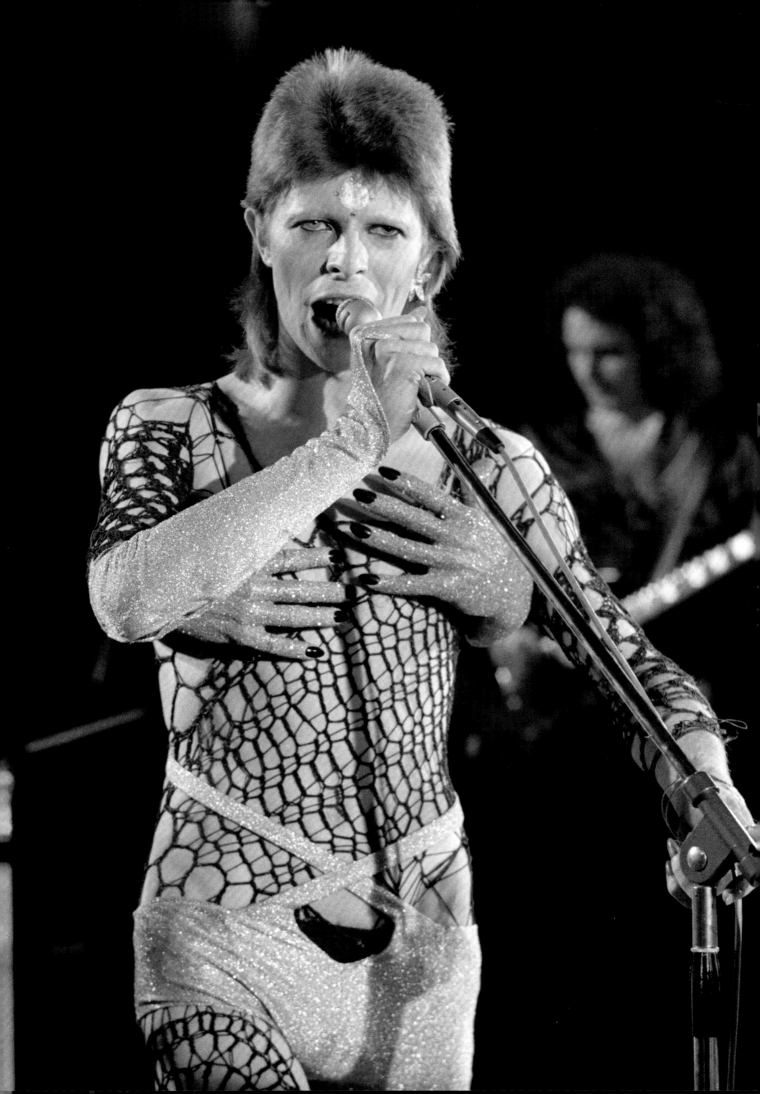

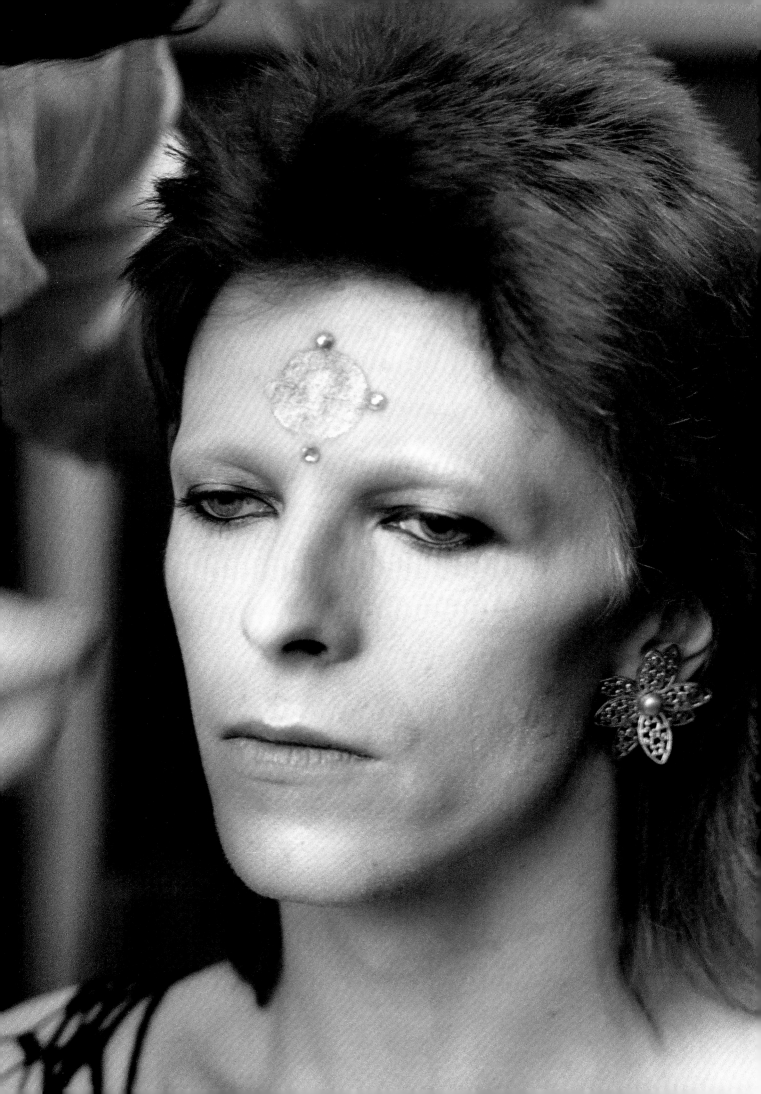

"I don't know
where I'm going
from here,
but I promise
it won't
be boring." DB

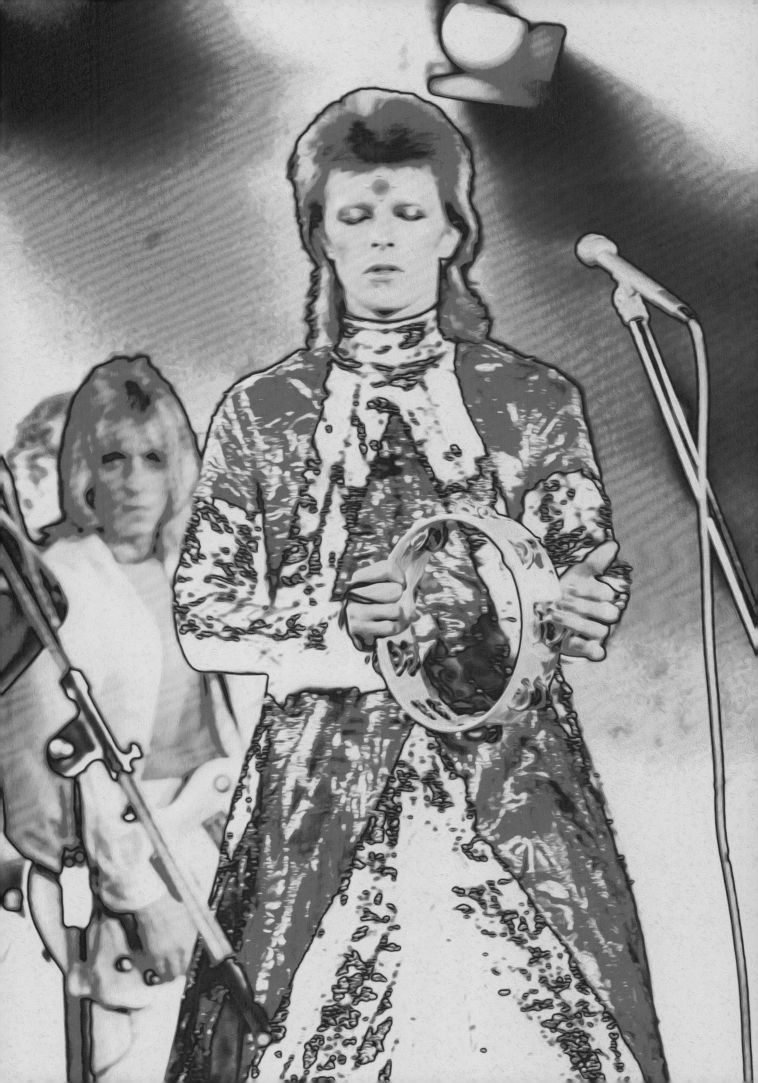

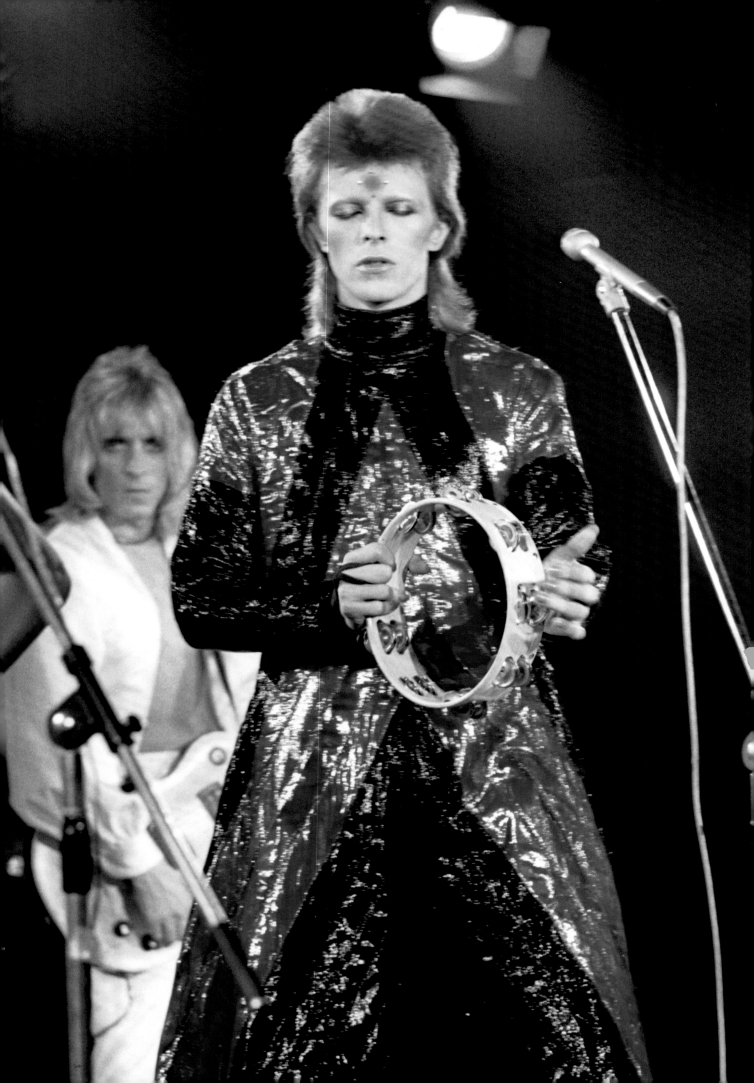

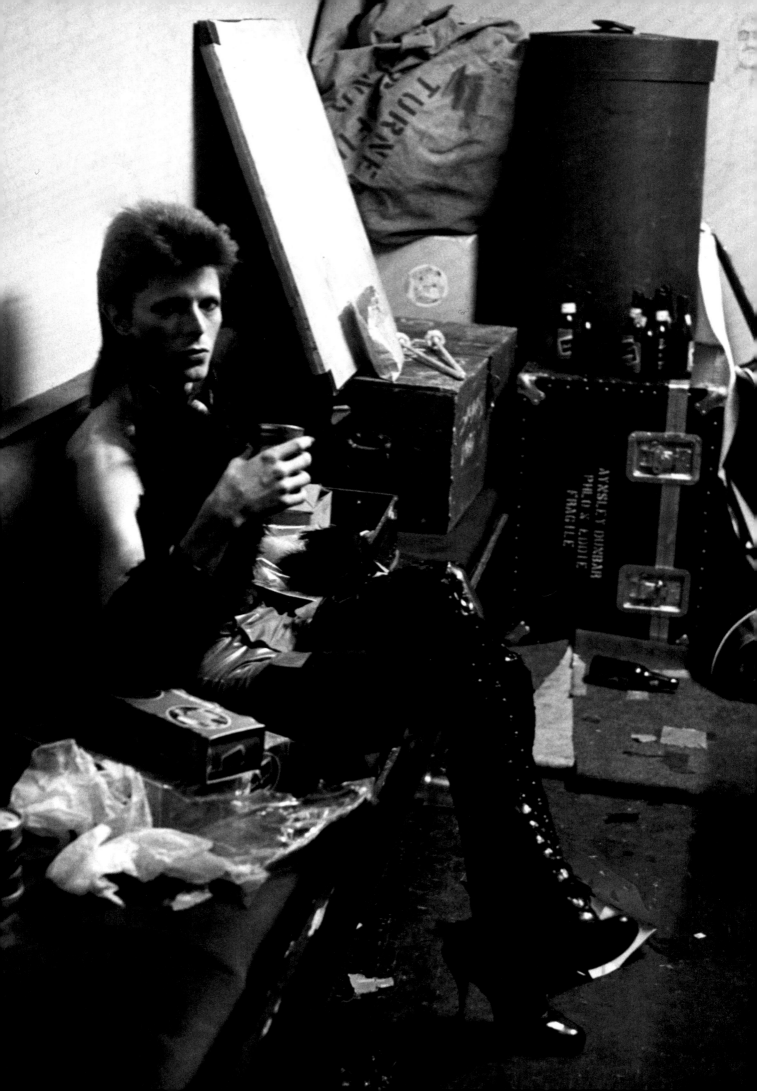

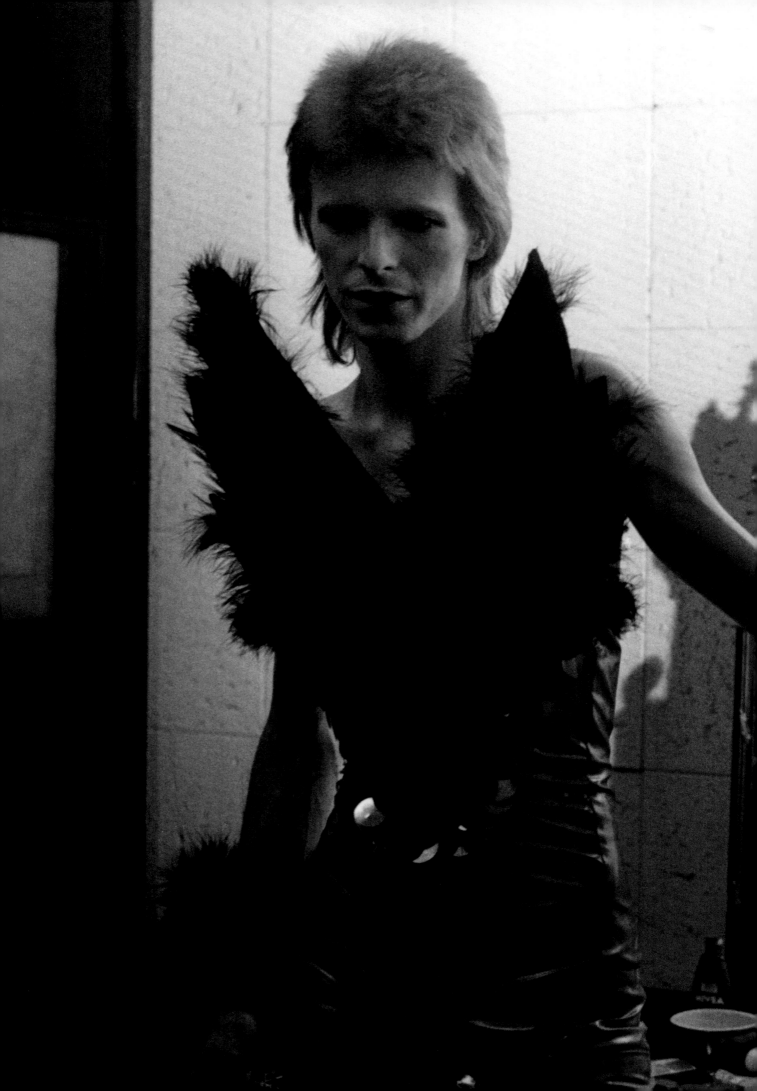

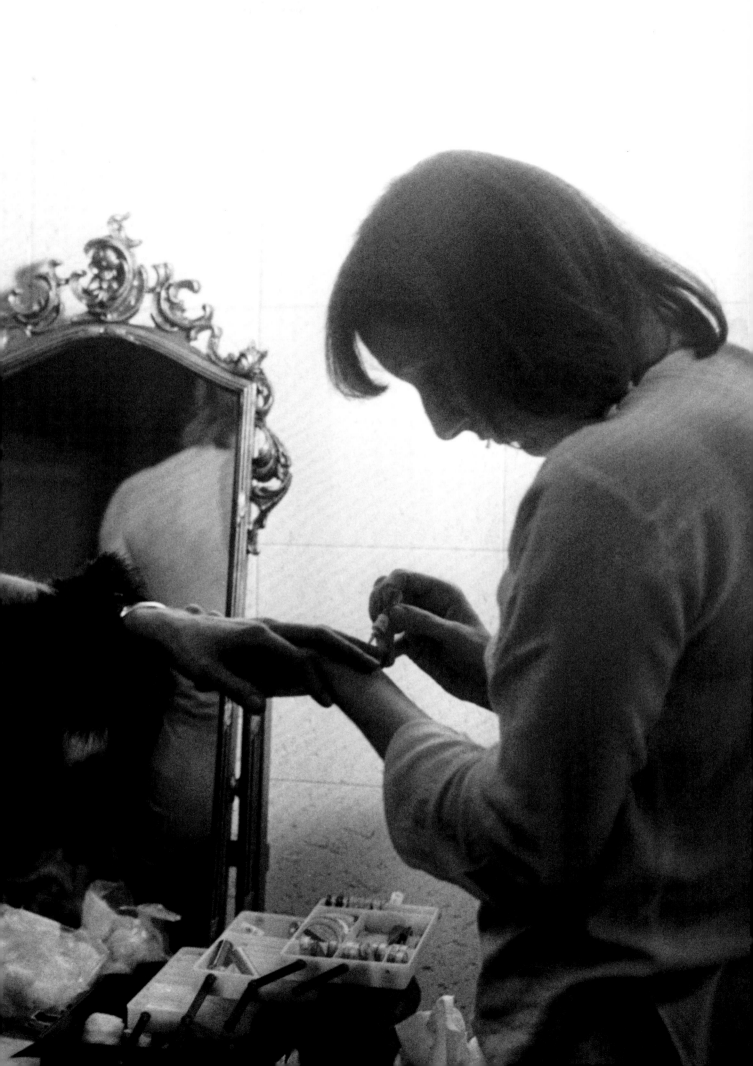

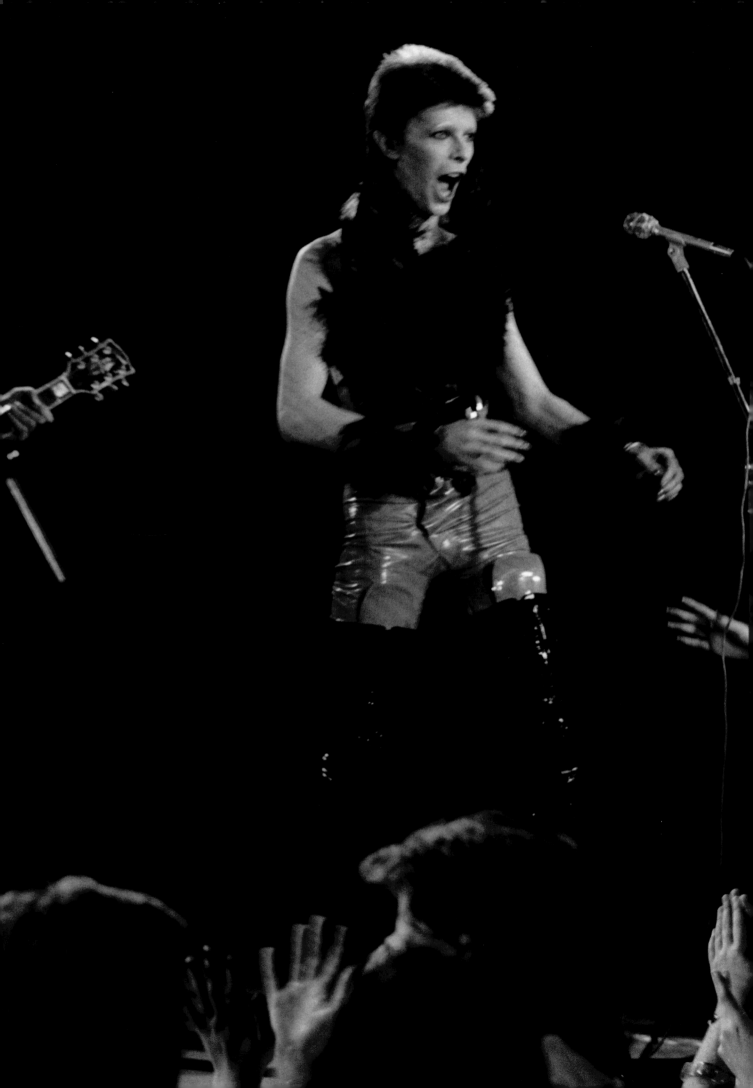

"I always had a repulsive need
to be something more than human.
I felt very puny as a human.
I thought, fuck that.
I want to be a superhuman." DB

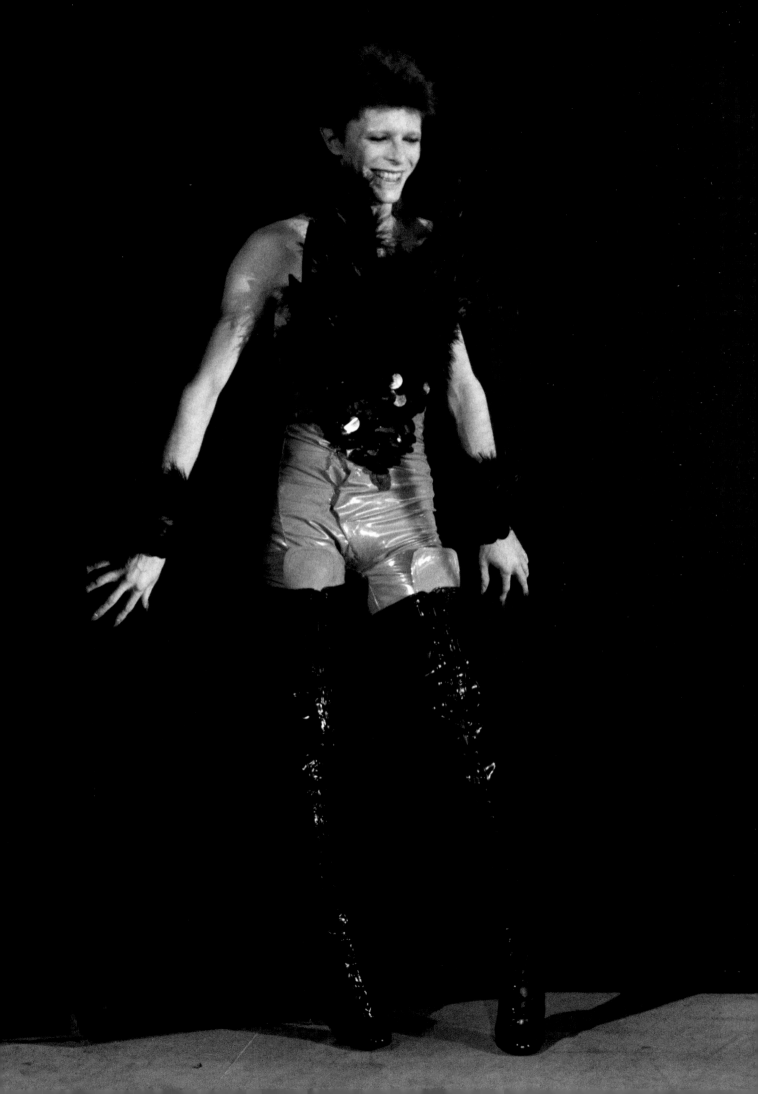

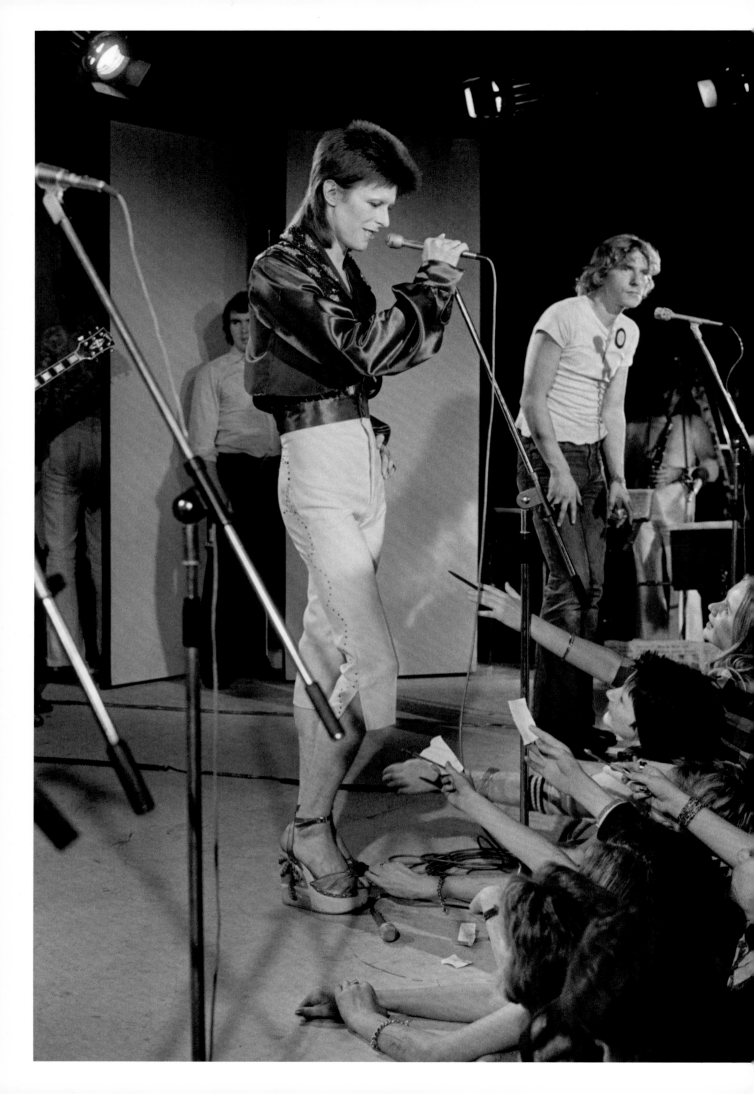

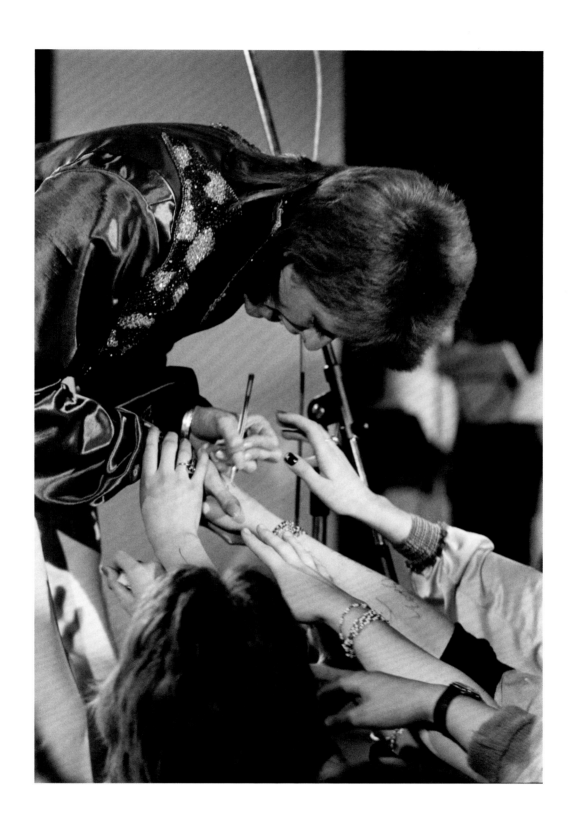

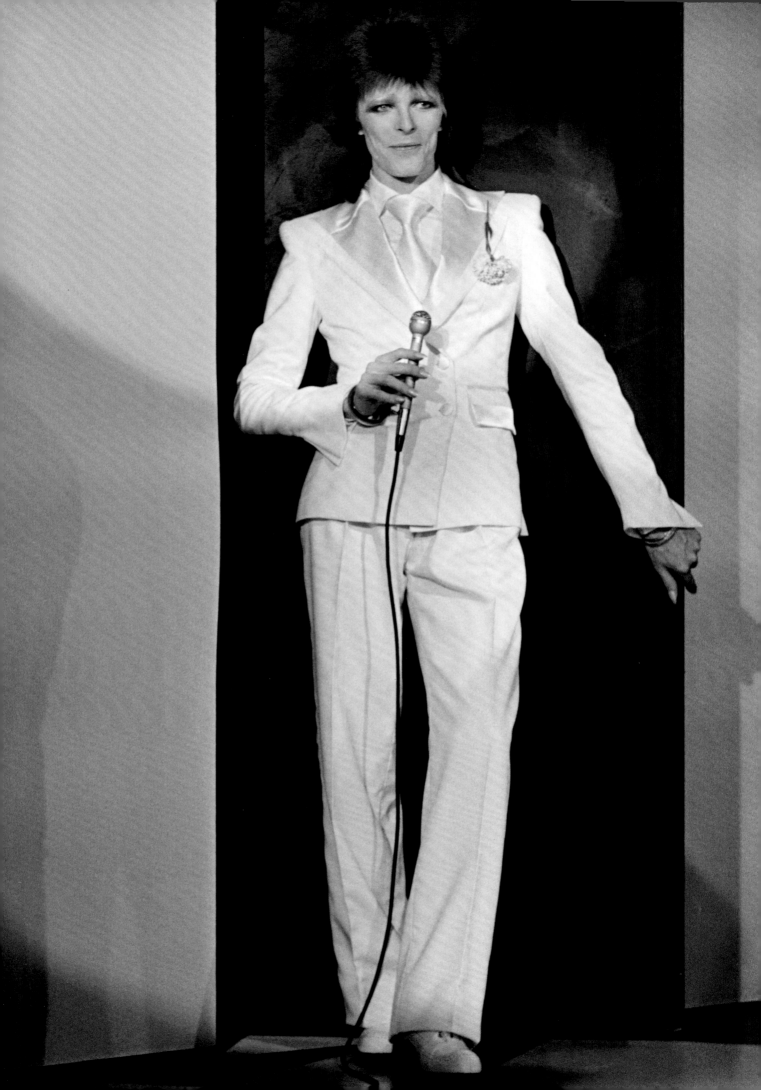

"He was visually the most interesting person
I've ever had the chance to photograph.
I never knew what he'd look like
when he walked through the door."

Terry O'Neill

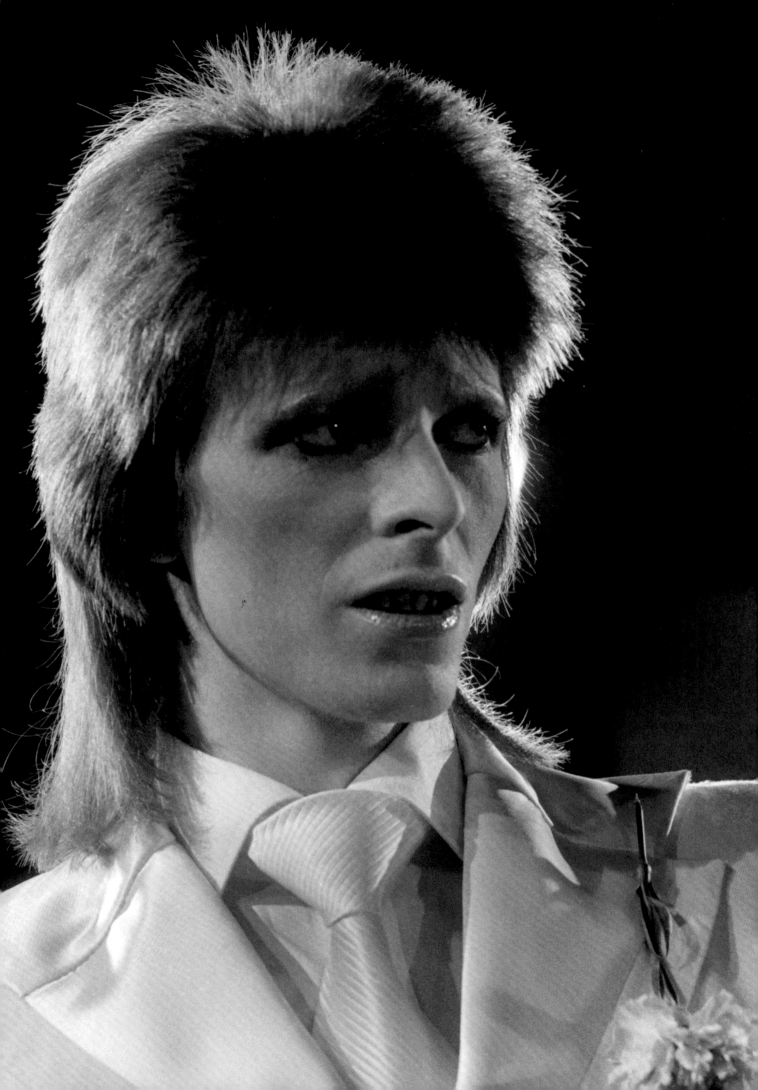

"I'm an instant star,
just add water
and stir." DB

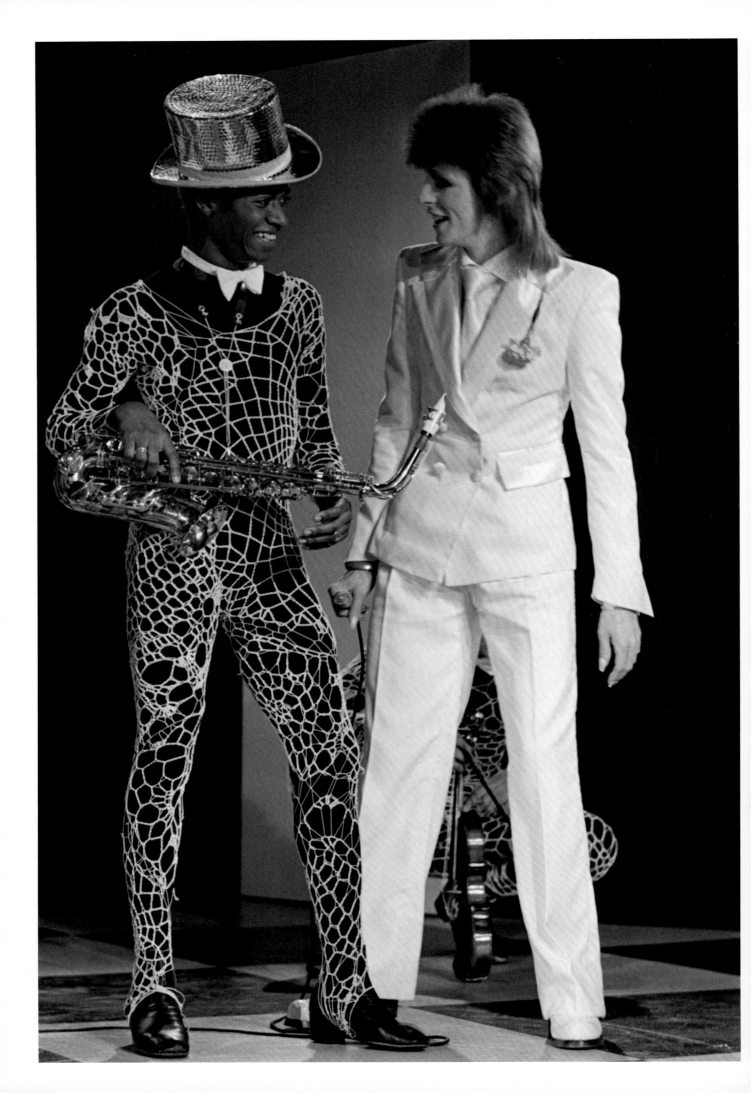

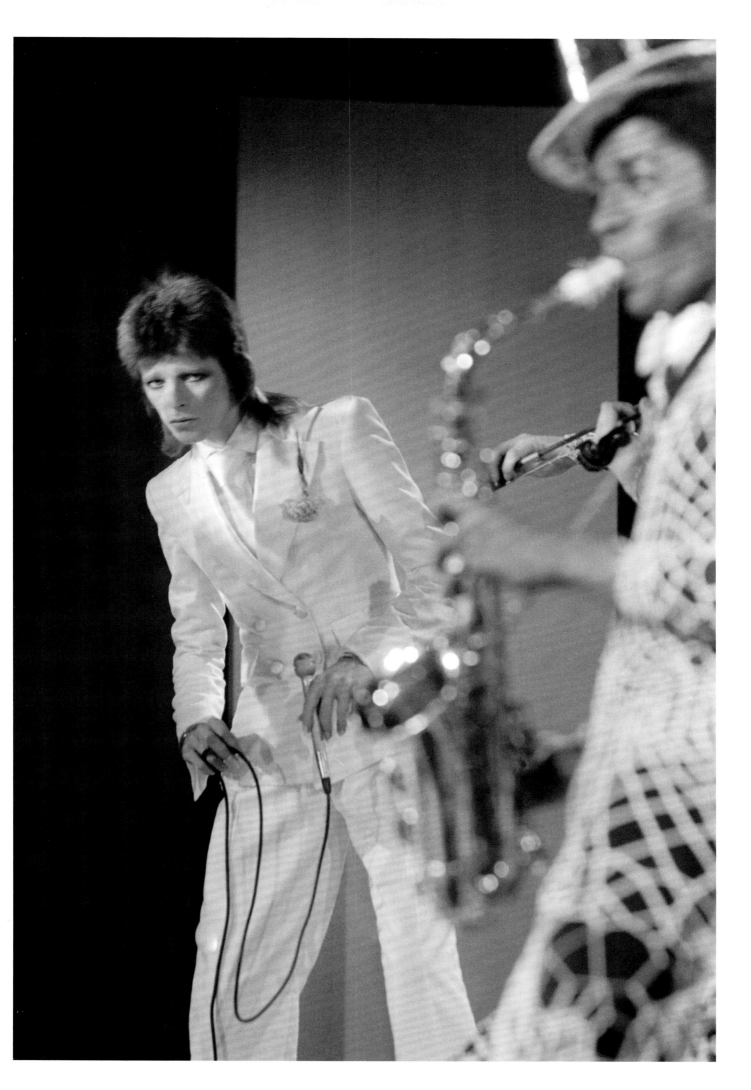

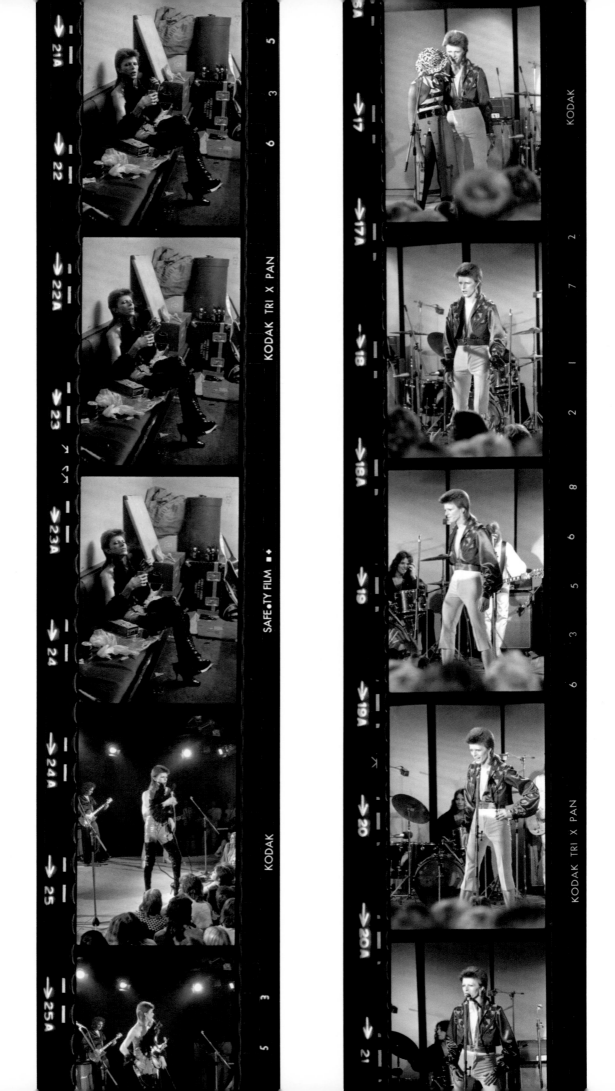

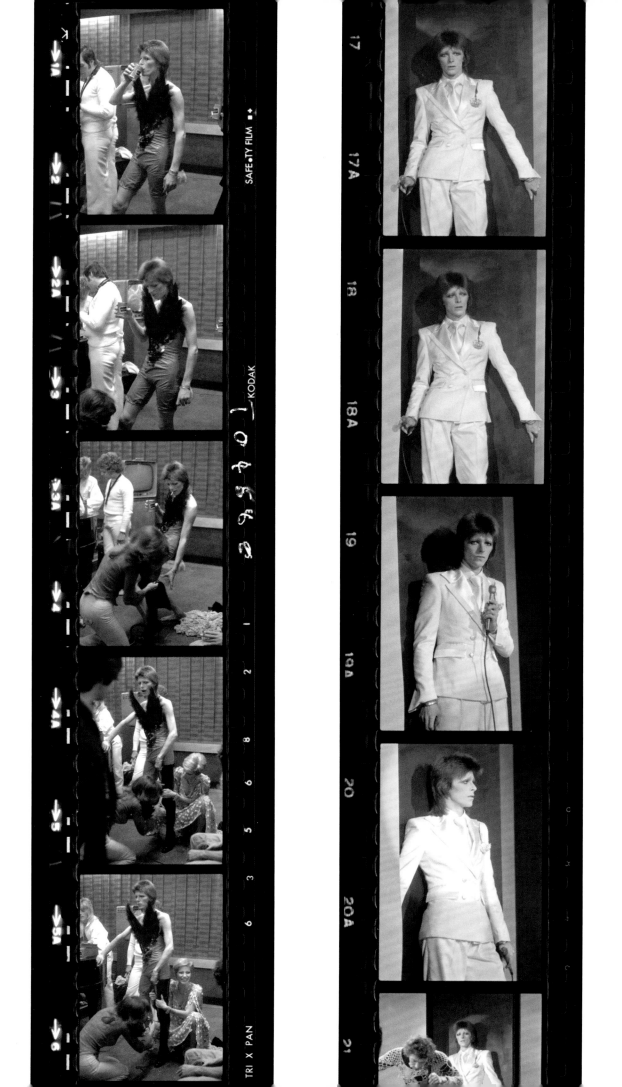

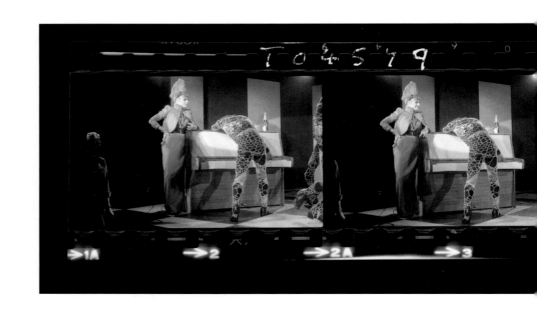

"Sometimes I don't feel as if
I'm a person at all.

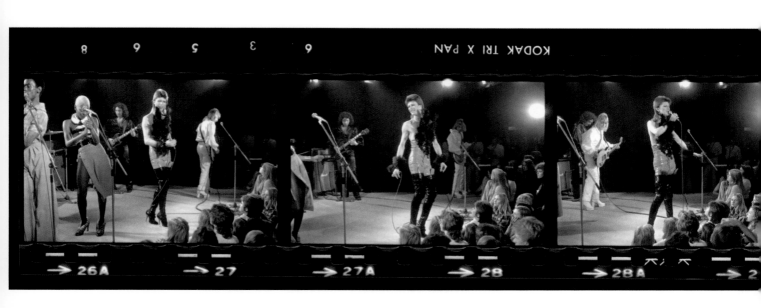

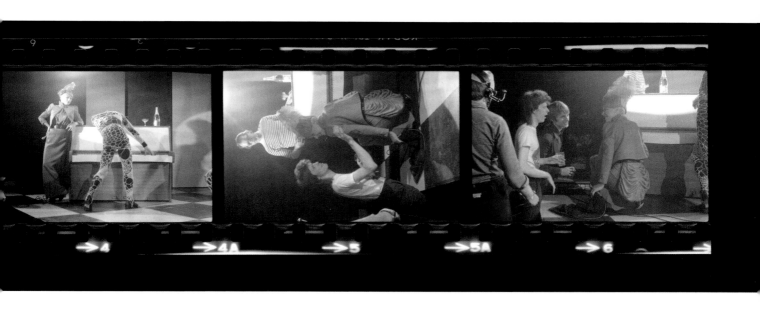

I'm just a collection of other people's ideas." DB

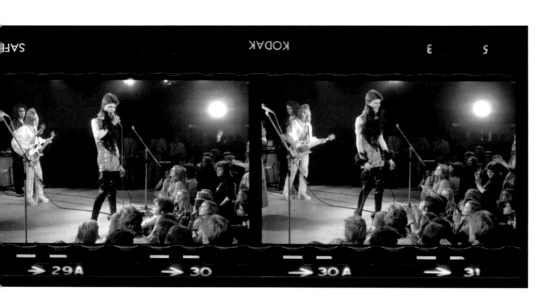

1974

DIAMOND
DOGS

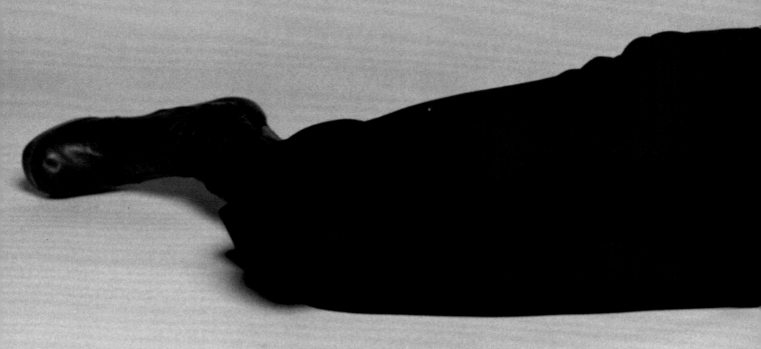

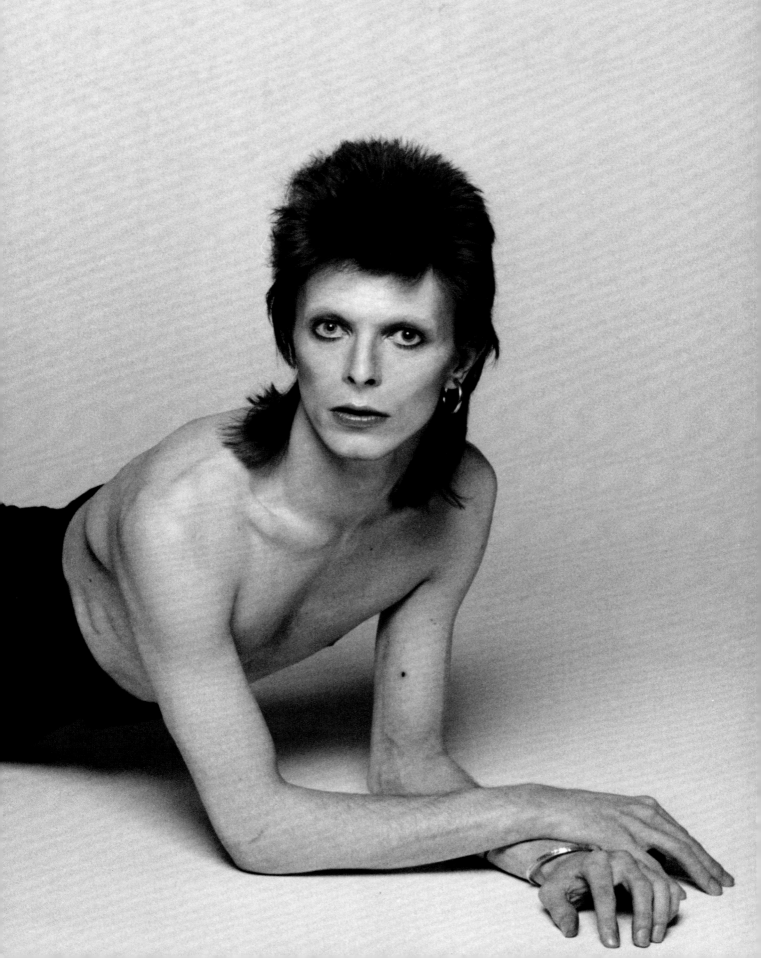

"Less than a year after he had laid Ziggy to rest
Bowie had a new character,
new music, new fashion, new art,
a whole new persona."

Terry O'Neill

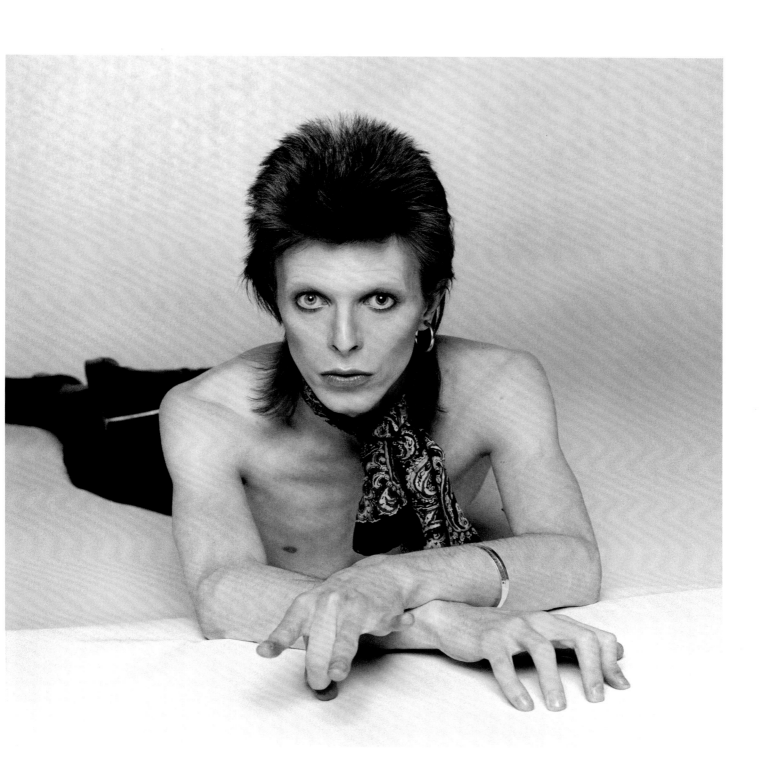

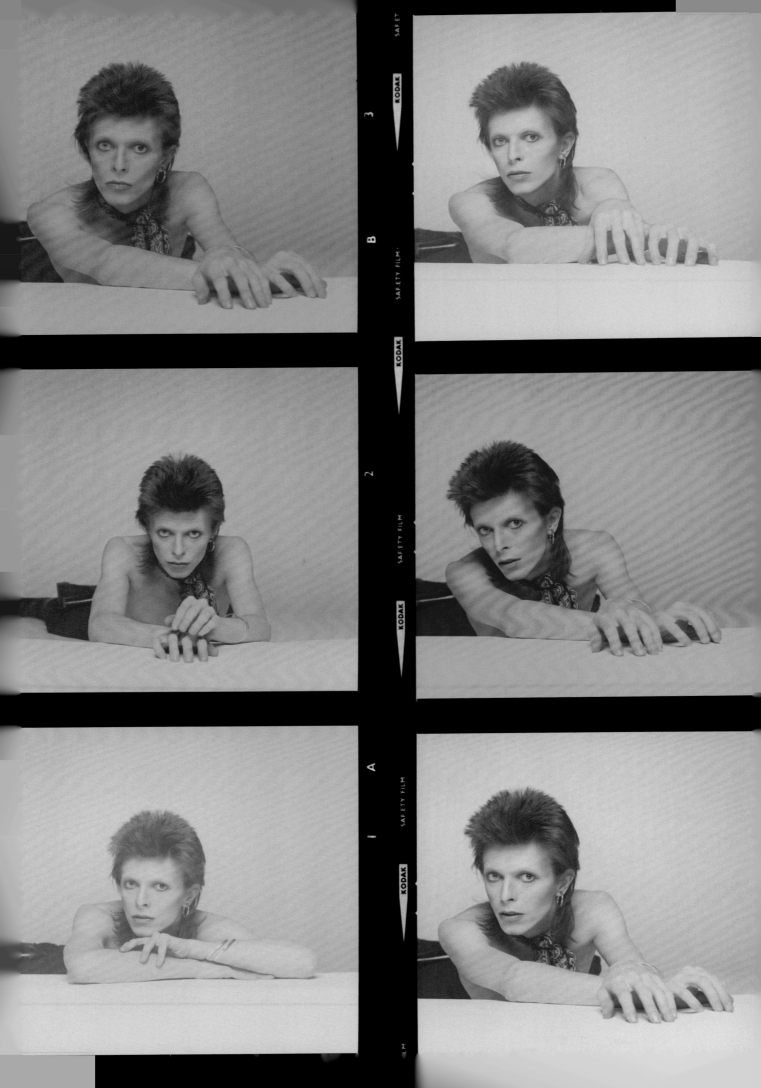

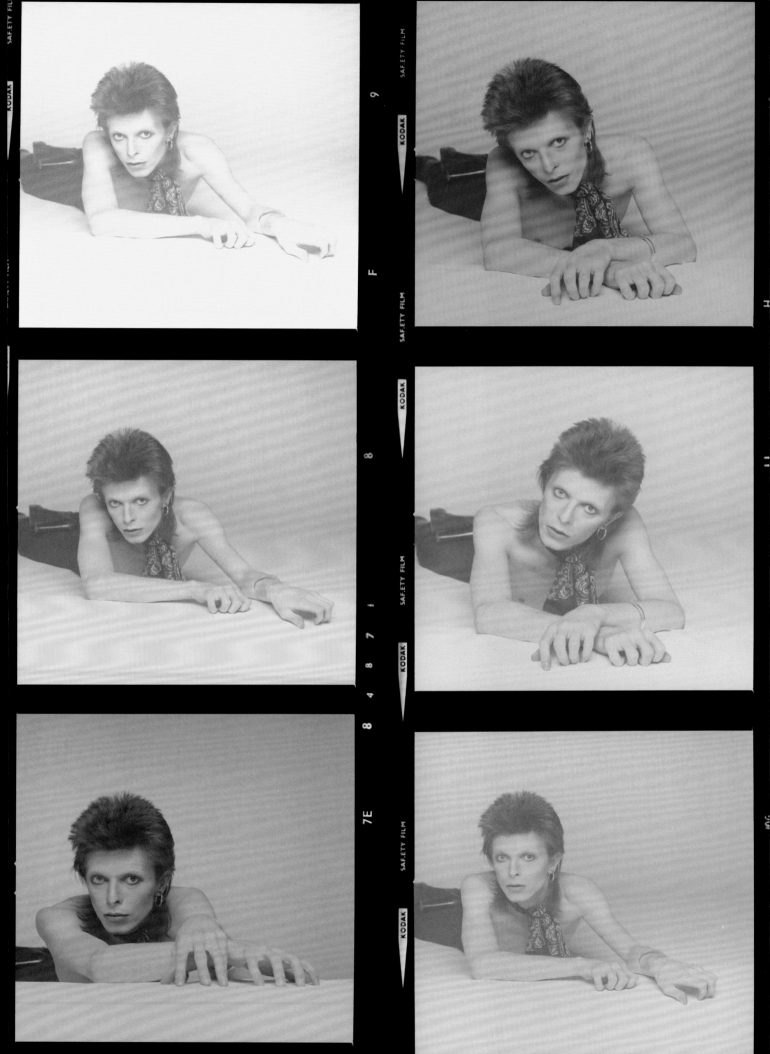

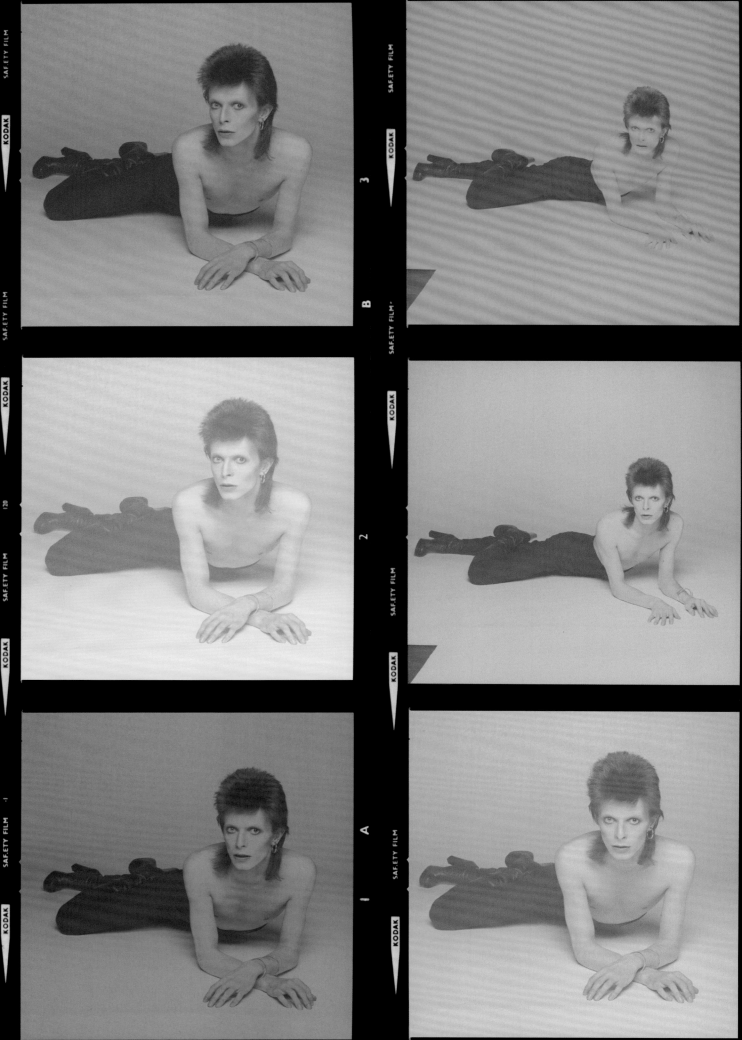

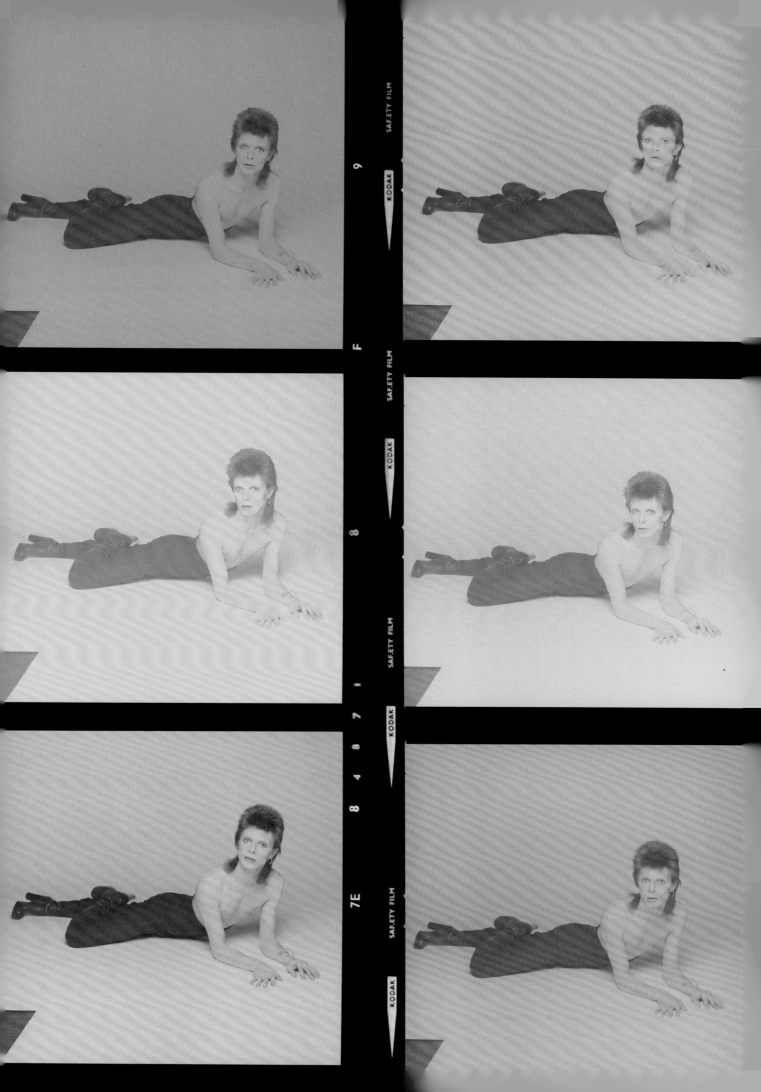

"The artist Guy Peellaert was
commissioned to paint Bowie
as half-man half-dog,
but needed images to work from.
I photographed David
in the man poses
and later a dog for the hindquarters.
Guy painted a composite
of my photographs and the
album duly came out."

Terry O'Neill

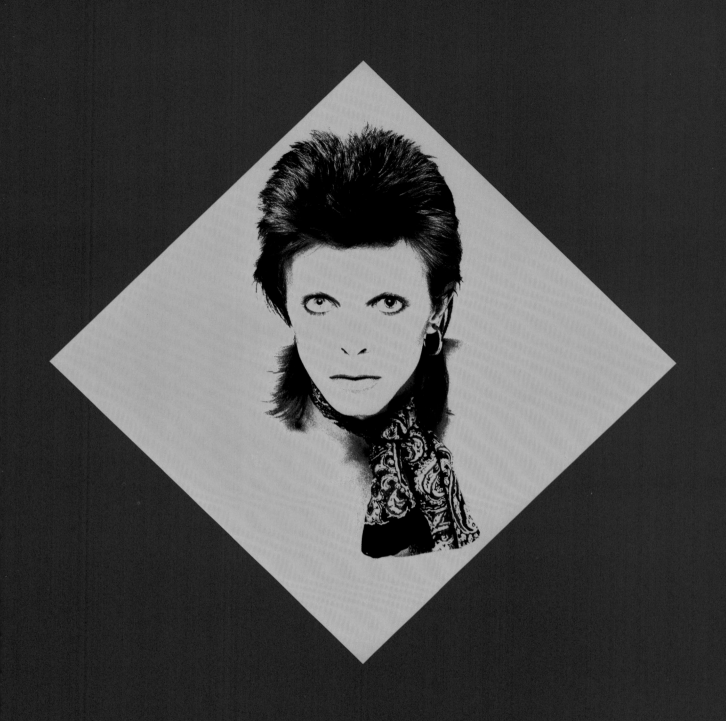

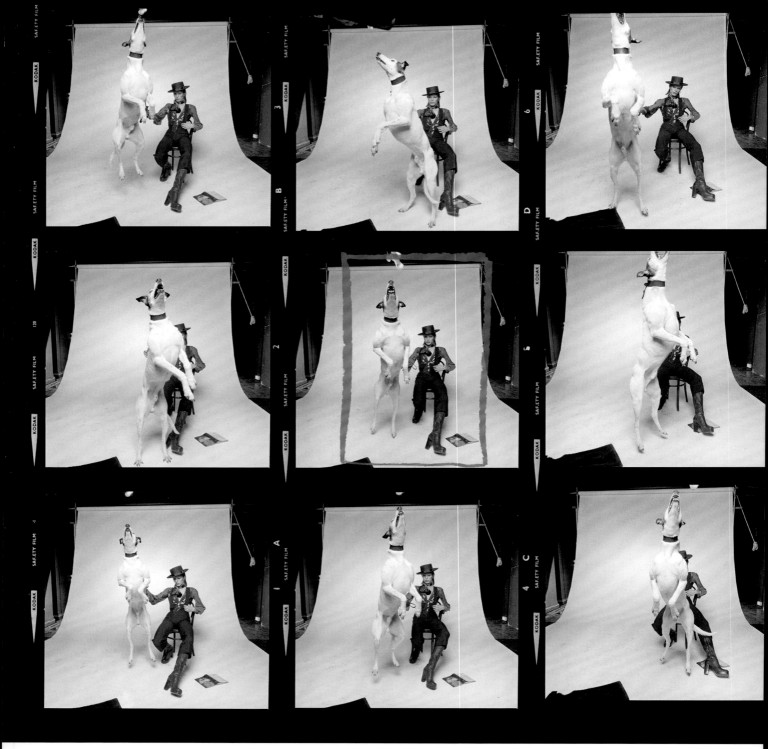

"I took this as a publicity shot for the LP *Diamond Dogs*.
As I started to shoot with the dog sitting quietly beside Bowie,
it suddenly got overexcited and reared six feet
into the air, barking madly.
This terrified the life out of everyone in the studio,
except Bowie, who didn't even flinch."

Terry O'Neill

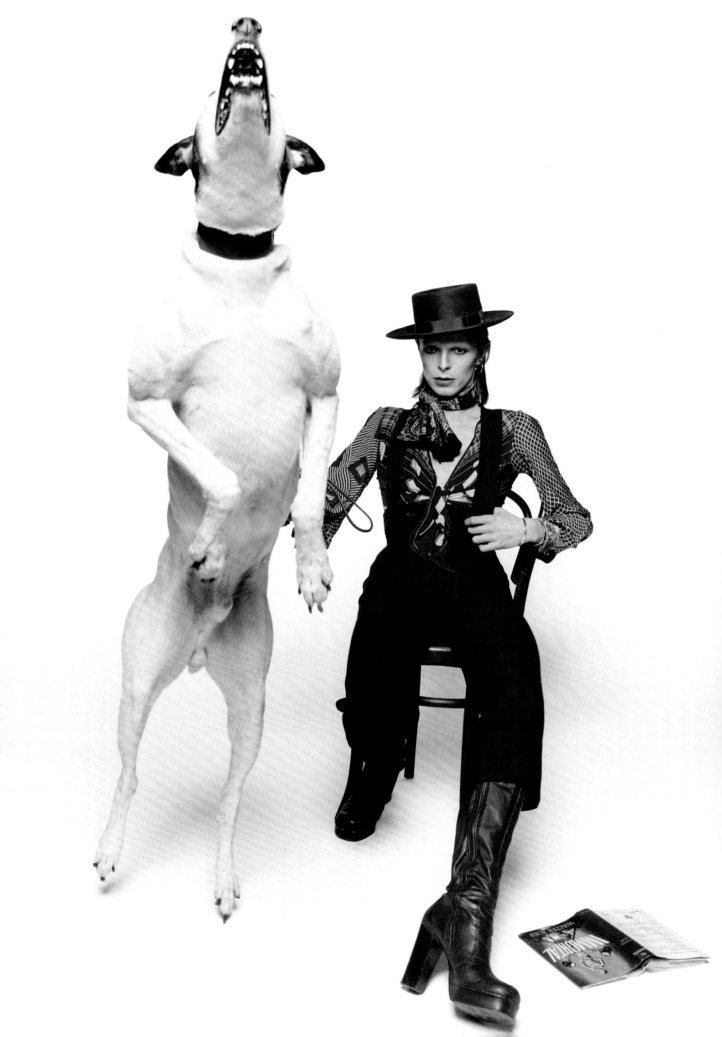

1974

LOS ANGELES MAGAZINE INTERVIEW

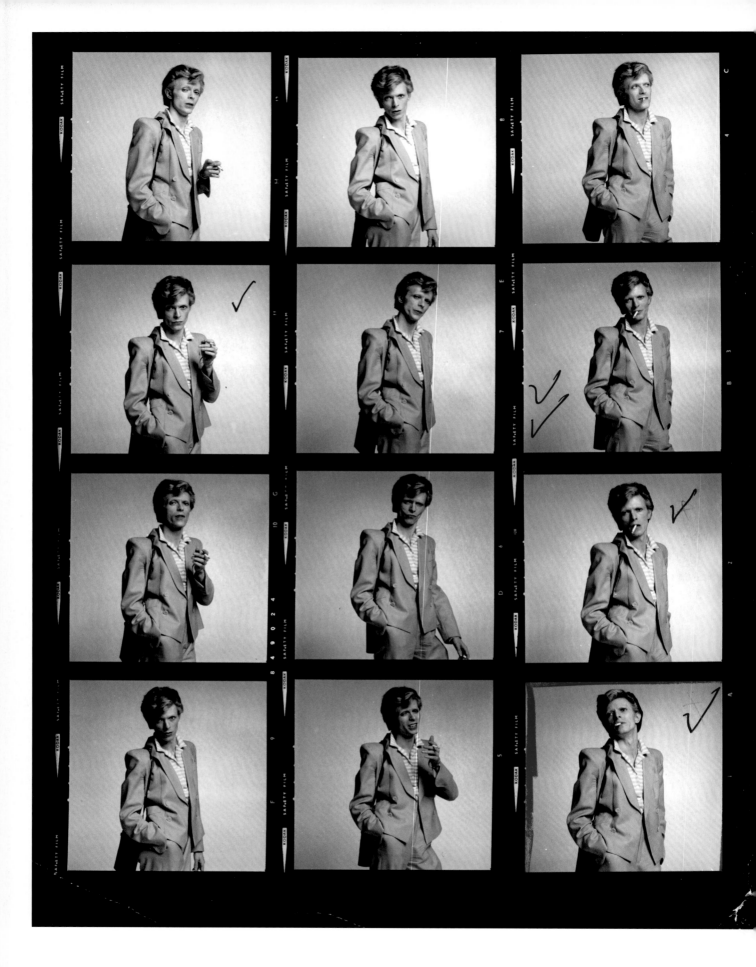

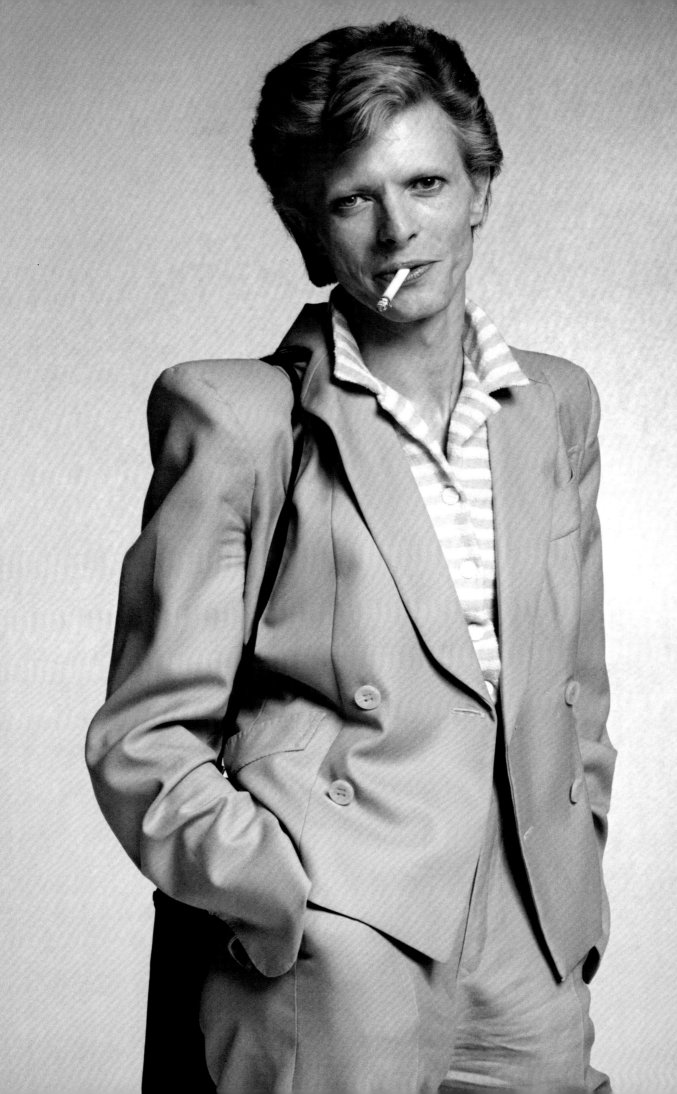

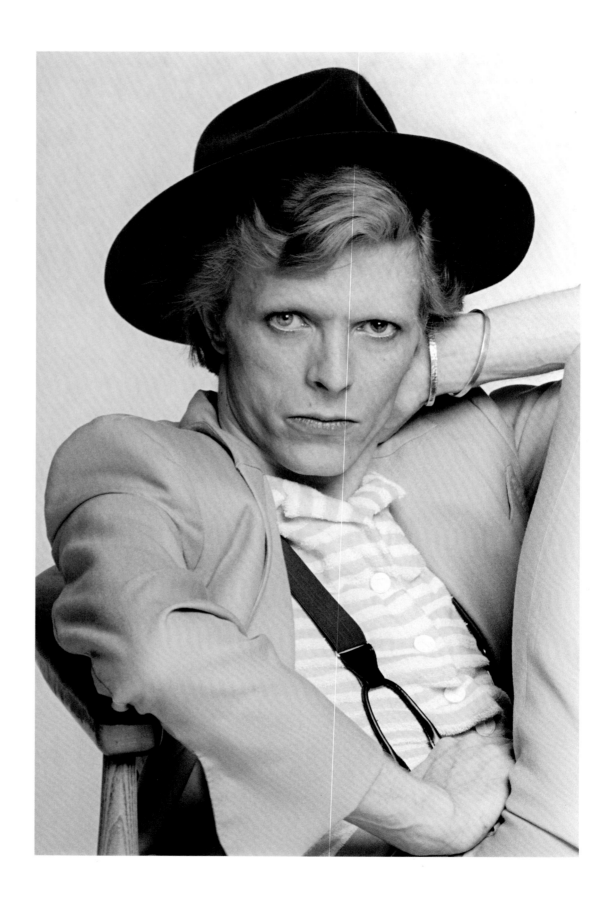

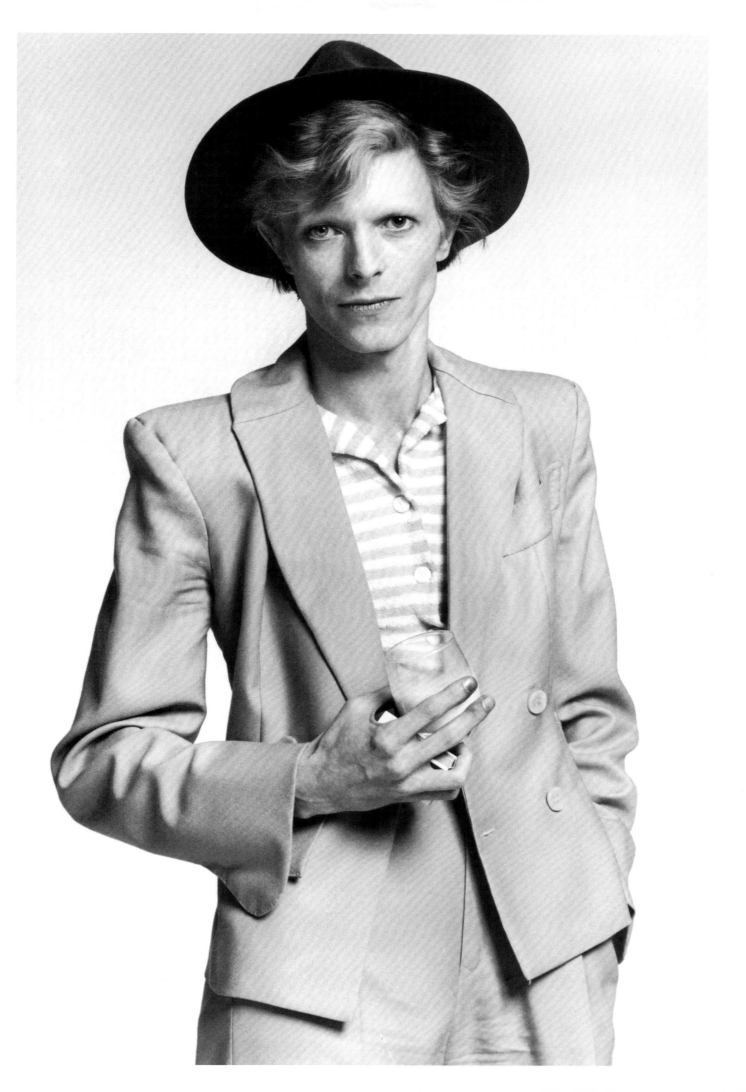

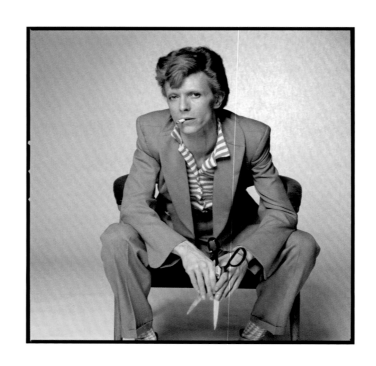

"He's got a cigarette in his mouth
and he's holding a pair of scissors.
I didn't ask him to.
He just saw them on the floor,
picked them up
and I thought – why change it?"

Terry O'Neill

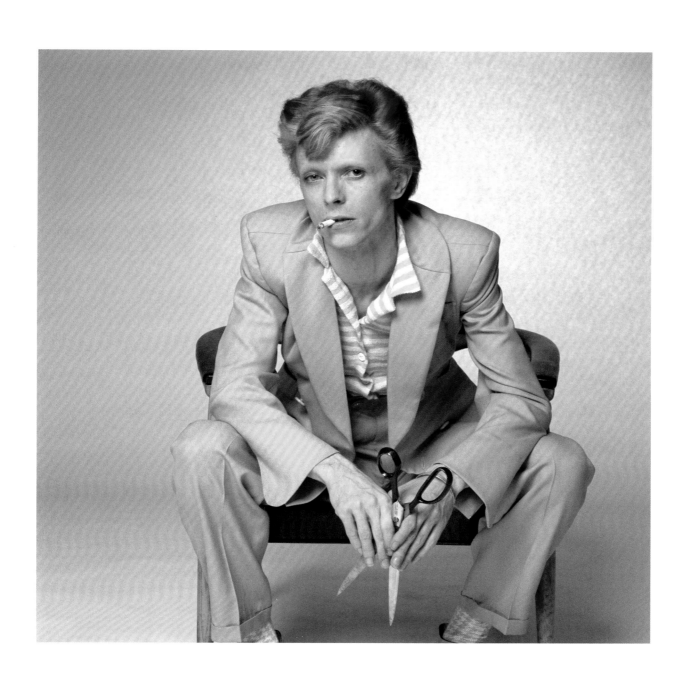

"Make the best of
every moment.
We're not evolving.
We're not going anywhere." DB

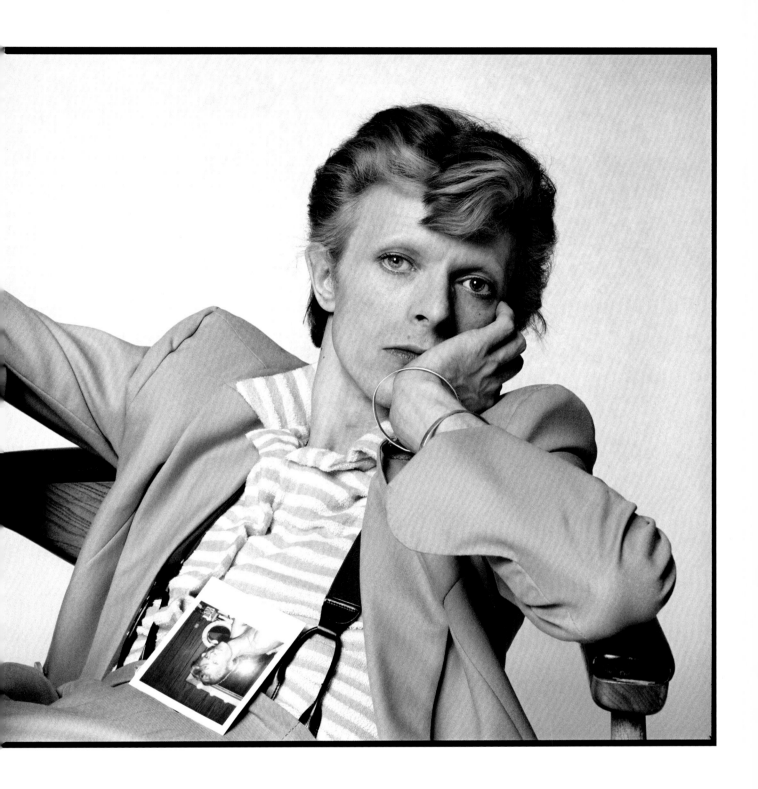

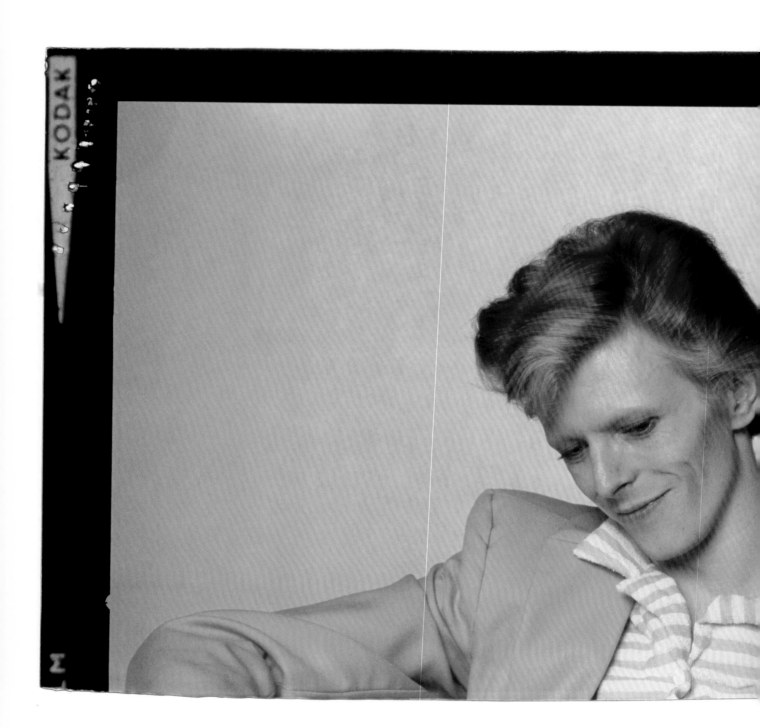

Bowie, influenced by William Burroughs,
used the "cut up" method to create lyrics,
a technique first introduced in 1959
by painter Brion Gysin.
Terry often used similar methods to
ensure specific shots would not be used by art directors.

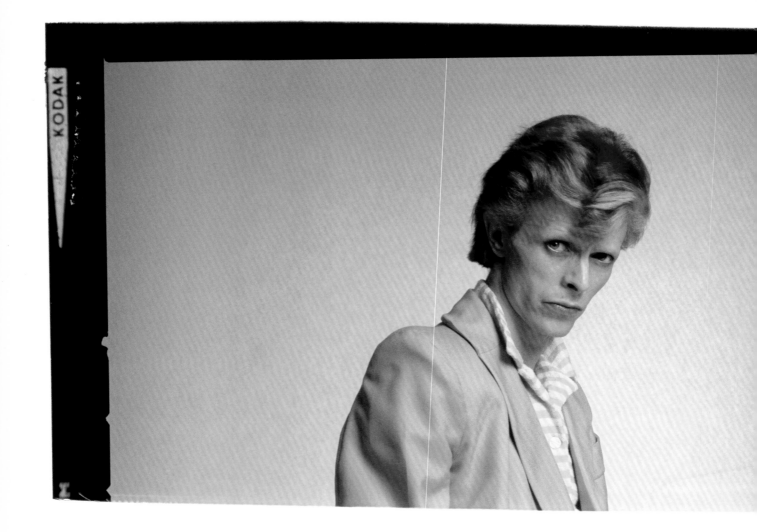

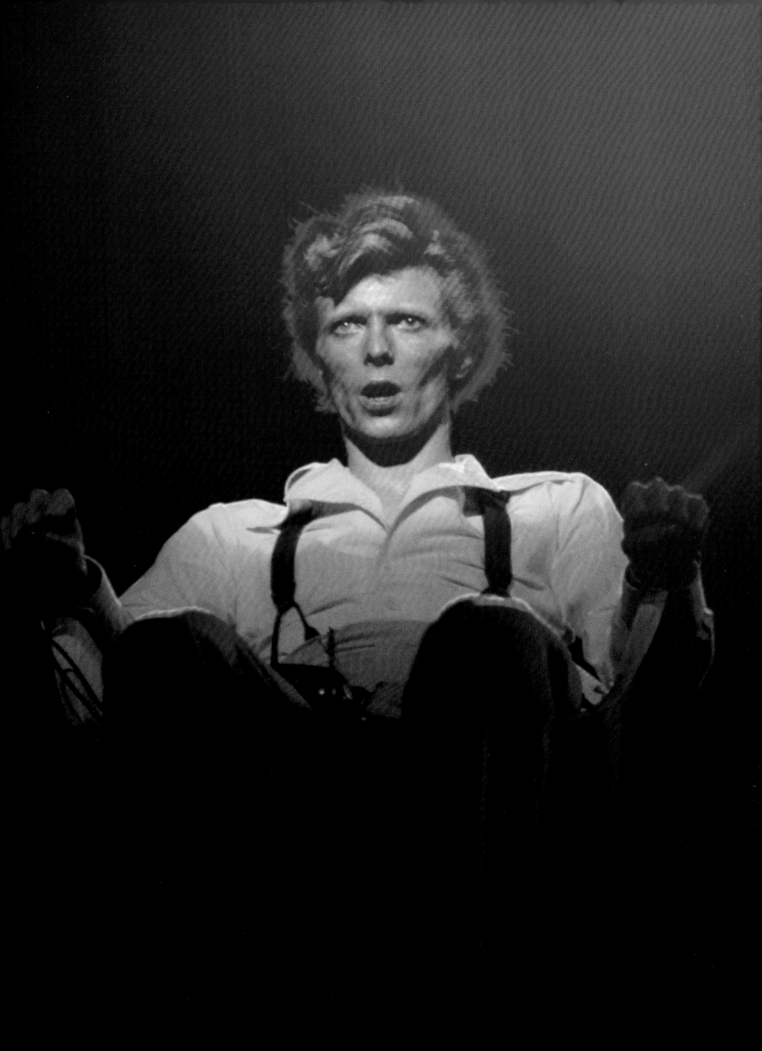

"It was next to impossible to capture
in photographs
David's presence when performing.
His shows were pure theatre."

Terry O'Neill

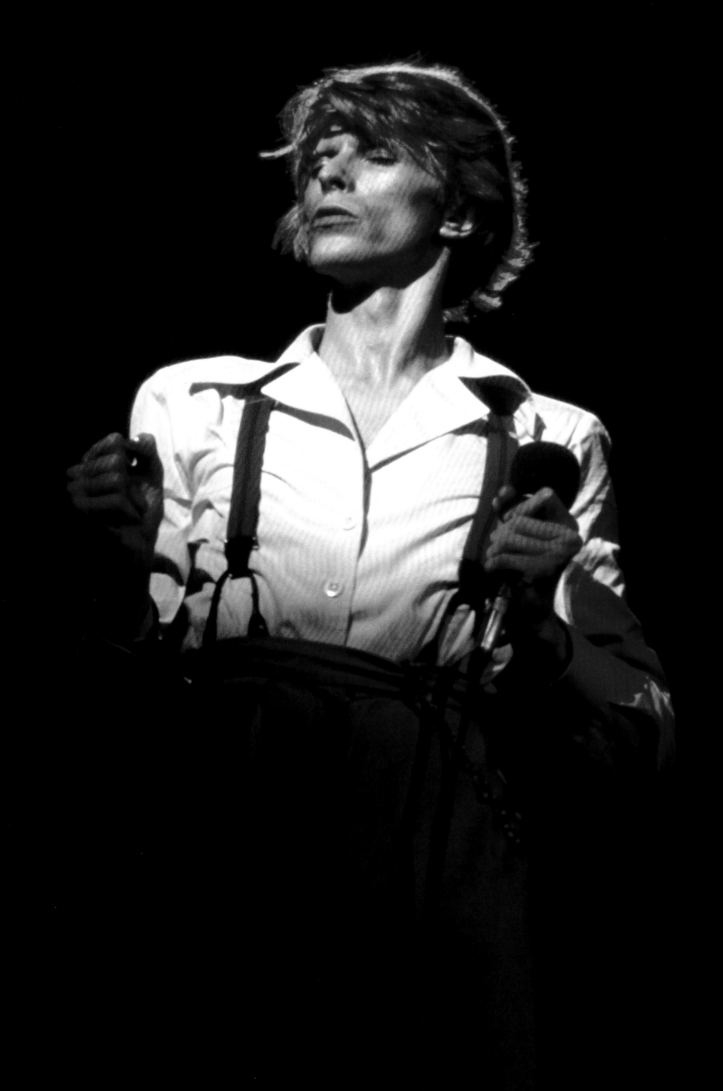

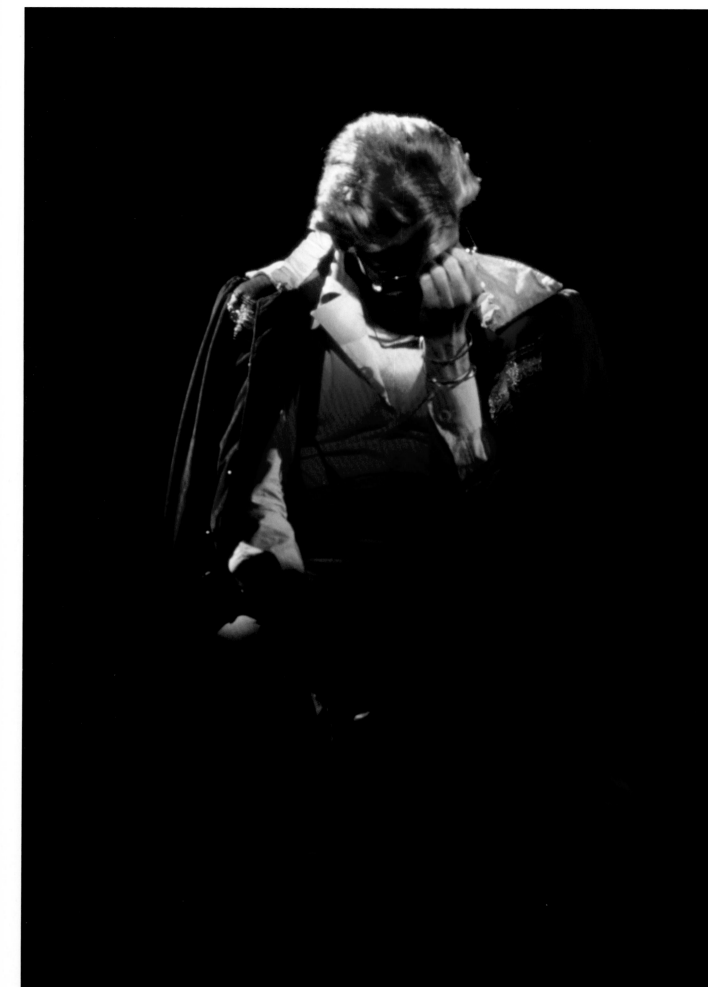

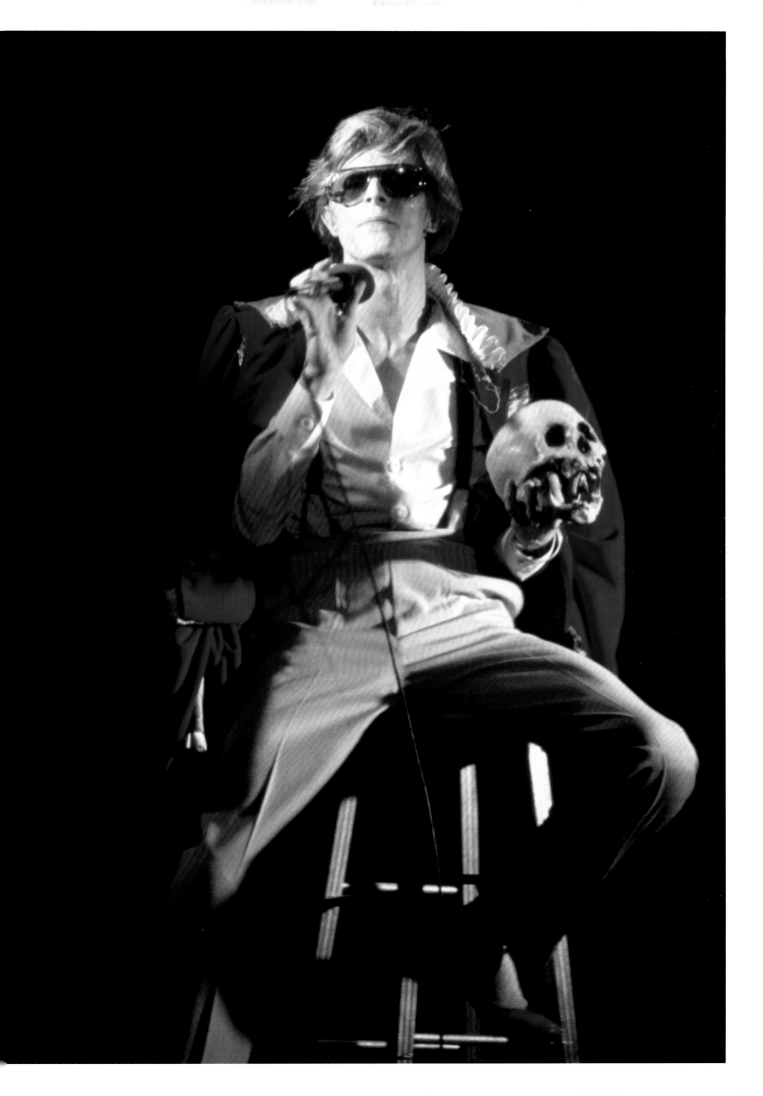

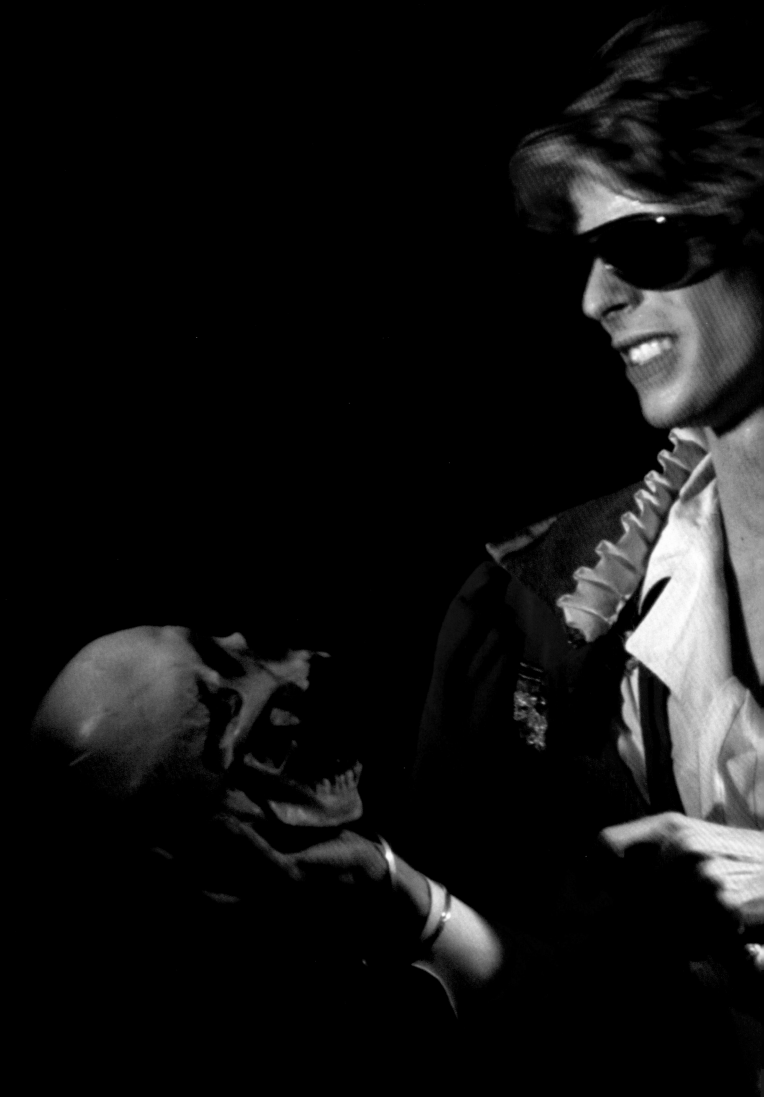

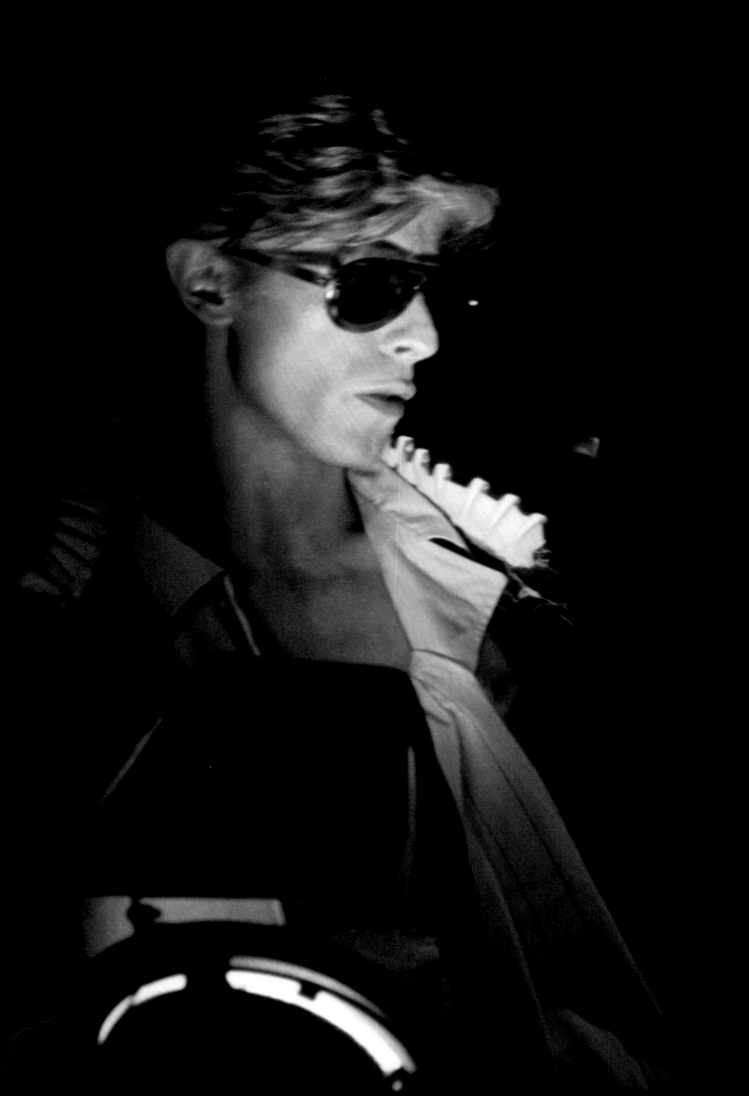

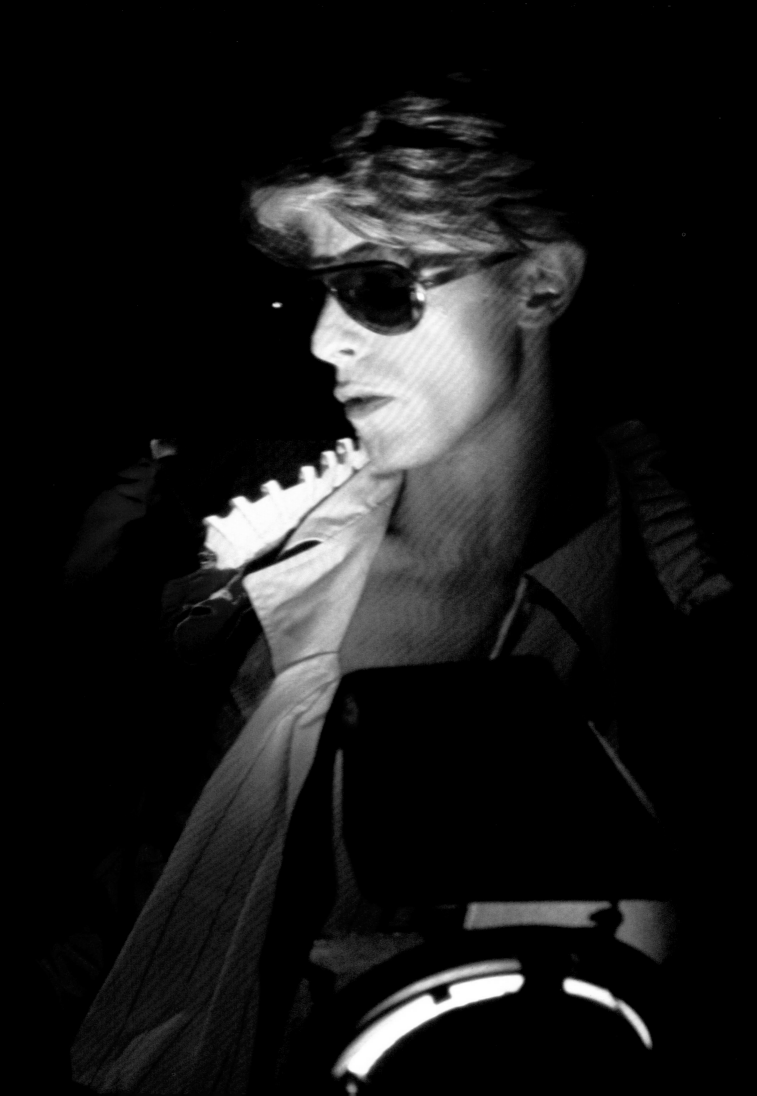

"It's always time
to question
what has become
standard and
established." DB

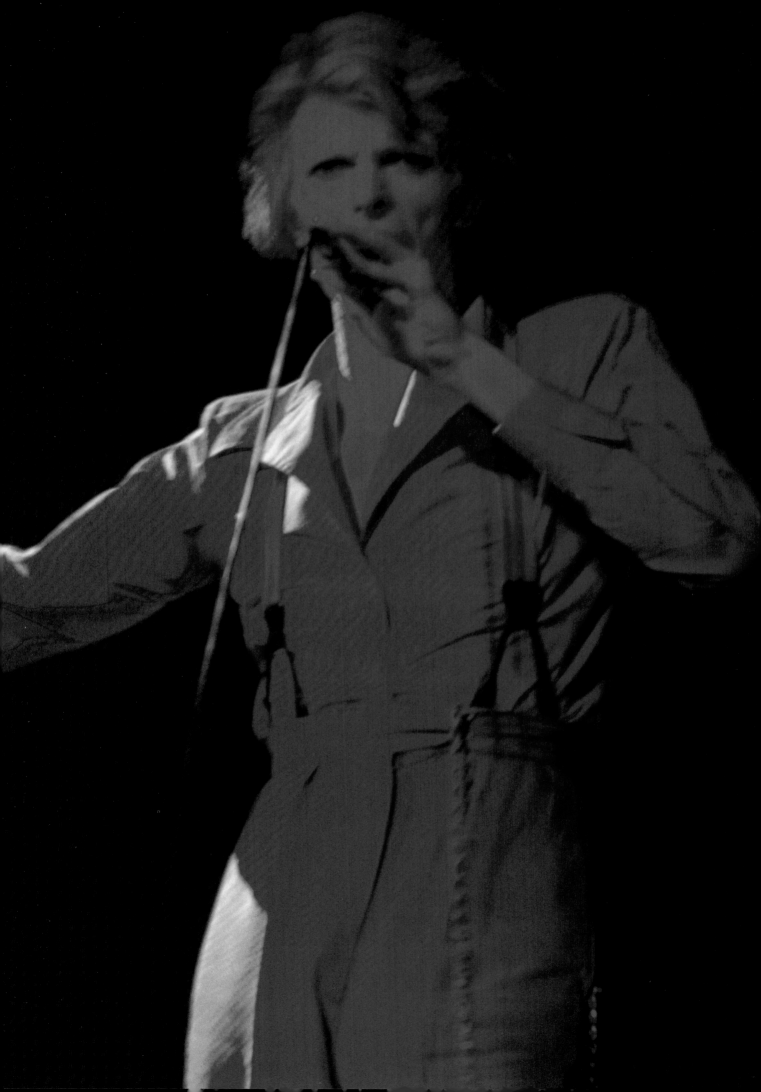

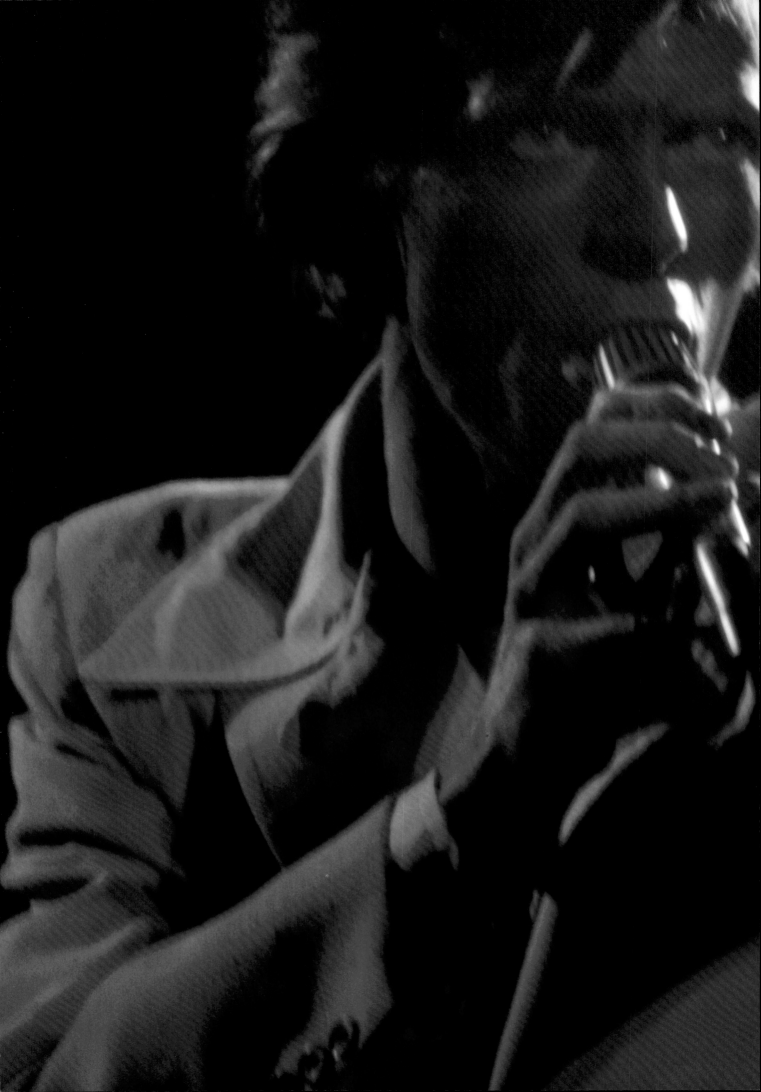

"I find only freedom
in the realms of
eccentricity." DB

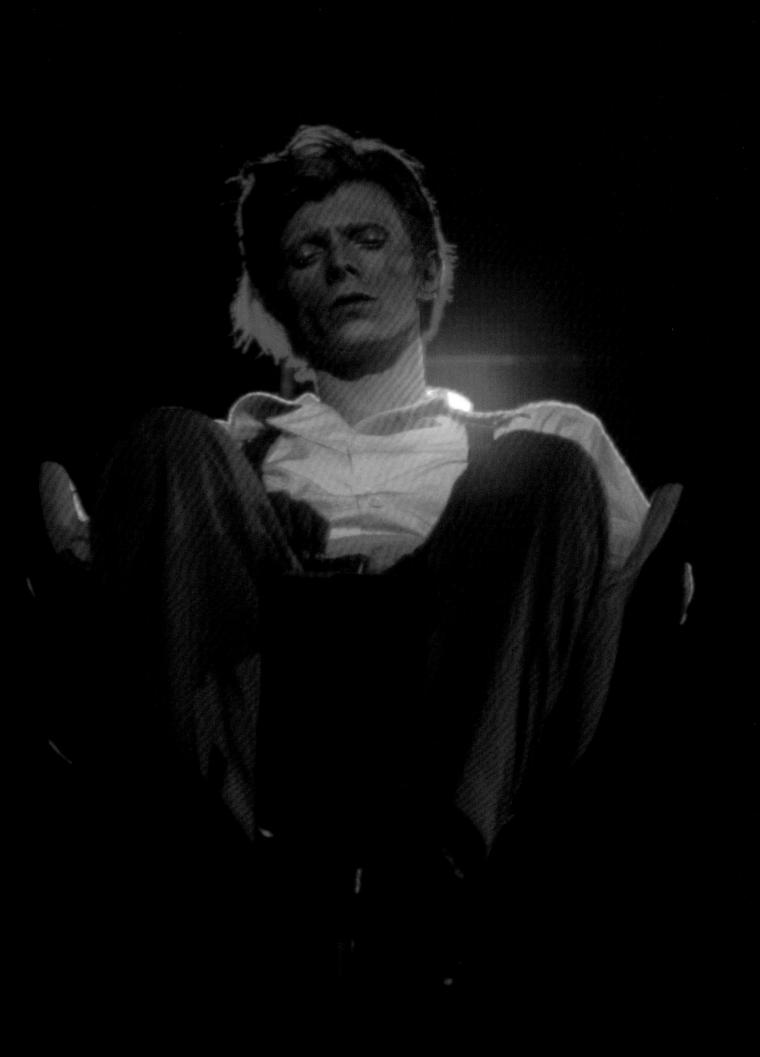

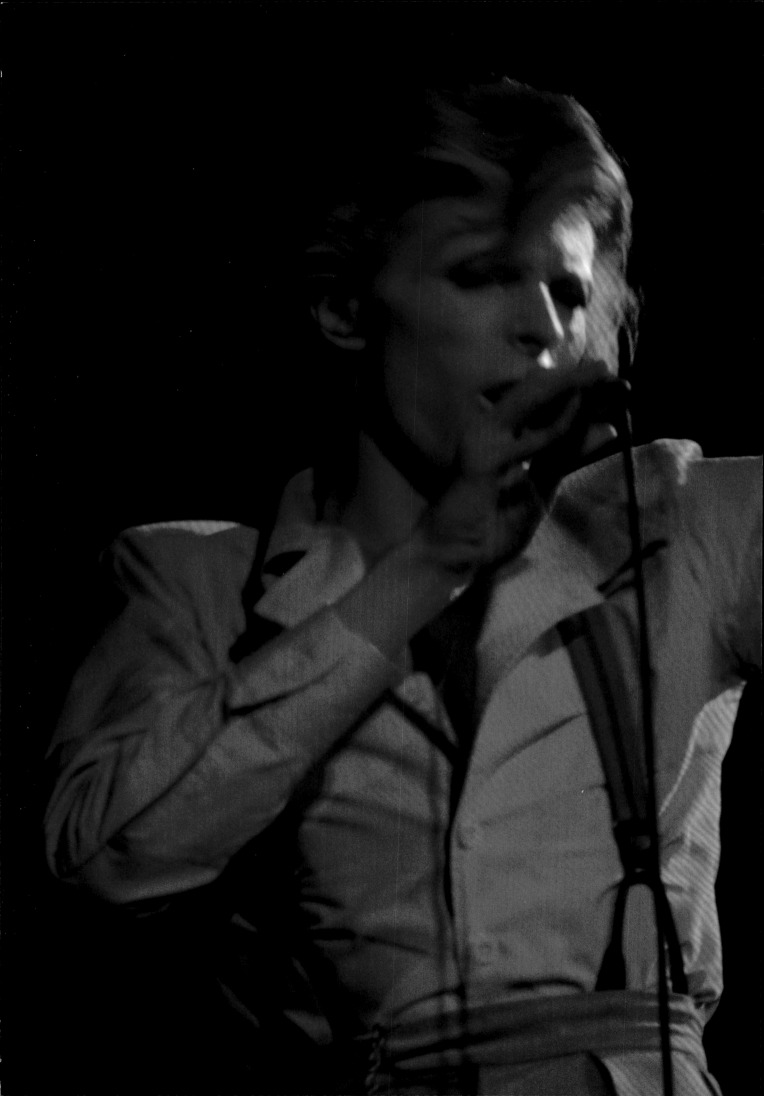

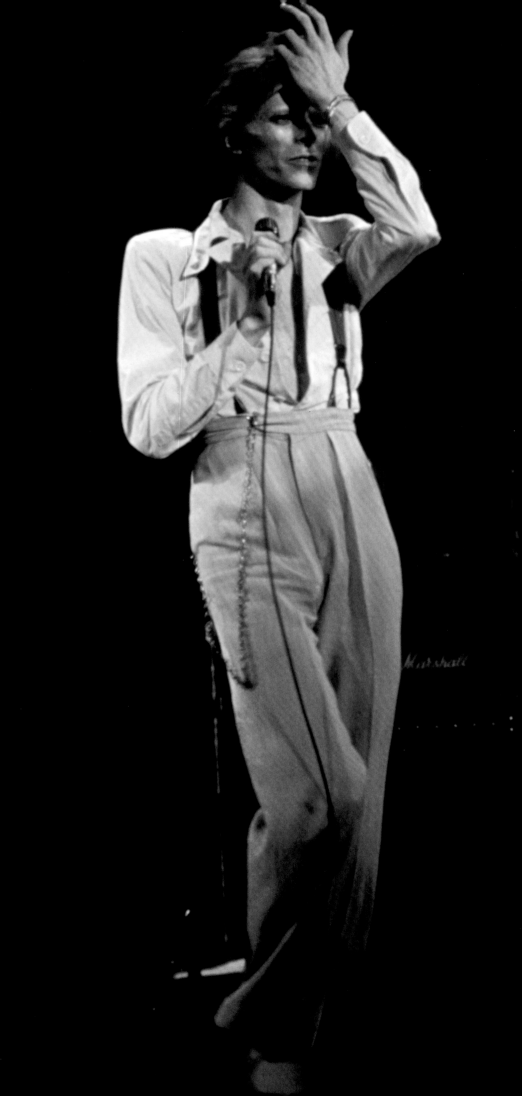

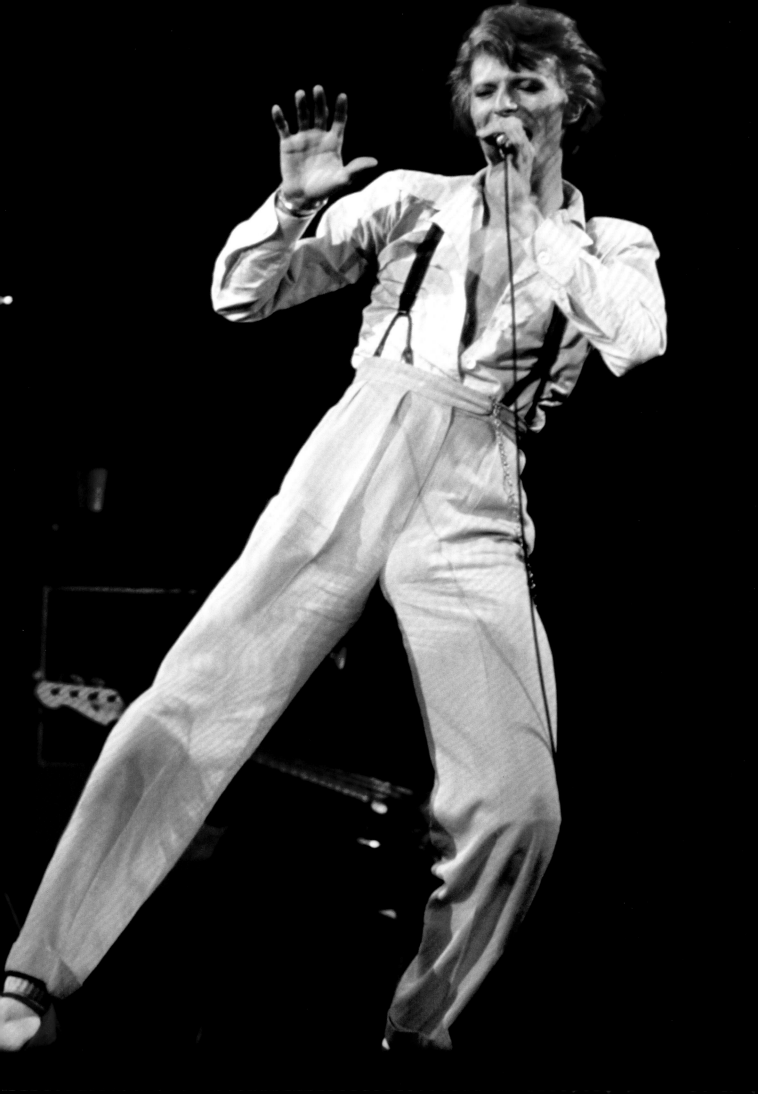

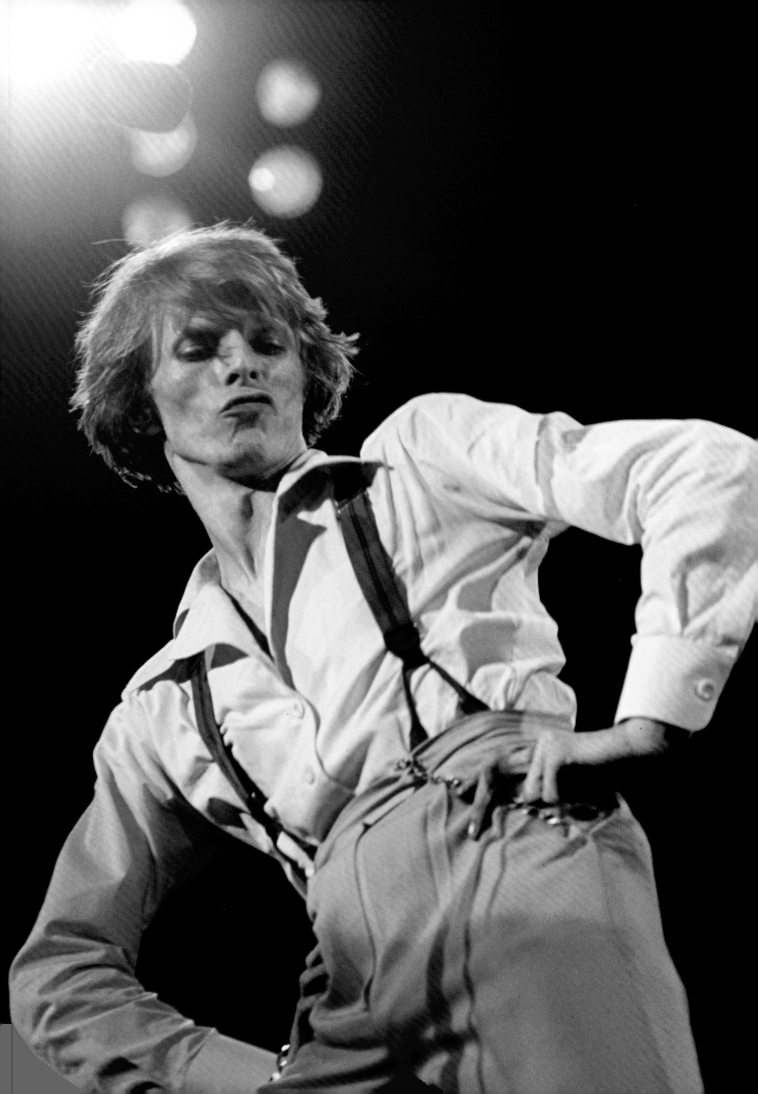

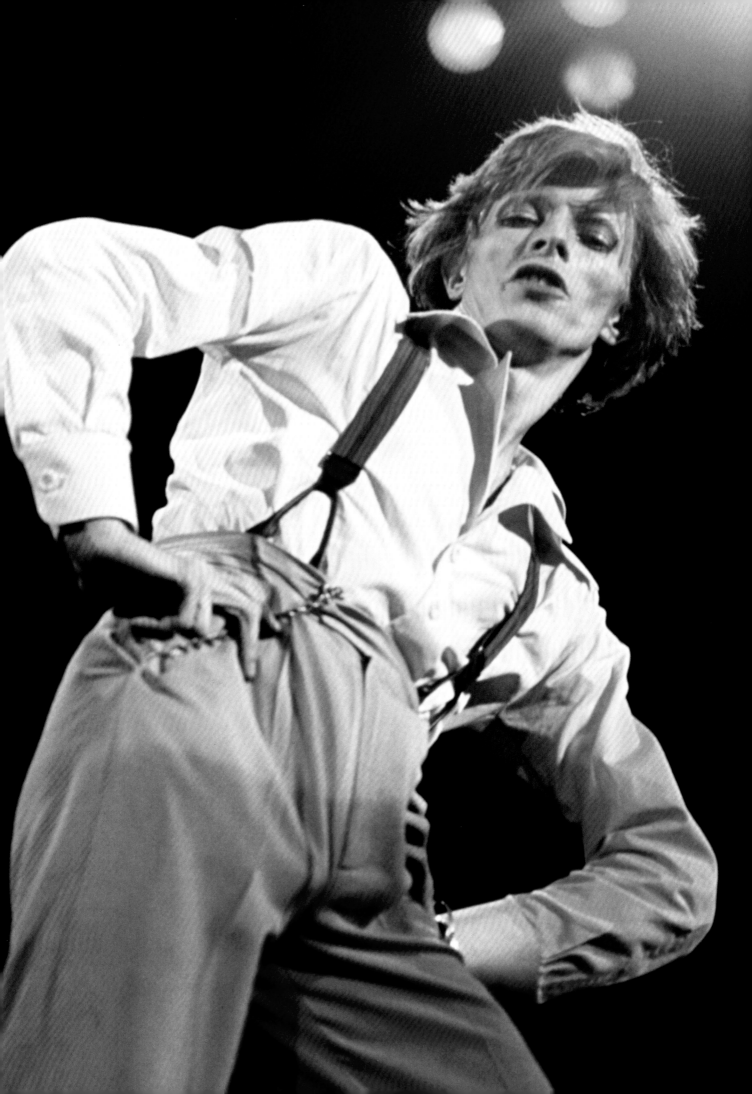

"Bowie was an actor.
Even as a singer, on stage,
it was all about the performance."

Terry O'Neill

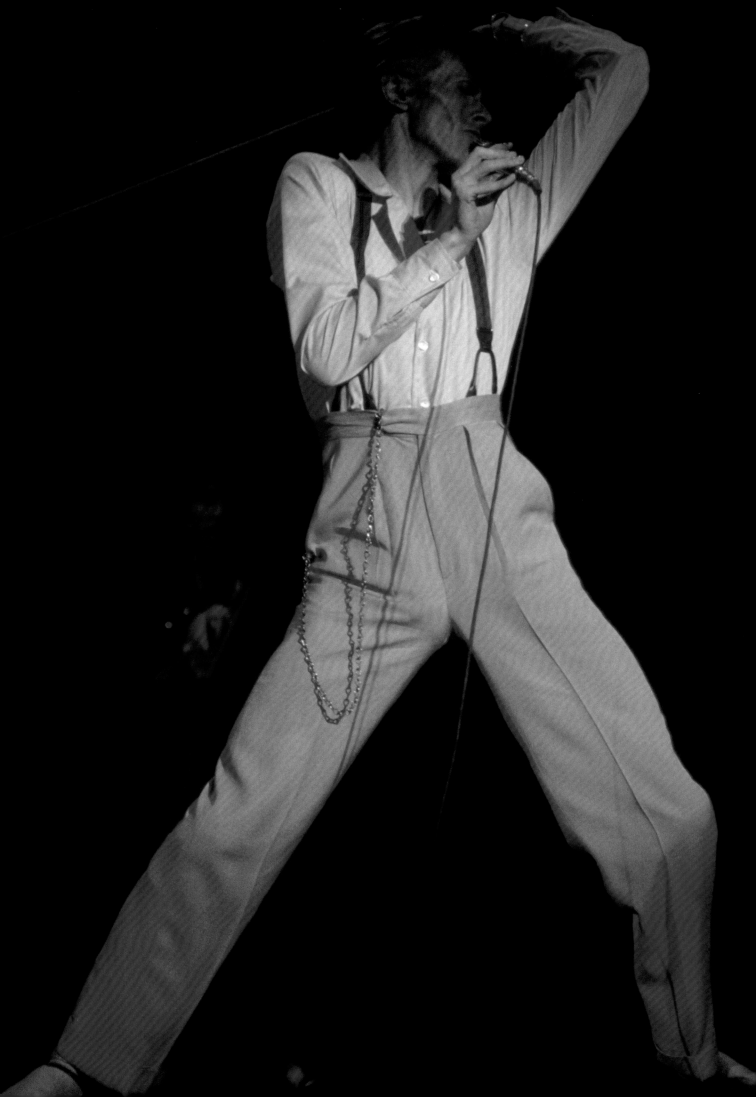

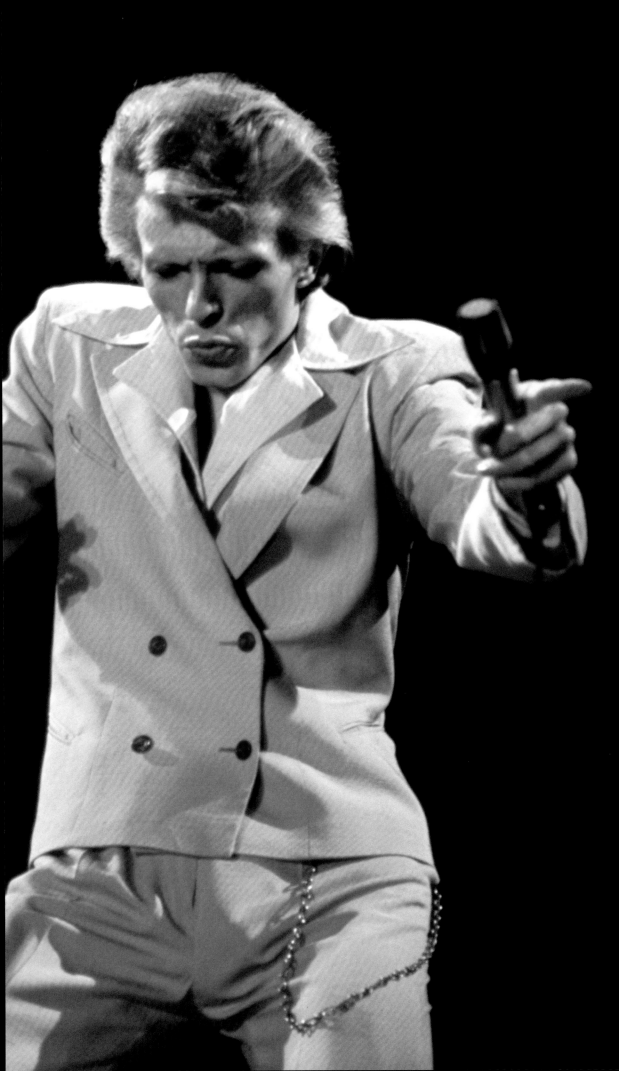

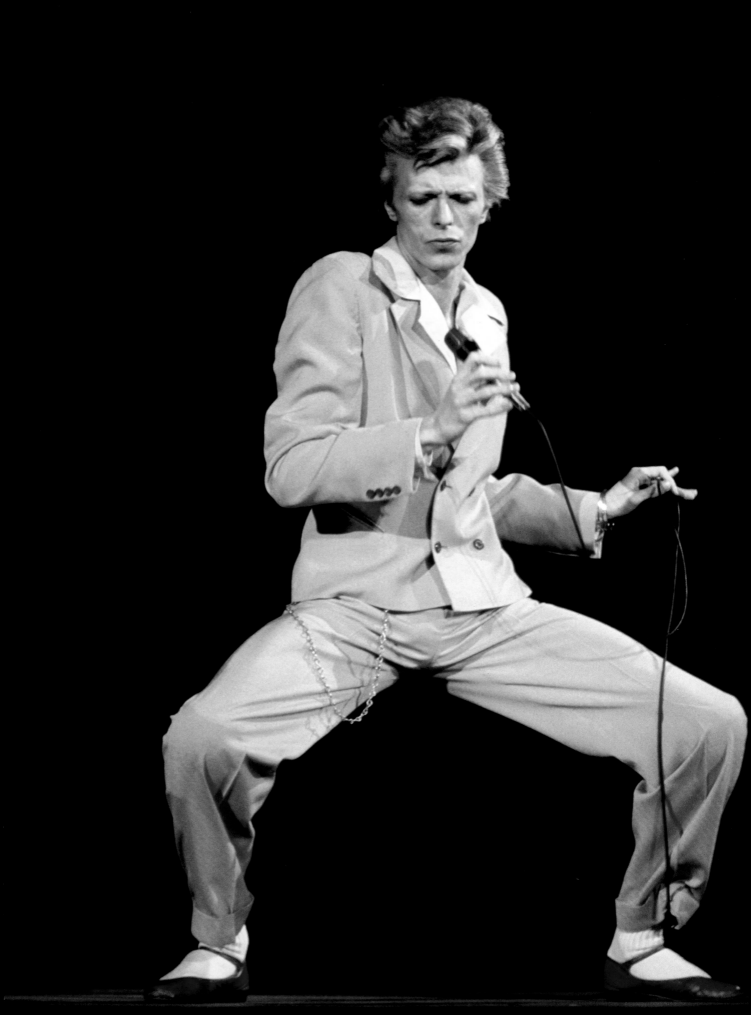

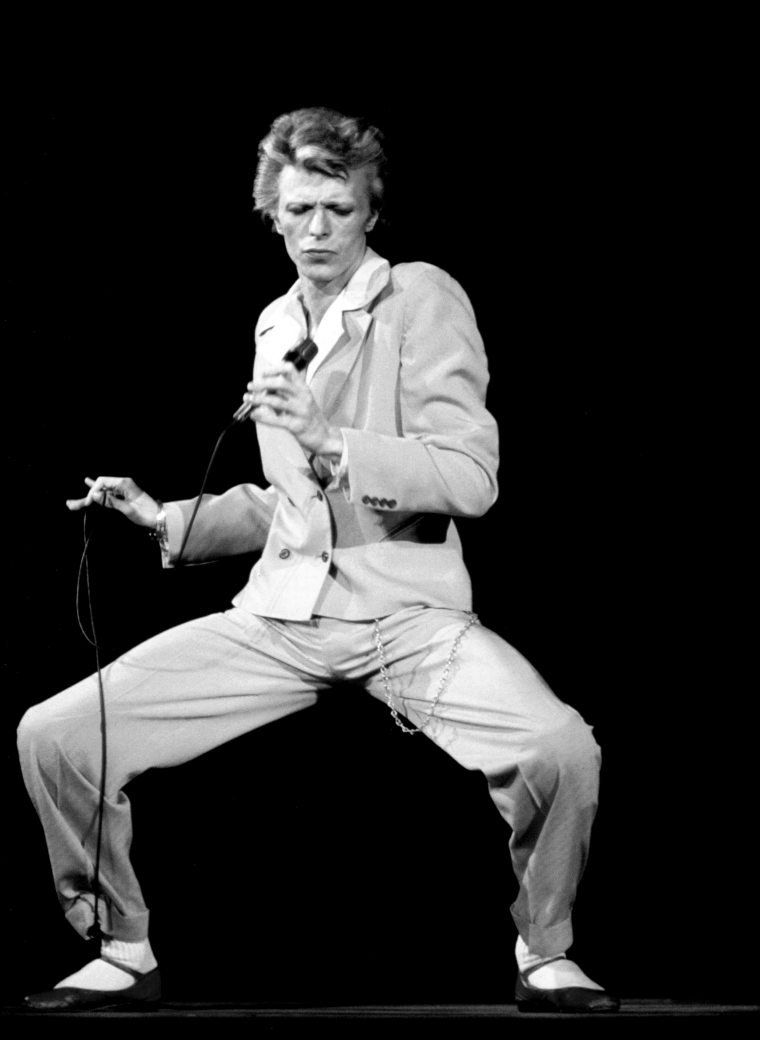

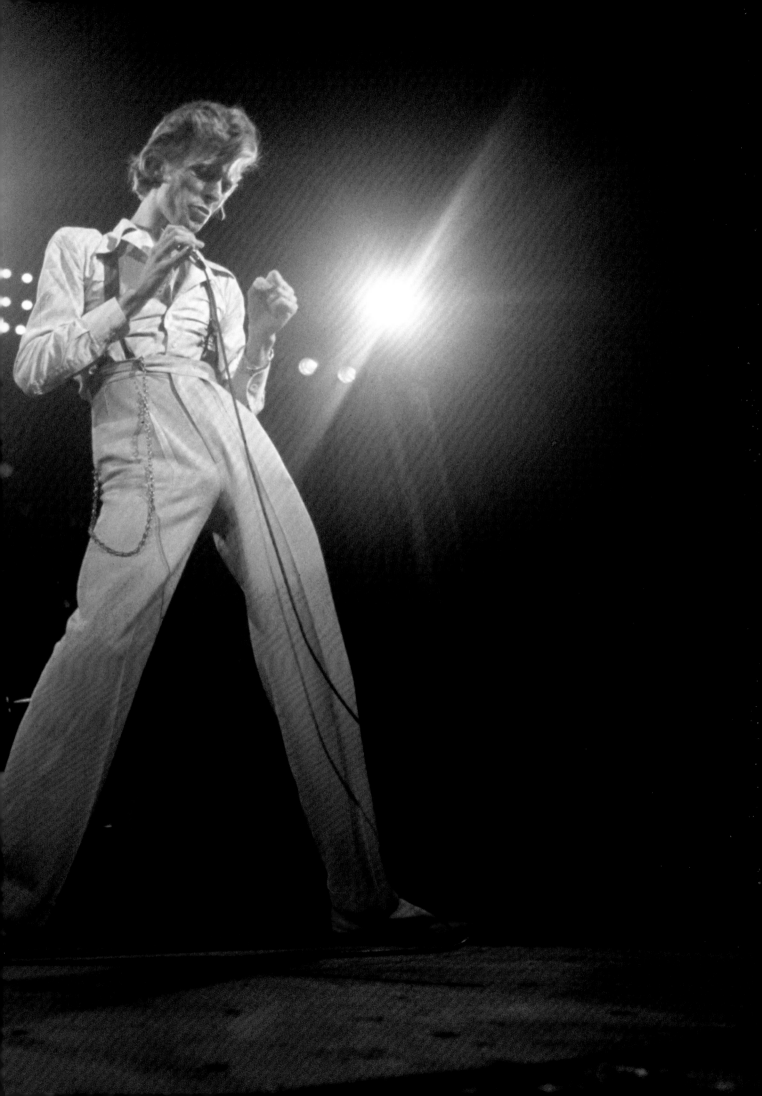

"I'm always amazed
that people take what
I say seriously.
I don't even take what
I am seriously." DB

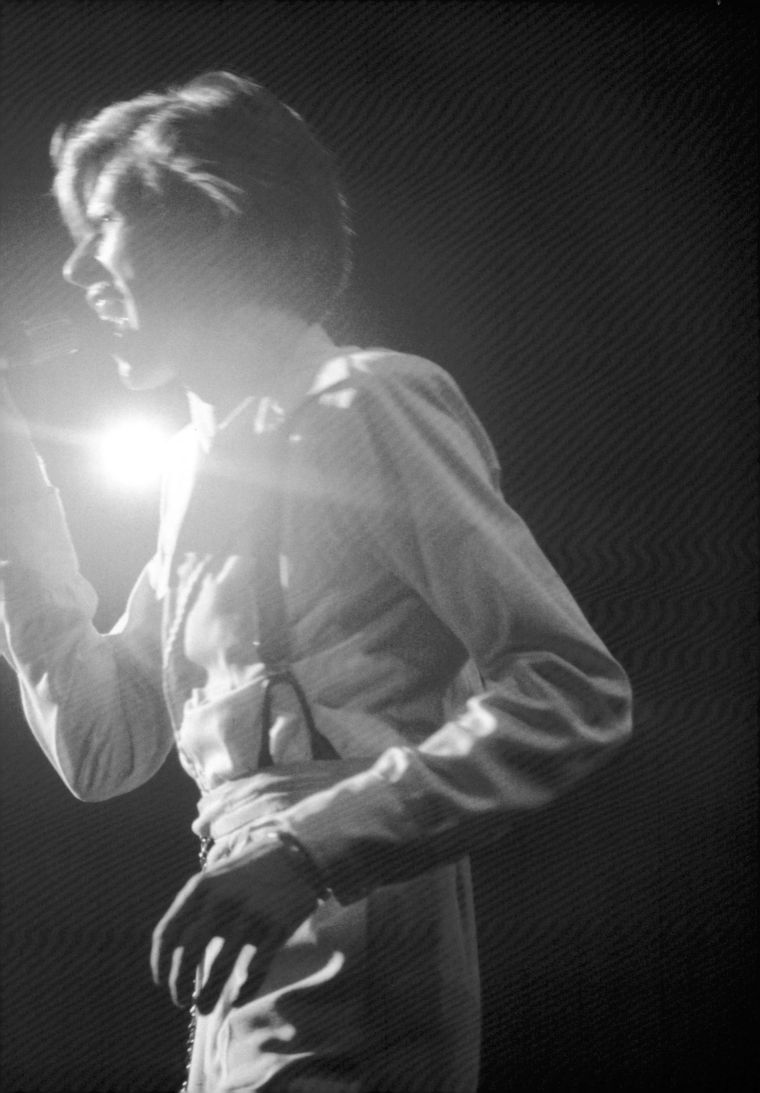

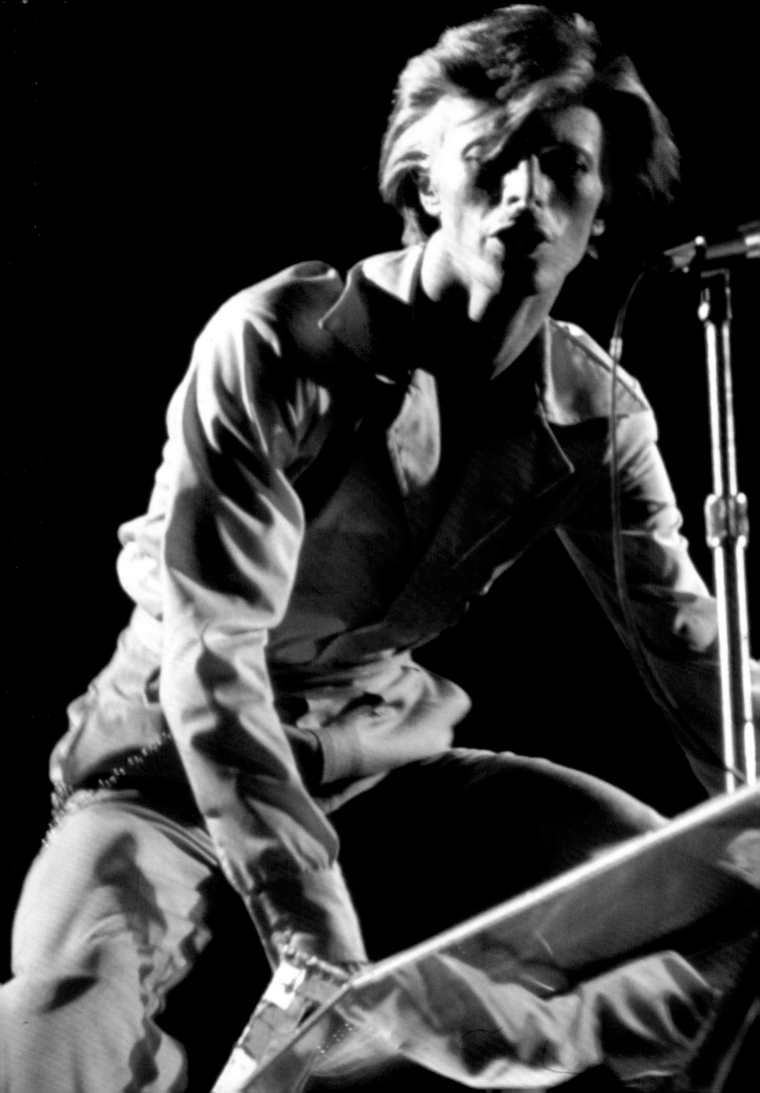

"I'm just an individual
who doesn't feel that
I need to have somebody
qualify my work in
any particular way.
I'm working for me." DB

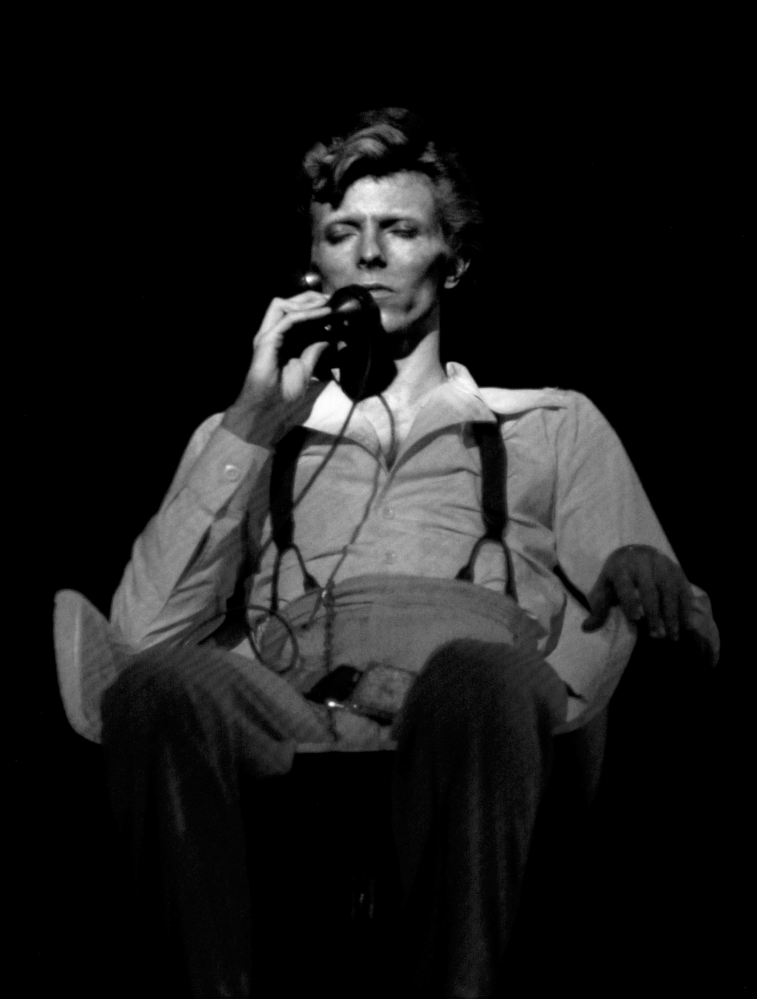

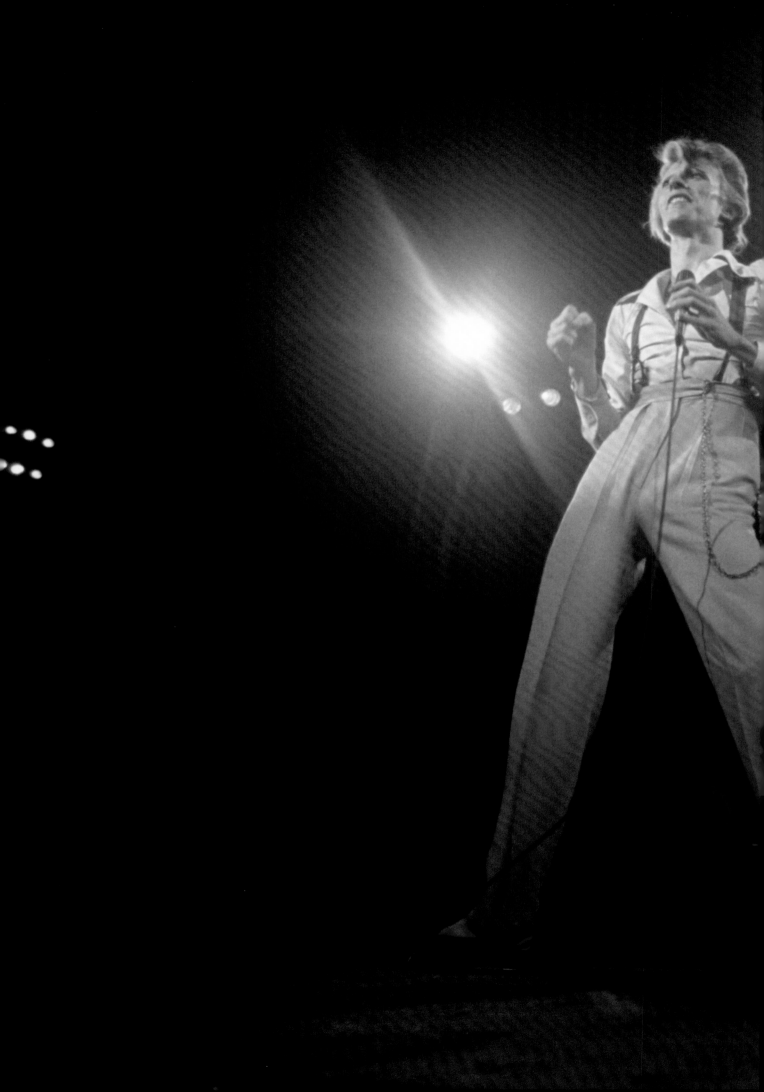

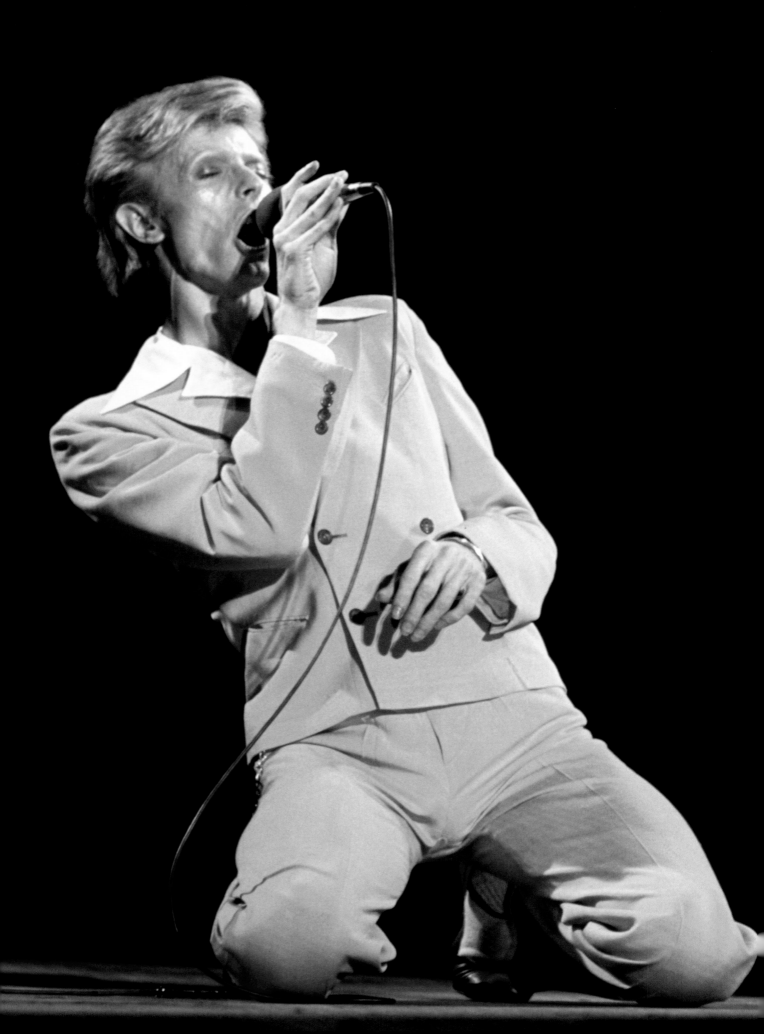

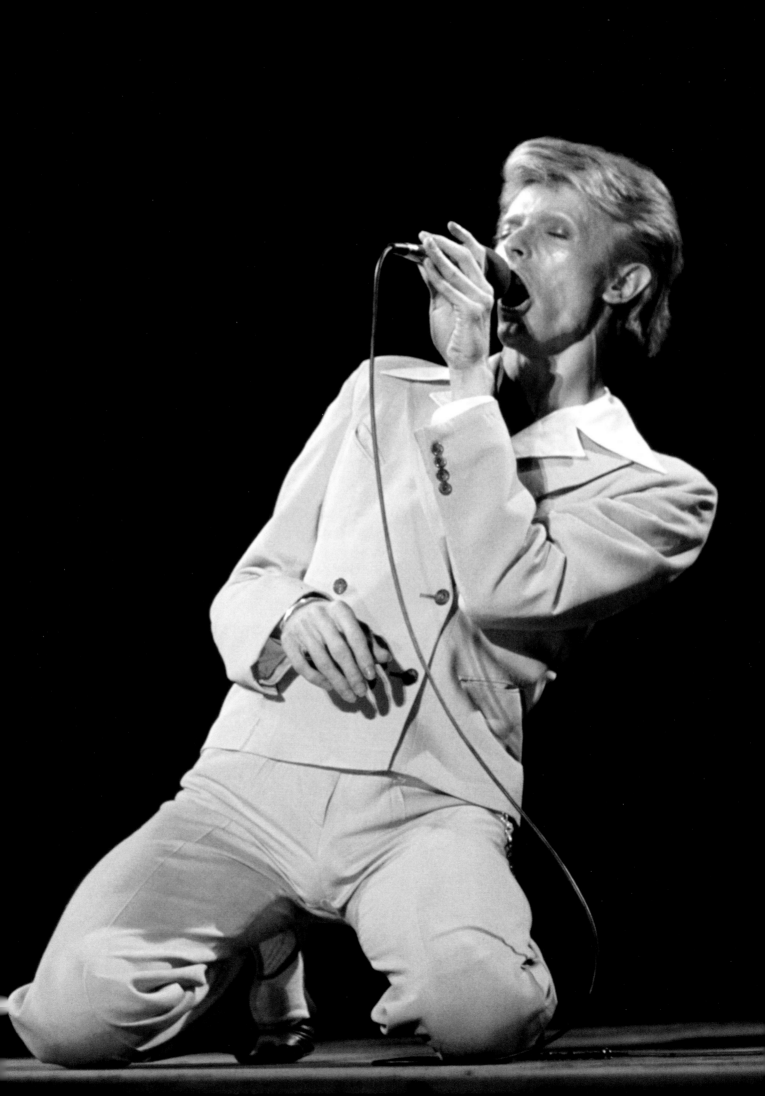

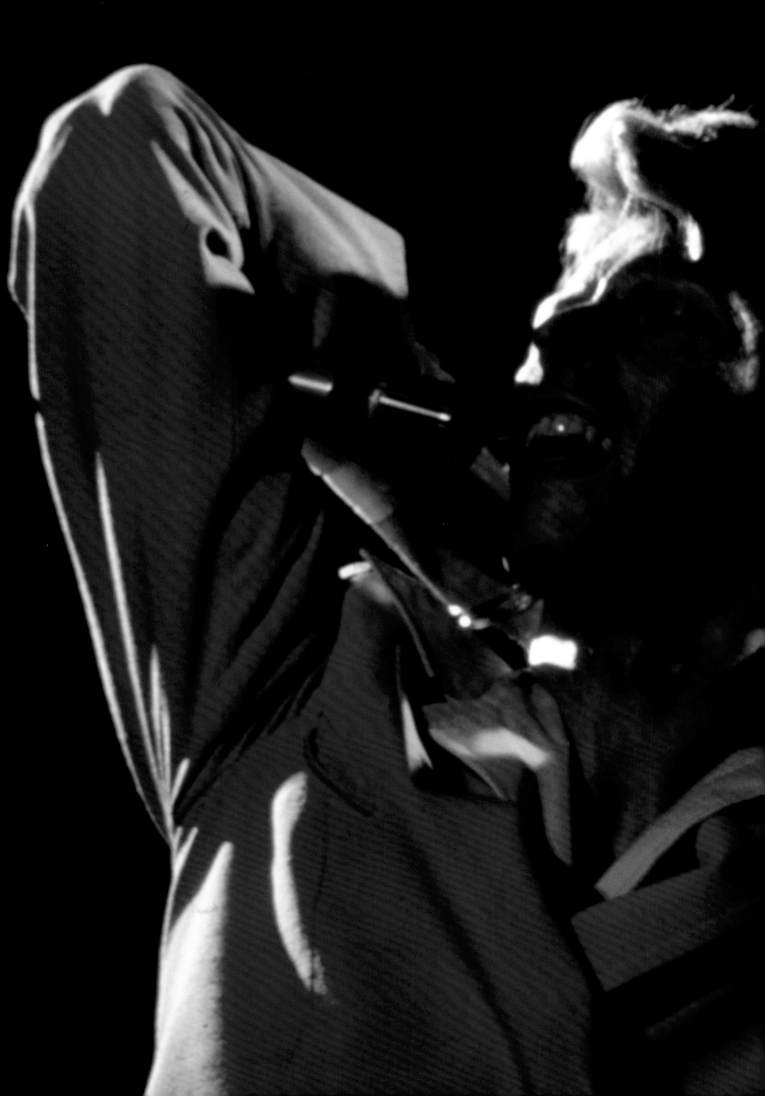

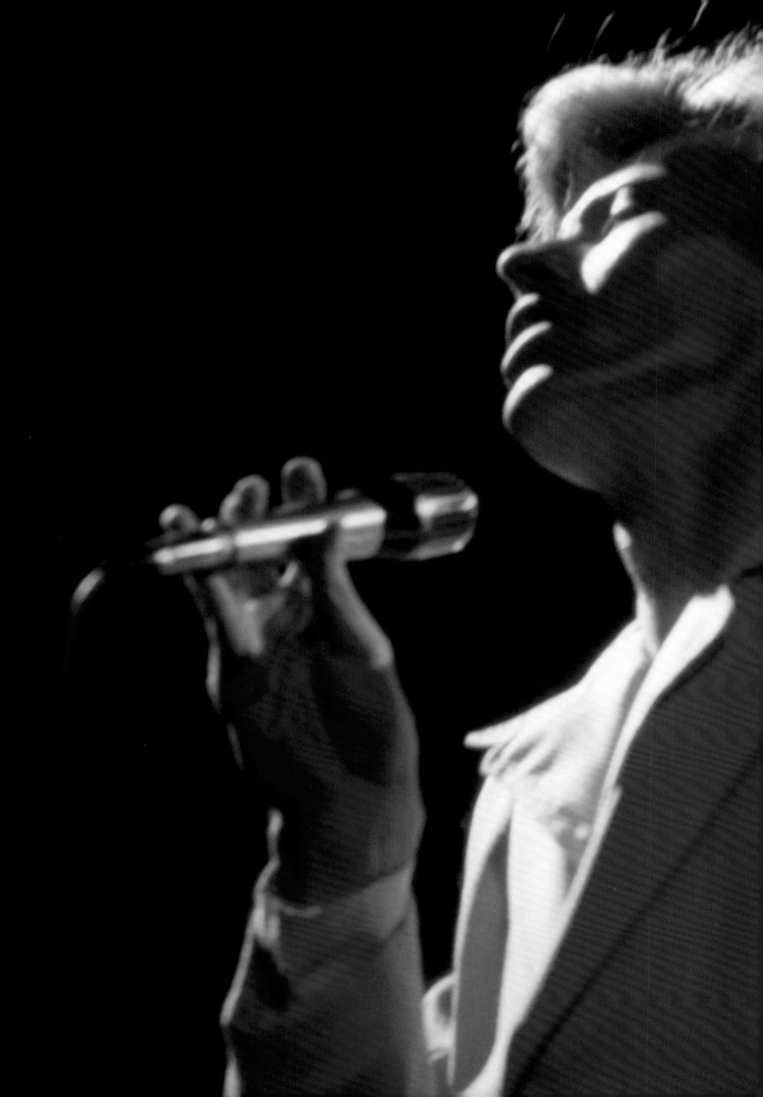

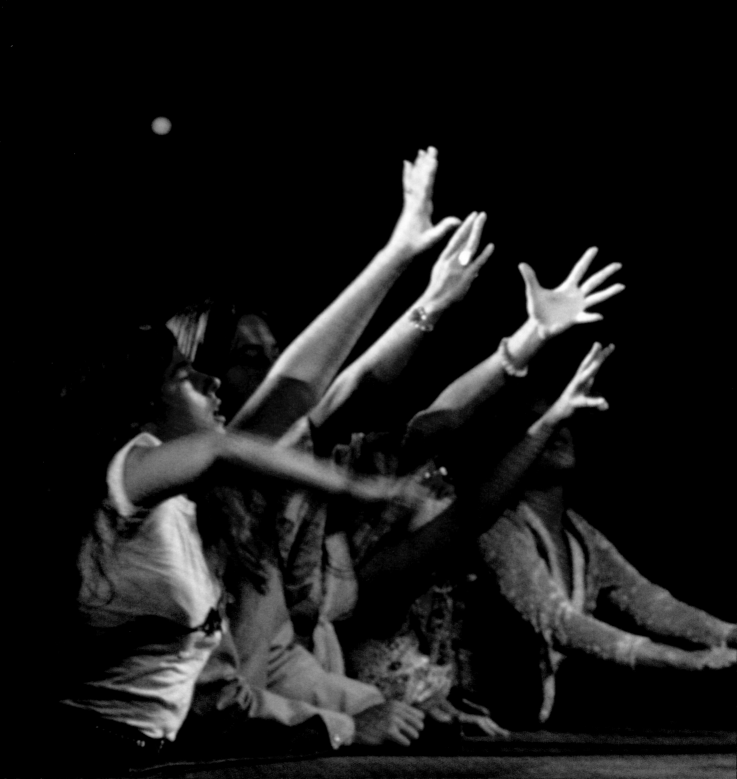

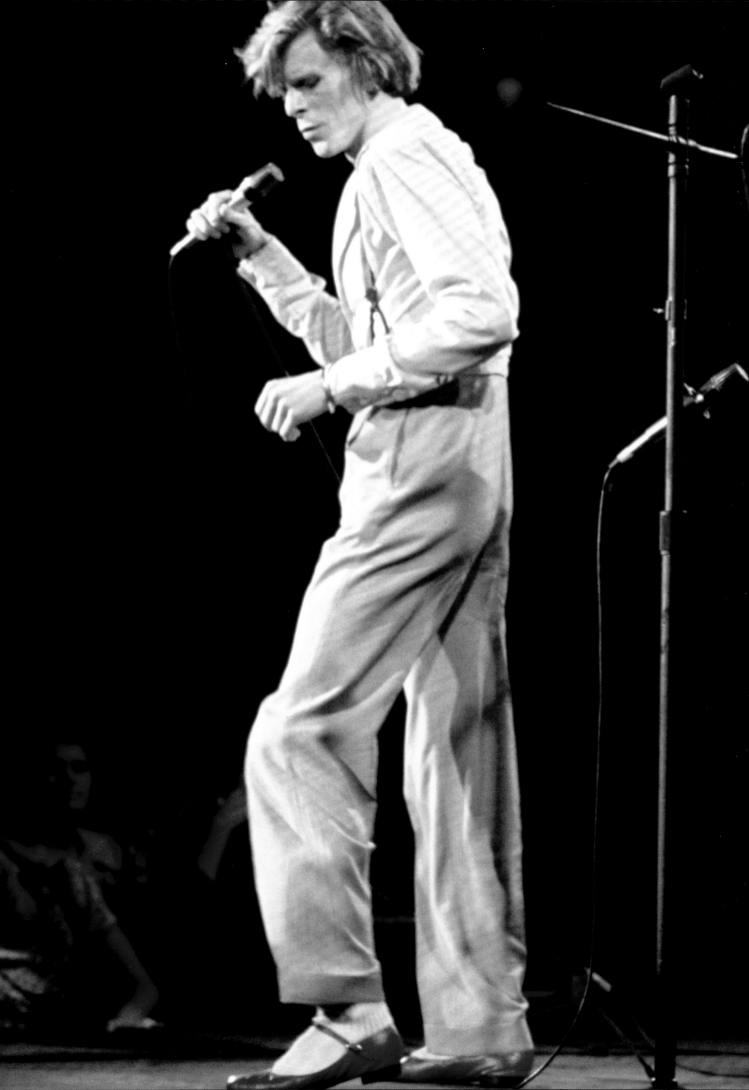

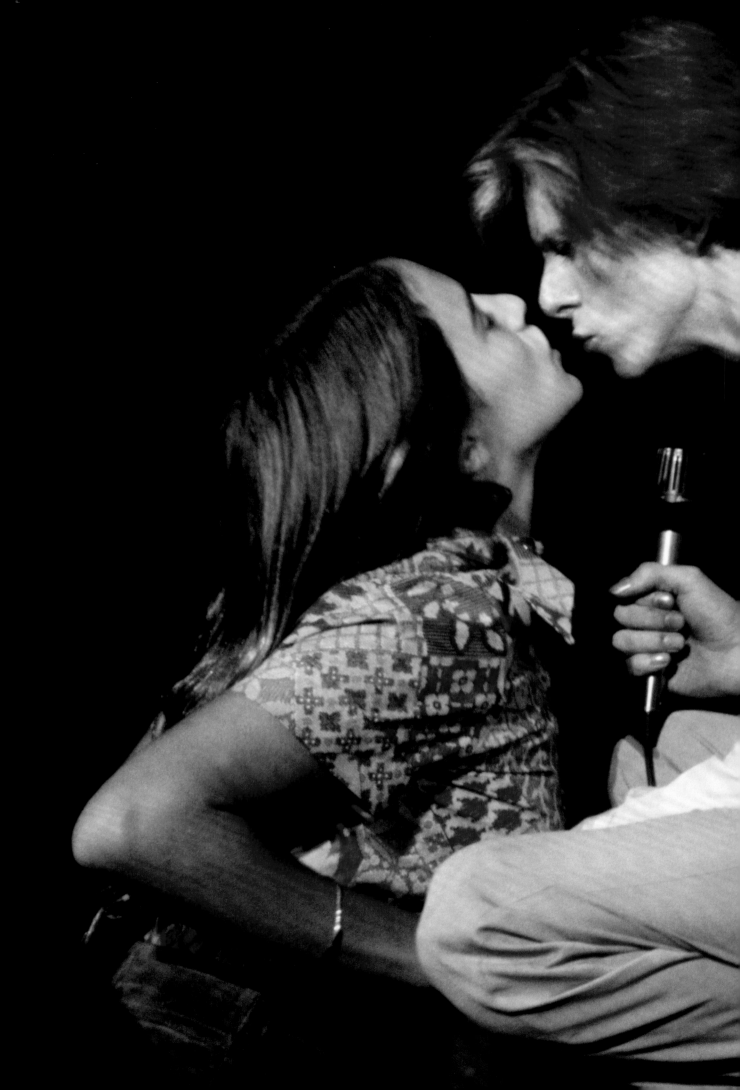

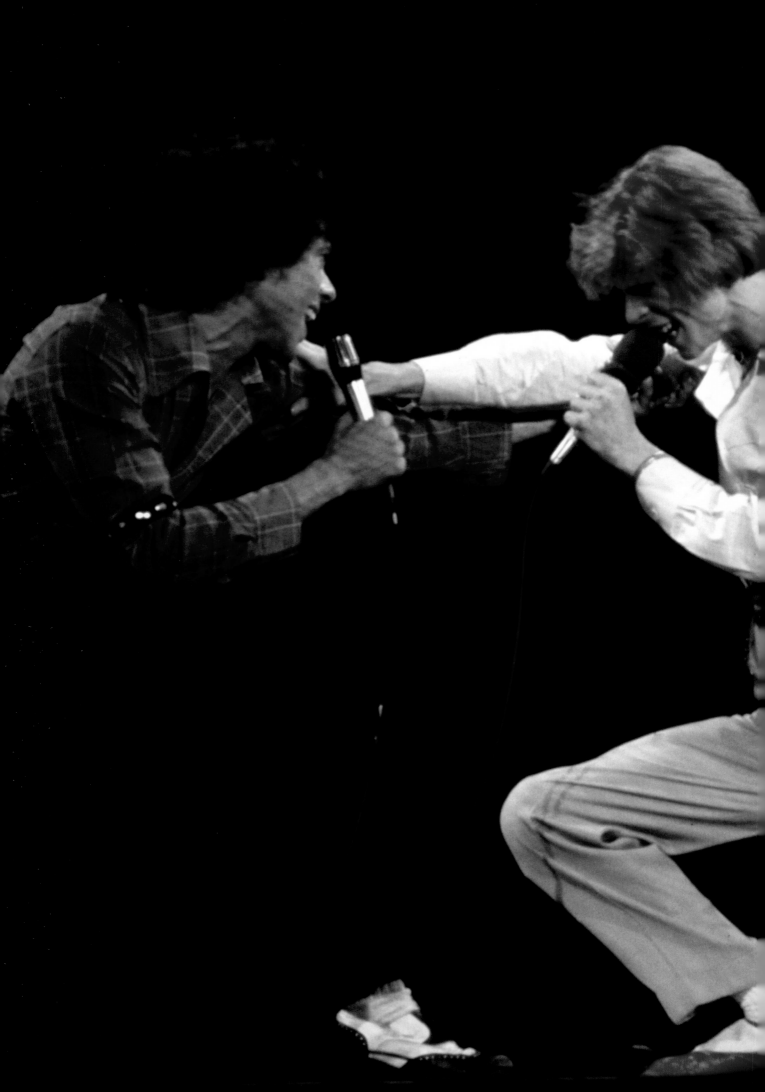

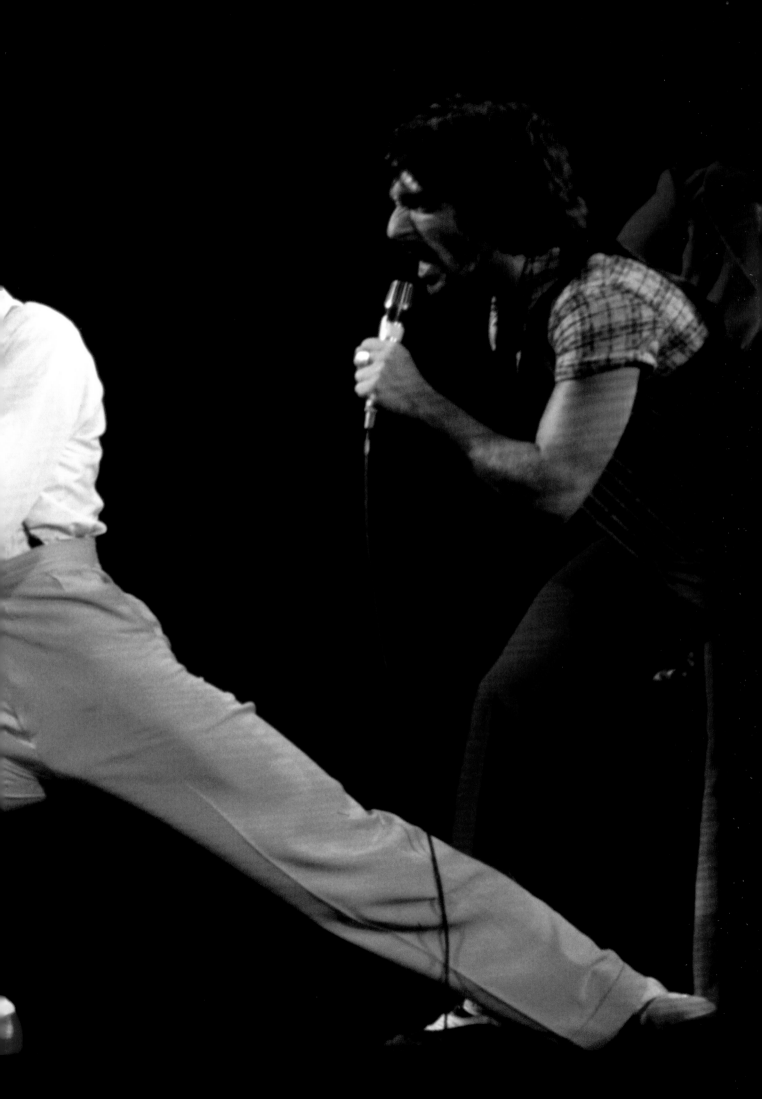

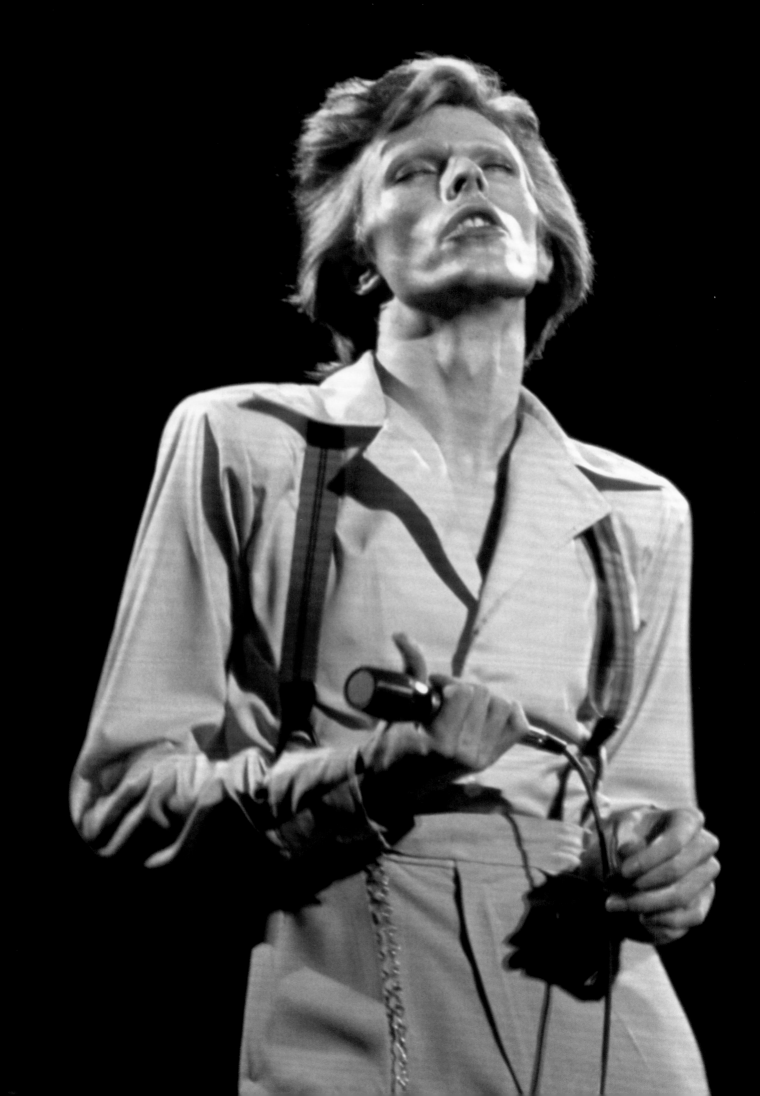

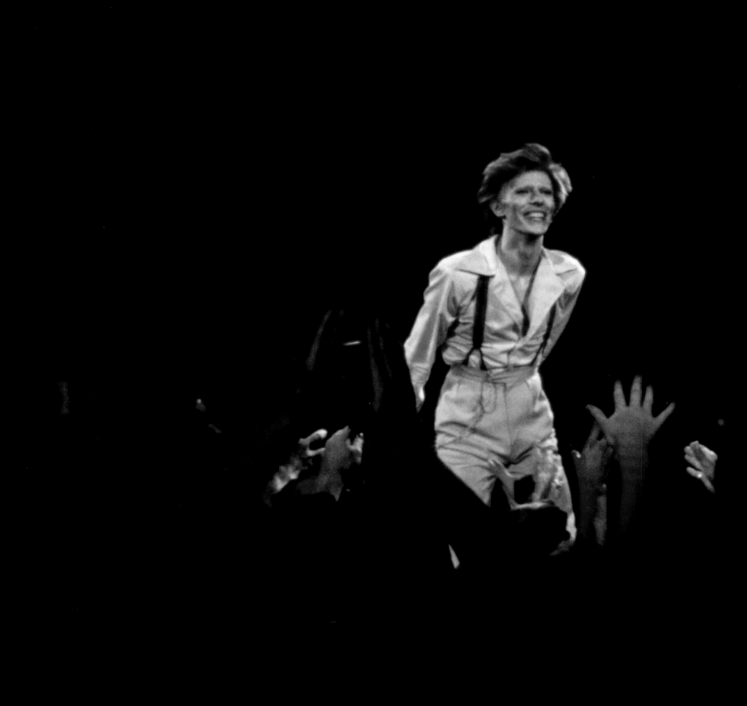

Average set list:

1984

Rebel Rebel

Sweet Thing

Changes

Moonage Daydream

Aladdin Sane (1913-1938-197?)

John, I'm Only Dancing

All the Young Dudes

Suffragette City

Cracked Actor

Rock 'n' Roll With Me

Space Oddity

Diamond Dogs

Panic in Detroit

The Jean Genie

Big Brother

Time

Rock 'n' Roll Suicide

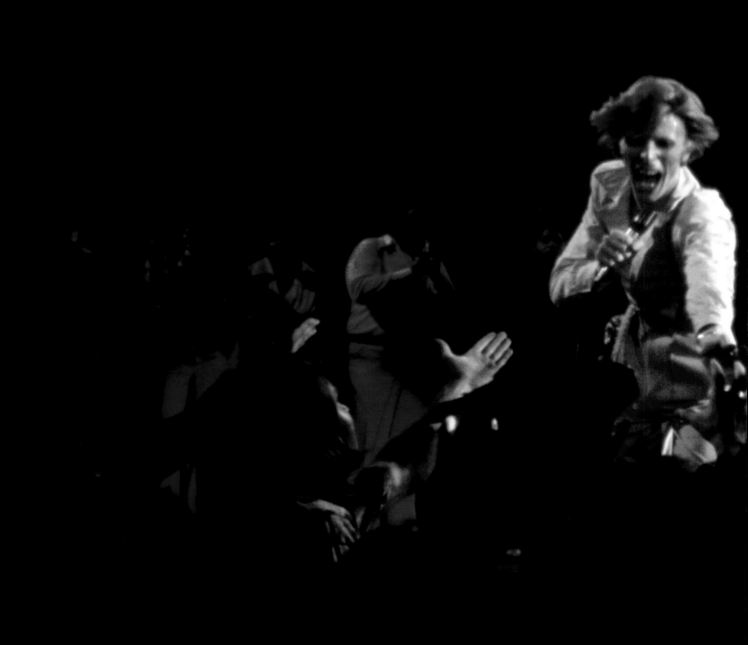

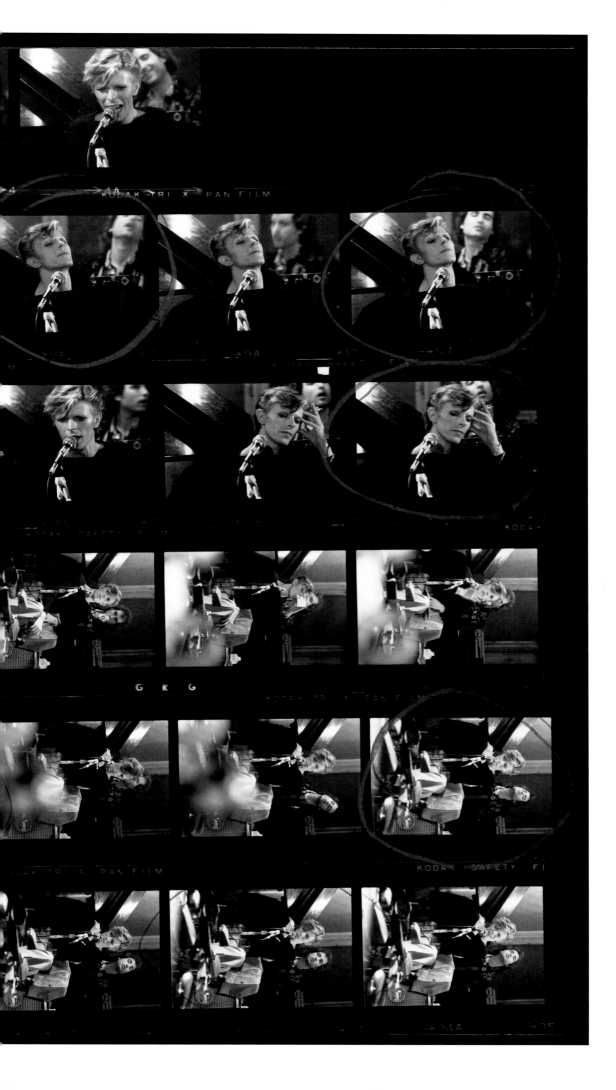

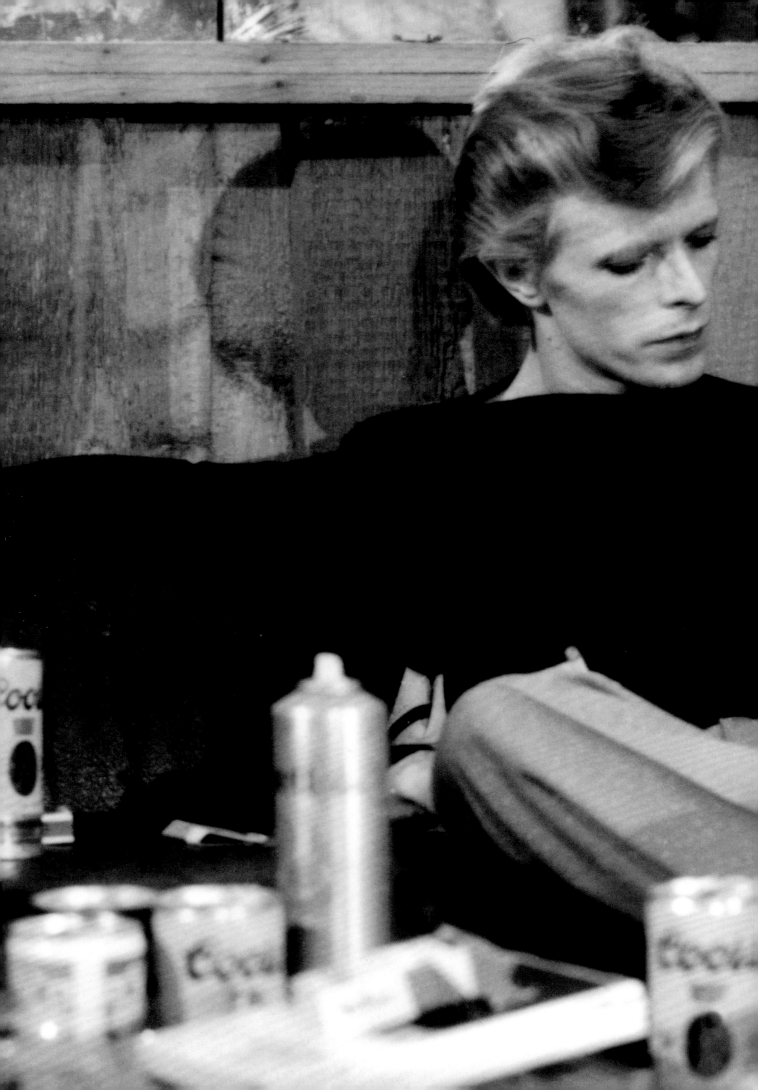

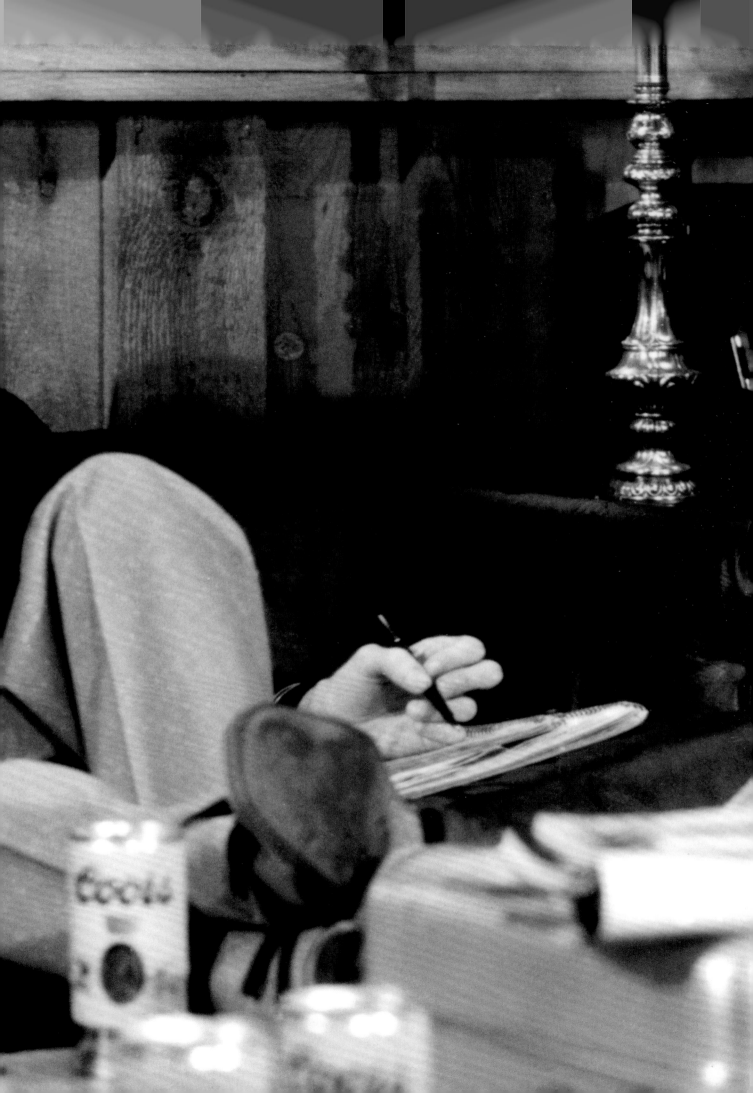

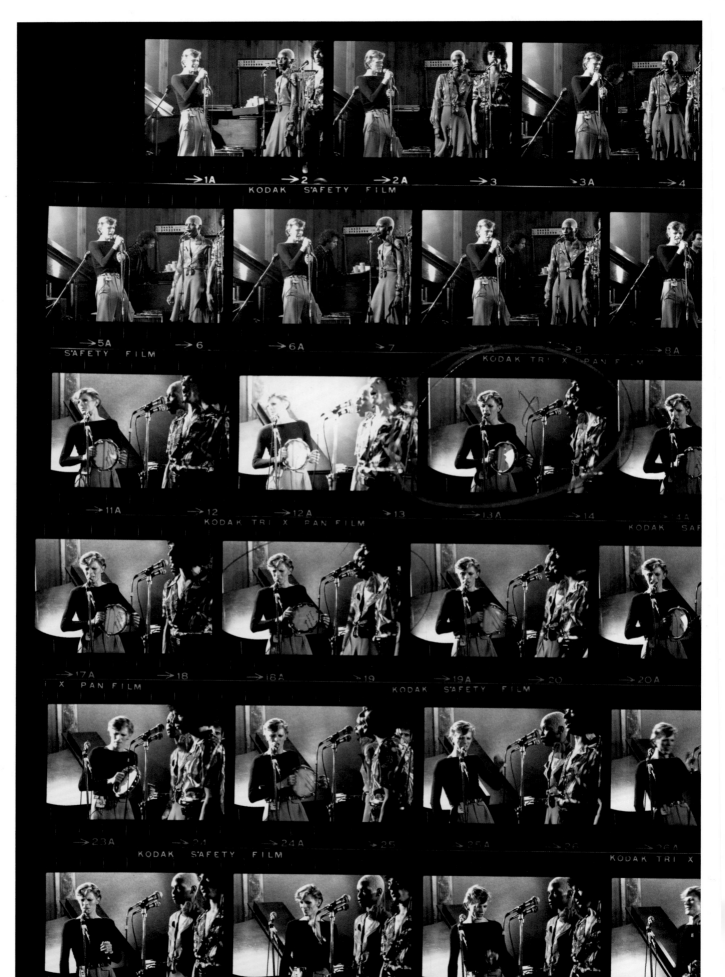

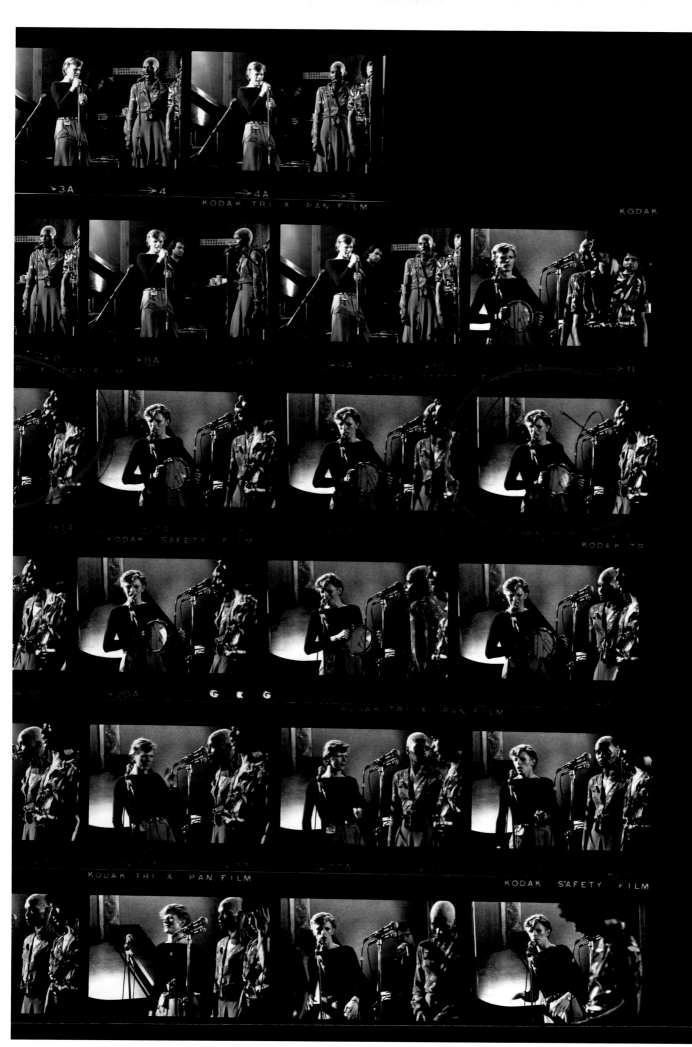

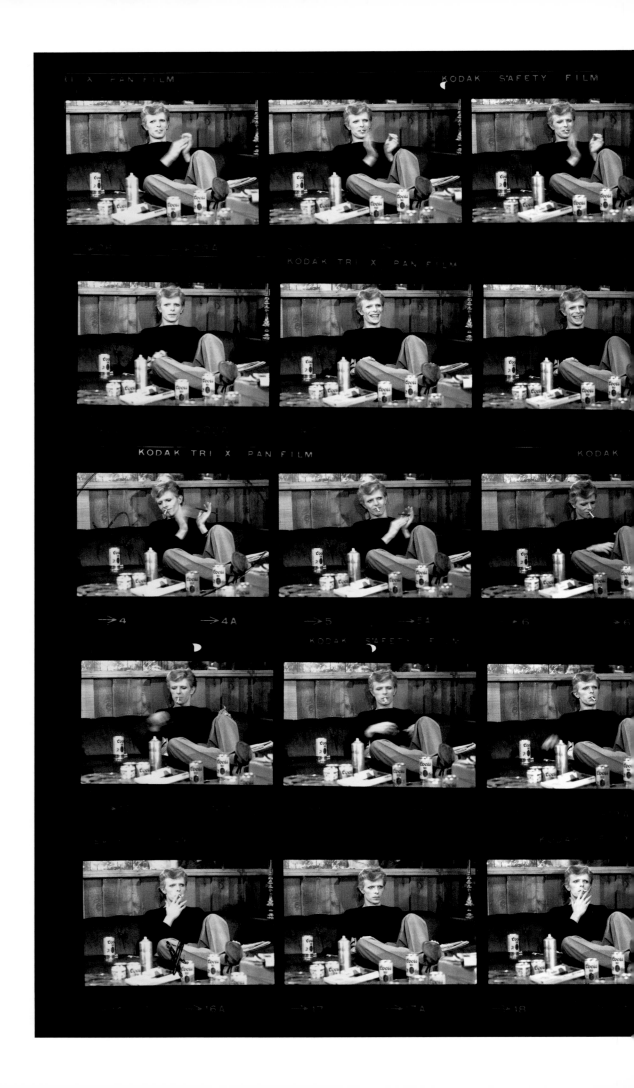

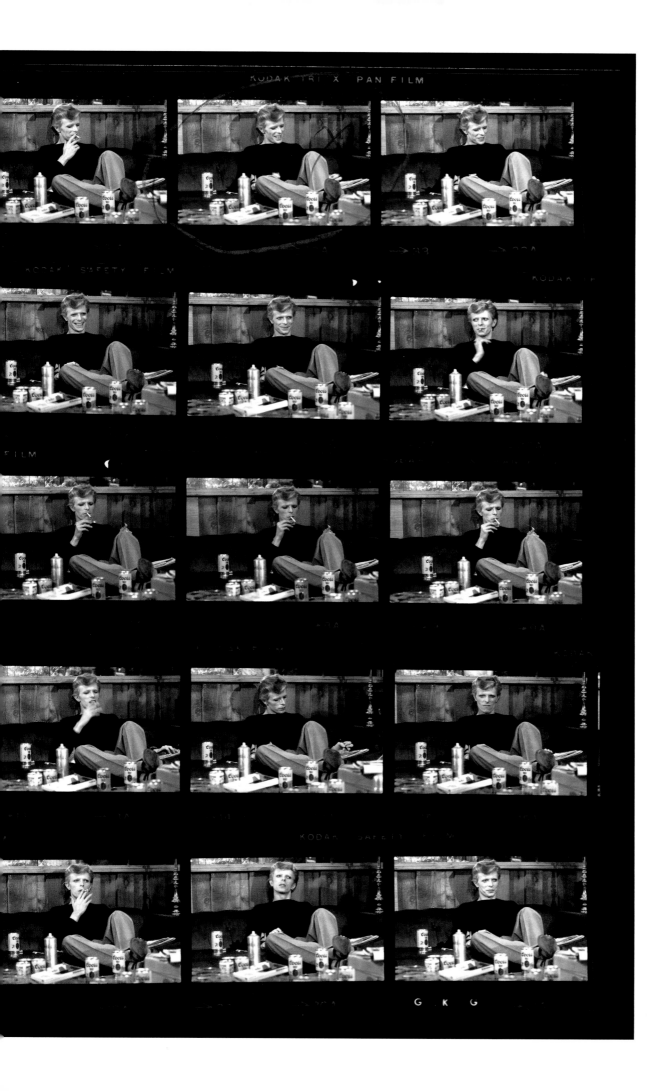

1974

WHEN BOWIE

MET BURROUGHS

THE WILD BOYS

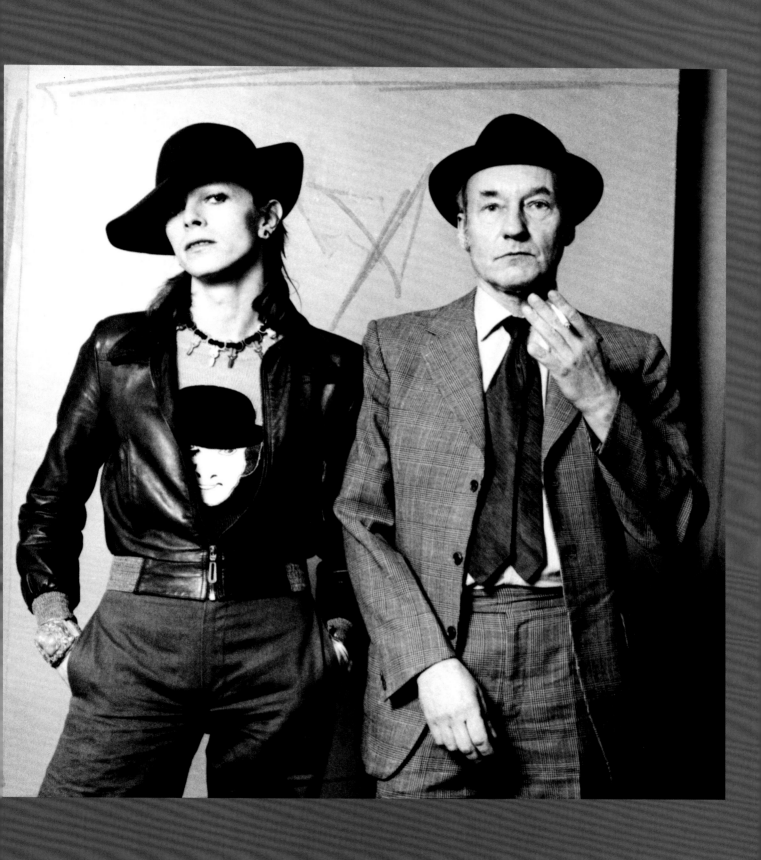

Beat
Godfather
Meets
Glitter
Mainman

William Burroughs, say hello to David Bowie

William Seward Burroughs is not a talkative man. Once at a dinner he gazed down into a pair of stereo microphones trained to pick up his every munch and said, "I don't like talk and I don't like talkers. Like Ma Barker. You remember Ma Barker? Well, that's what she always said, 'Ma Barker doesn't like talk and she doesn't like talkers.' She just sat there with her gun."

This was on my mind as much as the mysterious personality of David Bowie when an Irish cabbie drove Burroughs and me to Bowie's London home on November 17th ("Strange blokes down this part o' London, mate"). I had spent the last several weeks arranging this two-way interview. I had brought Bowie all of Burroughs' novels: *Naked Lunch, Nova Express, The Ticket That Exploded* and the rest. He'd only had time to read *Nova Express*. Burroughs for his part had only heard two Bowie songs, "Five Years" and "Star Man," though he had read all of Bowie's lyrics. Still they had expressed interest in meeting each other.

Bowie's house is decorated in a science-fiction mode: A gigantic painting, by an artist whose style fell midway between Salvador Dali and Norman Rockwell, hung over a plastic sofa. Quite a contrast to Burroughs' humble two-room Piccadilly flat, decorated with photos of Brion Gysin – modest quarters for such a successful writer, more like the Beat Hotel in Paris than anything else.

Soon Bowie entered, wearing three-tone NASA jodhpurs. He jumped right into a detailed description of the painting and its surrealistic qualities. Burroughs nodded, and the interview conversation began. The three of us sat in the room for two hours, talking and taking lunch: a Jamaican fish dish, prepared by a Jamaican in the Bowie entourage, with avocados stuffed with shrimp and a beaujolais nouveau, served by two interstellar Bowieites.

There was immediate liking and respect between the two. In fact, a few days after the conversation Bowie asked Burroughs for a favour: A production of *The Maids* staged by Lindsay Kemp, Bowie's old mime teacher, had been closed down in London by playwright Jean Genet's London publisher. Bowie wanted to bring the matter to Genet's attention personally. Burroughs was impressed by Bowie's description of the production and promised to help. A few weeks later, Bowie went to Paris in search of Genet, following leads from Burroughs.

Who knows? Perhaps a collaboration has begun; perhaps, as Bowie says, they may be the Rogers and Hammerstein of the Seventies.

Burroughs: Do you do all your designs yourself?

Bowie: Yes, I have to take total control myself. I can't let anybody else do anything, for I find that I can do things better for me. I don't want to get other people playing with what they think that I'm trying to do. I don't like to read things that people write about me. I'd rather read what kids have to say about me, because it's not their profession to do that.

People look to me to see what the spirit of the Seventies is, at least 50% of them do. Critics I don't understand. They get too intellectual. They're not very well-versed in street talk; it takes them longer to say it. So they have to do it in dictionaries and they take longer to say it.

I went to a middle-class school, but my background is working class. I got the best of both worlds, I saw both classes, so I have a pretty fair idea of how people live and why they do it. I can't articulate it too well, but I have a feeling about it. But not the upper class. I want to meet the Queen and then I'll know. How do you take the picture that people paint of you?

Burroughs: They try to categorize you. They want to see their picture of you and if they don't see their picture of you they're very upset. Writing is seeing how close you can come to make it happen, that's the object of all art. What else do they think man really wants, a whiskey priest on a mission he doesn't believe in? I think the most important thing in the world is that the artists should take over this planet because they're the only ones who can make anything happen. Why should we let these fucking newspaper politicians take over from us?

Bowie: I change my mind a lot. I usually don't agree with what I say very much. I'm an awful liar.

Burroughs: I am too.

Bowie: I'm not sure whether it is me changing my mind, or whether I lie a lot. It's somewhere between the two. I don't exactly lie, I change my mind all the time. People are always

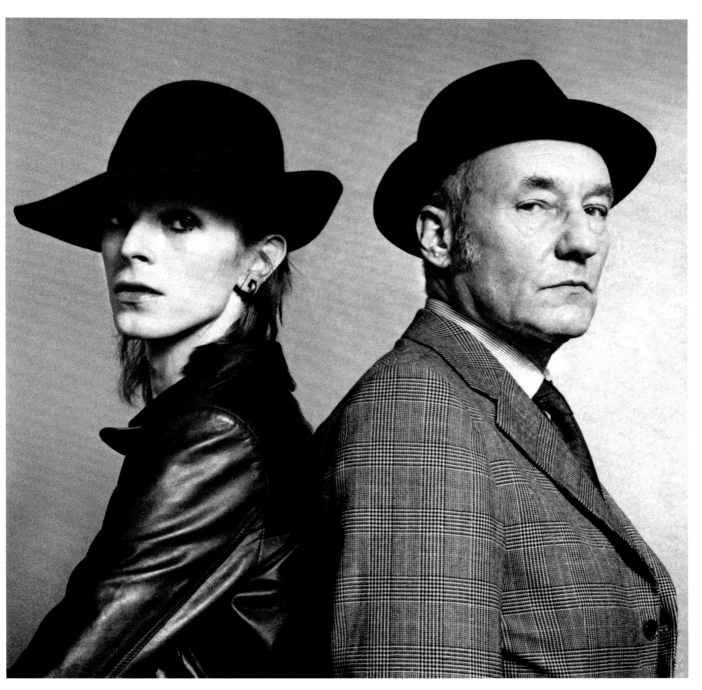

throwing things at me that I've said and I say that I didn't mean anything. You can't stand still on one point for your entire life.

Burroughs: Only politicians lay down what they think and that is it. Take a man like Hitler, he never changed his mind.

Bowie: *Nova Express* really reminded me of *Ziggy Stardust*, which I am going to be putting into a theatrical performance. Forty scenes are in it and it would be nice if the characters and actors learned the scenes and we all shuffled them around in a hat the afternoon of the performance and just performed it as the scenes come out. I got this all from you, Bill...so it would change every night.

Burroughs: That's a very good idea, visual cut-up in a different sequence.

Bowie: I get bored very quickly and that would give it some new energy. I'm rather kind of old school, thinking that when an artist does his work it's no longer his...I just see what people make of it. That is why the TV production of *Ziggy* will have

to exceed people's expectations of what they thought *Ziggy* was.

Burroughs: Could you explain this Ziggy Stardust image of yours? From what I can see it has to do with the world being on the eve of destruction within five years.

Bowie: The time is five years to go before the end of the earth. It has been announced that the world will end because of lack of natural resources. (The album was released three years ago.) Ziggy is in a position where all the kids have access to things that they thought they wanted. The older people have lost all touch with reality and the kids are left on their own to plunder anything. Ziggy was in a rock and roll band and the kids no longer want rock and roll. There's no electricity to play it. Ziggy's adviser tells him to collect news and sing it, 'cause there is no news. So Ziggy does this and there is terrible news. "All the Young Dudes" is a song about this news. It is no hymn to the youth as people thought. It is completely the opposite.

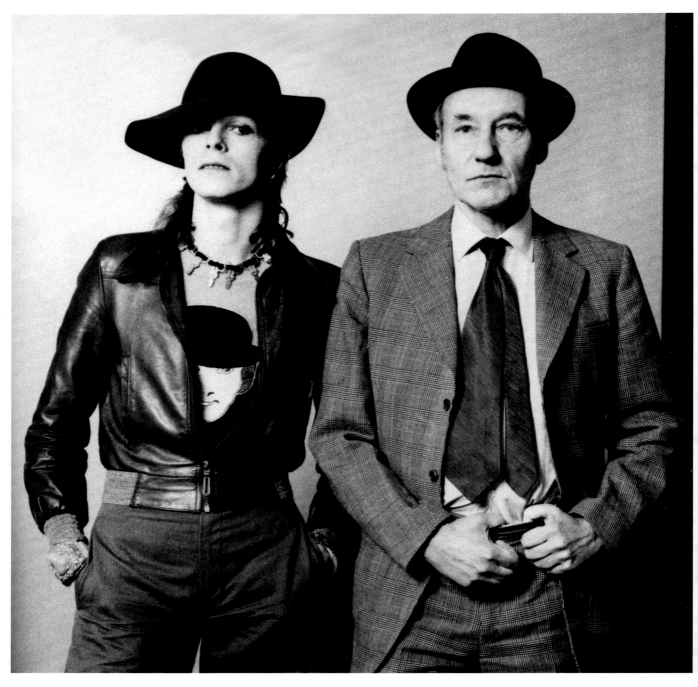

Burroughs: Where did this Ziggy idea come from, and this five-year idea? Of course, exhaustion of natural resources will not develop the end of the world. It will result in the collapse of civilization. And it will cut down the population by about three-quarters.

Bowie: Exactly. This does not cause the end of the world for Ziggy. The end comes when the infinites arrive. They really are a black hole, but I've made them people because it would be very hard to explain a black hole onstage.

Burroughs: Yes, a black hole onstage would be an incredible expense. And it would be a continuing performance, first eating up Shaftesbury Avenue.

Bowie: Ziggy is advised in a dream by the infinites to write the coming of a starman, so he writes "Star Man," which is the first news of hope that the people have heard. So they latch onto it immediately. The starmen that he is talking about are called the infinites, and they are black-hole jumpers. Ziggy has been talking about this amazing spaceman who will be coming

down to save the earth. They arrive somewhere in Greenwich Village. They don't have a care in the world and are of no possible use to us. They just happened to stumble into our universe by black-hole jumping. Their whole life is traveling from universe to universe. In the stage show, one of them resembles Brando, another one is a black New Yorker. I even have one called Queenie the Infinite Fox.

Now Ziggy starts to believe in all this himself and thinks himself a prophet of the future starman. He takes himself up to incredible spiritual heights and is kept alive by his disciples. When the infinites arrive, they take bits of Ziggy to make themselves real because in their original state they are anti-matter and cannot exist on our world. And they tear him to pieces onstage during the song "Rock 'n' Roll Suicide." As soon as Ziggy dies onstage the infinites take his elements and make themselves visible. It is a science-fiction fantasy of today and this is what literally blew my head off when I read *Nova Express*, which was written in 1961. Maybe we are the Rogers and Hammerstein of the Seventies, Bill!

Burroughs: Yes, I can believe that. The parallels are definitely there, and it sounds good.

Bowie: I must have the total image of a stage show. It has to be total with me. I'm just not content writing songs, I want to make it three-dimensional. Songwriting as an art is a bit archaic now. Just writing a song is not good enough.

Burroughs: It's the whole performance. It's not like somebody sitting down at the piano and just playing a piece.

Bowie: A song has to take on character, shape, body and influence people to an extent that they use it for their own devices. It must affect them not just as a song, but as a lifestyle. The rock stars have assimilated all kinds of philosophies, styles, histories, writings, and they throw out what they have gleaned from that.

Burroughs: The revolution will come from ignoring the others out of existence.

Bowie: Really. Now we have people who are making it happen on a level faster than ever. People who are into groups like Alice Cooper, the New York Dolls and Iggy Pop, who are denying totally and irrevocably the existence of people who are into the Stones and the Beatles. The gap has decreased from 20 years to 10 years.

Burroughs: The escalating rate of change. The media are really responsible for most of this. Which produces an incalculable effect.

Bowie: Once upon a time, even when I was 13 or 14, for me it was between 14 and 40 that you were old. Basically. But now it is 18-year-olds and 26-year-olds – there can be incredible discrepancies, which is really quite alarming. We are not trying to bring people together, but to wonder how much longer we've got. It would be positively boring if minds were in tune. I'm more interested in whether the planet is going to survive.

Burroughs: Actually, the contrary is happening; people are getting further and further apart.

Bowie: The idea of getting minds together smacks of the Flower Power period to me. The coming together of people I find obscene as a principle. It is not human. It is not a natural thing as some people would have us believe.

Copetas: What about love?

Burroughs: Ugh.

Bowie: I'm not at ease with the word "love."

Burroughs: I'm not either.

Bowie: I was told that it was cool to fall in love, and that period was nothing like that to me. I gave too much of my time and energy to another person and they did the same to me and we started burning out against each other. And that is what is termed love...that we decide to put all our values on another person. It's like two pedestals, each wanting to be the other pedestal.

Burroughs: I don't think that "love" is a useful word. It is predicated on a separation of a thing called sex and a thing called love and that they are separate. Like the primitive expressions in the old South when the woman is on a pedestal, and the man worshiped his wife and then went out and fucked a whore. It is primarily a Western concept and then it extended to the whole Flower Power thing of loving everybody. Well, you can't do that because the interests are not the same.

Bowie: The word is wrong, I'm sure. It is the way you understand love. The love that you see, among people who say, "We're in love," it's nice to look at...but wanting not to be alone, wanting to have a person there that they relate to for a few years is not often the love that carries on throughout the lives of those people. There is another word. I'm not sure whether it is a word. Love is every type of relationship that you think of...I'm sure it means relationship, every type of relationship that you can think of.

Copetas: What of sexuality, where is it going?

Bowie: Sexuality and where it is going is an extraordinary question, for I don't see it going anywhere. It is with me, and that's it. It's not coming out as a new advertising campaign next year. It's just there. Everything you can think about sexuality is just there. Maybe there are different kinds of sexuality, maybe they'll be brought into play more. Like one time it was impossible to be homosexual as far as the public were concerned. Now it is accepted. Sexuality will never change, for people have been fucking their own particular ways since time began and will continue to do it. Just more of those ways will be coming to light. It might even reach a puritan state.

Burroughs: There are certain indications that it might be going that way in the future, real backlash.

Bowie: Oh yes, look at the rock business. Poor old Clive Davis. He was found to be absconding with money and there were also drug things tied up with it. And that has started a whole clean-up campaign among record companies; they're starting to ditch some of their artists.

I'm regarded quite asexually by a lot of people. And the people that understand me the best are nearer to what I understand about me. Which is not very much, for I'm still searching. I don't know, the people who are coming anywhere close to where I think I'm at regard me more as an erogenous kind of thing. But the people who don't know so much about me regard me more sexually.

But there again, maybe it's the disinterest with sex after a certain age, because the people who do kind of get nearer to me are generally older. And the ones who regard me as more of a sexual thing are generally younger. The younger people get into the lyrics in a different way; there's much more of a tactile understanding, which is the way I prefer it. 'Cause that's the way I get off on writing, especially William's. I can't say that I analyze it all and that's exactly what you're saying, but from a feeling way I got what you meant. It's there, a whole wonderhouse of strange shapes and colours, tastes, feelings.

I must confess that up until now I haven't been an avid reader of William's work. I really did not get past Kerouac to be honest. But when I started looking at your work I really couldn't believe it. Especially after reading *Nova Express*. I really related to that. My ego obviously put me on to the "Pay Color" chapter, then I started dragging out lines from the rest of the book.

Burroughs: Your lyrics are quite perceptive.

Bowie: They're a bit middle class, but that's all right, 'cause I'm middle class.

Burroughs: It is rather surprising that they are such complicated lyrics, that can go down with a mass audience. The content of most pop lyrics is practically zero, like "Power to the People."

Bowie: I'm quite certain that the audience that I've got for my stuff don't listen to the lyrics.

Burroughs: That's what I'm interested in hearing about... do they understand them?

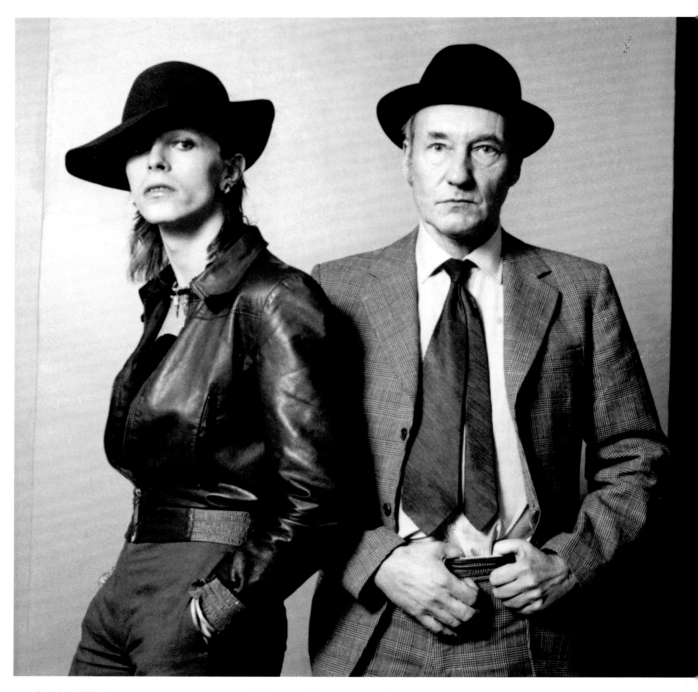

Bowie: Well, it comes over more as a media thing and it's only after they sit down and bother to look. On what level they are reading them, they do understand them, because they will send me back their own kind of write-ups of what I'm talking about, which is great for me because sometimes I don't know. There have been times when I've written something and it goes out and it comes back in a letter from some kid as to what they think about it and I've taken their analysis to heart so much that I have taken up his thing. Writing what my audience is telling me to write.

Lou Reed is the most important definitive writer in modern rock. Not because of the stuff that he does, but the direction that he will take it. Half the new bands would not be around if it were not for Lou. The movement that Lou's stuff has created is amazing. New York City is Lou Reed. Lou writes in the street-gut level and the English tend to intellectualize more.

Burroughs: What is your inspiration for writing, is it literary?

Bowie: I don't think so.

Burroughs: Well, I read this eight-line poem of yours and it is very reminiscent of TS Eliot.

Bowie: Never read him.

Burroughs: (Laughs) It is very reminiscent of "The Waste Land." Do you get any of your ideas from dreams?

Bowie: Frequently.

Burroughs: I get 70% of mine from dreams.

Bowie: There's a thing that just as you go to sleep, if you keep your elbows elevated that you will never go below the dream stage. And I've used that quite a lot and it keeps me dreaming much longer than if I just relaxed.

Burroughs: I dream a great deal, and then because I am a light sleeper, I will wake up and jot down just a few words and they will always bring the whole idea back to me.

Bowie: I keep a tape recorder by the bed and then if anything comes I just say it into the tape recorder. As for my inspiration, I haven't changed my views much since I was

about 12, really, I've just got a 12-year-old mentality. When I was in school I had a brother who was into Kerouac and he gave me *On The Road* to read when I was 12 years old. That's still been a big influence.

Copetas: The images both of you transpire are very graphic, almost comic-booky in nature.

Bowie: Well, yes, I find it easier to write in these little vignettes; if I try to get any more heavy, I find myself out of my league. I couldn't contain myself in what I say. Besides if you are really heavier there isn't that much more time to read that much, or listen to that much. There's not much point in getting any heavier...there's too many things to read and look at. If people read three hours of what you've done, then they'll analyze it for seven hours and come out with seven hours of their own thinking...where if you give them 30 seconds of your own stuff they usually still come out with seven hours of their own thinking. They take hook images of what you do. And they pontificate on the hooks. The sense of the immediacy of the image. Things have to hit for the moment. That's one of the reasons I'm into video; the image has to hit immediately. I adore video and the whole cutting up of it.

What are your projects at the moment?

Burroughs: At the moment I'm trying to set up an institute of advanced studies somewhere in Scotland. Its aim will be to extend awareness and alter consciousness in the direction of greater range, flexibility and effectiveness at a time when traditional disciplines have failed to come up with viable solutions. You see, the advent of the space age and the possibility of exploring galaxies and contacting alien life forms poses an urgent necessity for radically new solutions. We will be considering only non-chemical methods with the emphasis placed on combination, synthesis, interaction and rotation of methods now being used in the East and West, together with methods that are not at present being used to extend awareness or increase human potentials.

We know exactly what we intend to do and how to go about doing it. As I said, no drug experiments are planned and no drugs other than alcohol, tobacco and personal medications obtained on prescription will be permitted in the centre. Basically, the experiments we propose are inexpensive and easy to carry out. Things such as yoga-style meditation and exercises, communication, sound, light and film experiments, experiments with sensory deprivation chambers, pyramids, psychotronic generators and Reich's orgone accumulators, experiments with infra-sound, experiments with dream and sleep.

Bowie: That sounds fascinating. Are you basically interested in energy forces?

Burroughs: Expansion of awareness, eventually leading to mutations. Did you read *Journey Out of the Body*? Not the usual book on astral projection. This American businessman found he was having these experiences of getting out of the body – never used any hallucinogenic drugs. He's now setting up this astral air force. This psychic thing is really a rave in the States now. Did you experience it much when you were there?

Bowie: No, I really hid from it purposely. I was studying Tibetan Buddhism when I was quite young, again influenced by Kerouac. The Tibetan Buddhist Institute was available so I trotted down there to have a look. Lo and behold there's a guy down in the basement who's the head man in setting up a place in Scotland for the refugees, and I got involved purely on a sociological level – because I wanted to help get the refugees out of India, for they were really having a shitty time of it down there, dropping like flies due to the change of atmosphere from the Himalayas.

Scotland was a pretty good place to put them, and then more and more I was drawn to their way of thinking, or non-thinking, and for a while got quite heavily involved in it. I got to the point where I wanted to become a novice monk and about two weeks before I was actually going to take those steps, I broke up and went out on the streets and got drunk and never looked back.

Burroughs: Just like Kerouac.

Bowie: Go to the States much?

Burroughs: Not since '71.

Bowie: It has changed, I can tell you, since then.

Burroughs: When were you last back?

Bowie: About a year ago.

Burroughs: Did you see any of the porn films in New York?

Bowie: Yes, quite a few.

Burroughs: When I was last back, I saw about 30 of them. I was going to be a judge at the erotic film festival.

Bowie: The best ones were the German ones; they were really incredible.

Burroughs: I thought that the American ones were still the best. I really like film...I understand that you may play Valentine Michael Smith in the film version of *Stranger in a Strange Land*.

Bowie: No, I don't like the book much. In fact, I think it is terrible. It was suggested to me that I make it into a movie, then I got around to reading it. It seemed a bit too Flower-Powery and that made me a bit wary.

Burroughs: I'm not that happy with the book either. You know, science fiction has not been very successful. It was supposed to start a whole new trend and nothing happened. For the special effects in some of the movies, like *2001*, it was great. But it all ended there.

Bowie: I feel the same way. Now I'm doing Orwell's *1984* on television; that's a political thesis and an impression of the way in another country. Something of that nature will have more impact on television. I don't believe in proper cinema; it doesn't have the strength of television. People having to go out to the cinema is really archaic. I'd much rather sit at home.

Burroughs: Do you mean the whole concept of the audience?

Bowie: Yes, it is ancient. No sense of immediacy.

Burroughs: Exactly, it all relates back to image and the way in which it is used.

Bowie: Right. I'd like to start a TV station.

Burroughs: There are hardly any programmes worth anything any more. The British TV is a little better than American. The best thing the British do is natural history. There was one last week with sea lions eating penguins, incredible. There is no reason for dull programmes, people get very bored with housing projects and coal strikes.

Bowie: They all have an interest level of about three seconds. Enough time to get into the commentator's next sentence. And that is the premise it works on. I'm going

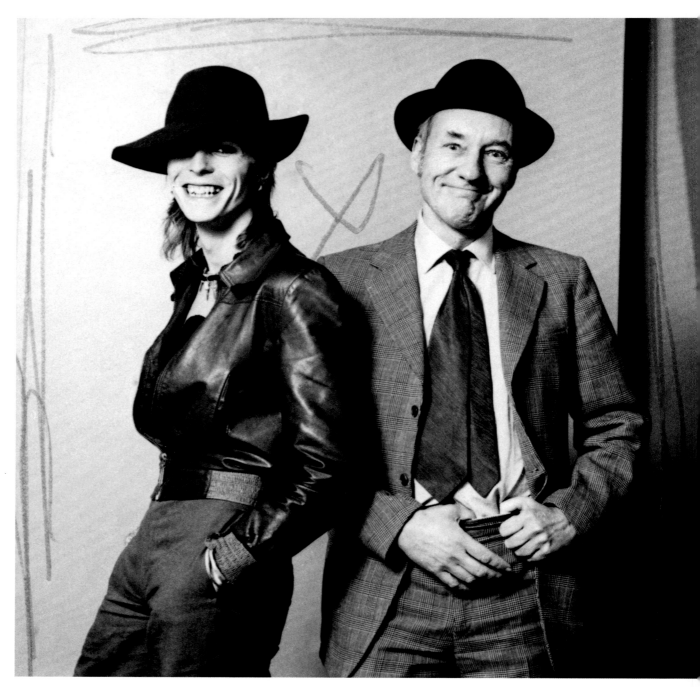

to put together all the bands that I think are of great value in the States and England, then make an hour-long programme about them. Probably a majority of people have never heard of these bands. They are doing and saying things in a way other bands aren't. Things like the Puerto Rican music at the Cheetah Club in New York. I want people to hear musicians like Joe Cuba. He has done things to whole masses of Puerto Rican people. The music is fantastic and important. I also want to start getting Andy Warhol films on TV.

Burroughs: Have you ever met Warhol?

Bowie: Yes, about two years ago I was invited up to The Factory. We got in the lift and went up and when it opened there was a brick wall in front of us. We rapped on the wall and they didn't believe who we were. So we went back down and back up again till finally they opened the wall and everybody was peering around at each other. That was shortly after the gun incident. I met this man who was the living dead. Yellow in complexion, a wig on that was the wrong colour, little glasses. I extended my hand and the guy

retired, so I thought, "The guy doesn't like flesh, obviously he's reptilian." He produced a camera and took a picture of me. And I tried to make small talk with him, and it wasn't getting anywhere.

But then he saw my shoes. I was wearing a pair of gold-and-yellow shoes, and he says, "I adore those shoes, tell me where you got those shoes." He then started a whole rap about shoe design and that broke the ice. My yellow shoes broke the ice with Andy Warhol.

I adore what he was doing. I think his importance was very heavy, it's become a big thing to like him now. But Warhol wanted to be cliche, he wanted to be available in Woolworth's, and be talked about in that glib type of manner. I hear he wants to make real films now which is very sad because the films he was making were the things that should be happening. I left knowing as little about him as a person as when I went in.

Burroughs: I don't think that there is any person there. It's a very alien thing, completely and totally unemotional. He's really

science-fiction character. He's got a strange green colour.

Bowie: That's what struck me. He's the wrong colour, this man is the wrong colour to be a human being. Especially under the stark neon lighting that is in The Factory. Apparently it is a real experience to behold him in the daylight.

Burroughs: I've seen him in all light and still have no idea as to what is going on, except that it is something quite purposeful. It's not energetic, but quite insidious, completely asexual. His films will be the late-night movies of the future.

Bowie: Exactly. Remember *Pork*? I want to get that onto TV. TV has eaten up everything else, and Warhol films are all that are left, which is fabulous. *Pork* could become the next *I Love Lucy*, the great American domestic comedy. It's about how people really live, not like Lucy, who never touched dishwater. It's about people living and hustling to survive. That's what *Pork* is all about. A smashing of the spectacle. Although I'd like to do my own version of *Sindbad The Sailor*. I think that is an all-time classic. But it would have to be done on an extraordinary level. It would be incredibly indulgent and expensive. It would have to utilize lasers and all the things that are going to happen in a true fantasy.

Even the use of holograms. Holograms are important. Videotape is next, then it will be holograms. Holograms will come into use in about seven years. Libraries of video cassettes should be developed to their fullest during the interim. You can't video enough good material from your own TV. I want to have my own choice of programmes. There has to be the necessary software available.

Burroughs: I audio-record everything I can.

Bowie: The media is either our salvation or our death. I'd like to think it's our salvation. My particular thing is discovering what can be done with media and how it can be used. You can't draw people together like one big huge family, people don't want that. They want isolation or a tribal thing. A group of 18 kids would much rather stick together and hate the next 18 kids down the block. You are not going to get two or three blocks joining up and loving each other. There are just too many people.

Burroughs: Too many people. We're in an overpopulated situation, but the less people you have does not include the fact that they are still heterogeneous. They are just not the same. All this talk about a world family is a lot of bunk. It worked with the Chinese because they are very similar.

Bowie: And now one man in four in China has a bicycle and that is pretty heavy considering what they didn't have before. And that's the miracle as far as they're concerned. It's like all of us having a jet plane over here.

Burroughs: It's because they are the personification of one character that they can live together without any friction. We quite evidently are not.

Bowie: It is why they don't need rock and roll. British rock and roll stars played in China, played a dirty great field and they were treated like a sideshow. Old women, young children, some teenagers, you name it, everybody came along, walked past them and looked at them on the stand. It didn't mean a thing. Certain countries don't need rock and roll because they were so drawn together as a family unit. China has its mother-father figure – I've never made my mind up which – it fluctuates between the two. For the West, Jagger is most certainly a mother

figure and he's a mother hen to the whole thing. He's not a cockadoodledoo; he's much more like a brothel keeper or a madame.

Burroughs: Oh, very much so.

Bowie: He's incredibly sexy and very virile. I also find him incredibly motherly and maternal clutched into his bosom of ethnic blues. He's a white boy from Dagenham trying his damnedest to be ethnic. You see, trying to tart the rock business up a bit is getting nearer to what the kids themselves are like, because what I find, if you want to talk in the terms of rock, a lot depends on sensationalism and the kids are a lot more sensational than the stars themselves. The rock business is a pale shadow of what the kids lives are usually like. The admiration comes from the other side. It's all a reversal, especially in recent years. Walk down Christopher Street and then you wonder exactly what went wrong. People are not like James Taylor; they may be molded on the outside, but inside their heads it is something completely different.

Burroughs: Politics of sound.

Bowie: Yes. We have kind of got that now. It has very loosely shaped itself into the politics of sound. The fact that you can now subdivide rock into different categories was something that you couldn't do ten years ago. But now I can reel off at least ten sounds that represent a kind of person rather than a type of music. The critics don't like to say that, because critics like being critics, and most of them wish they were rock and roll stars. But when they classify they are talking about people *not* music. It's a whole political thing.

Burroughs: Like infrasound, the sound below the level of hearing. Below 16 Mertz. Turned up full blast it can knock down walls for 30 miles. You can walk into the French patent office and buy the patent for 40p. The machine itself can be made very cheaply from things you could find in a junk yard.

Bowie: Like black noise. I wonder if there is a sound that can put things back together. There was a band experimenting with stuff like that; they reckon they could make a whole audience shake.

Burroughs: They have riot-control noise based on these soundwaves now. But you could have music with infrasound, you wouldn't necessarily have to kill the audience.

Bowie: Just maim them.

Burroughs: The weapon of the Wild Boys is a bowie knife, an 18-inch bowie knife, did you know that?

Bowie: An 18-inch bowie knife...you don't do things by halves, do you. No, I didn't know that was their weapon. The name Bowie just appealed to me when I was younger. I was into a kind of heavy philosophy thing when I was 16 years old, and I wanted a truism about cutting through the lies and all that.

Burroughs: Well, it cuts both ways, you know, double-edged on the end.

Bowie: I didn't see it cutting both ways till now.

By Craig Copetas, from *Rolling Stone*, Issue 155, 28 February 1974 © Rolling Stone LLC 1974

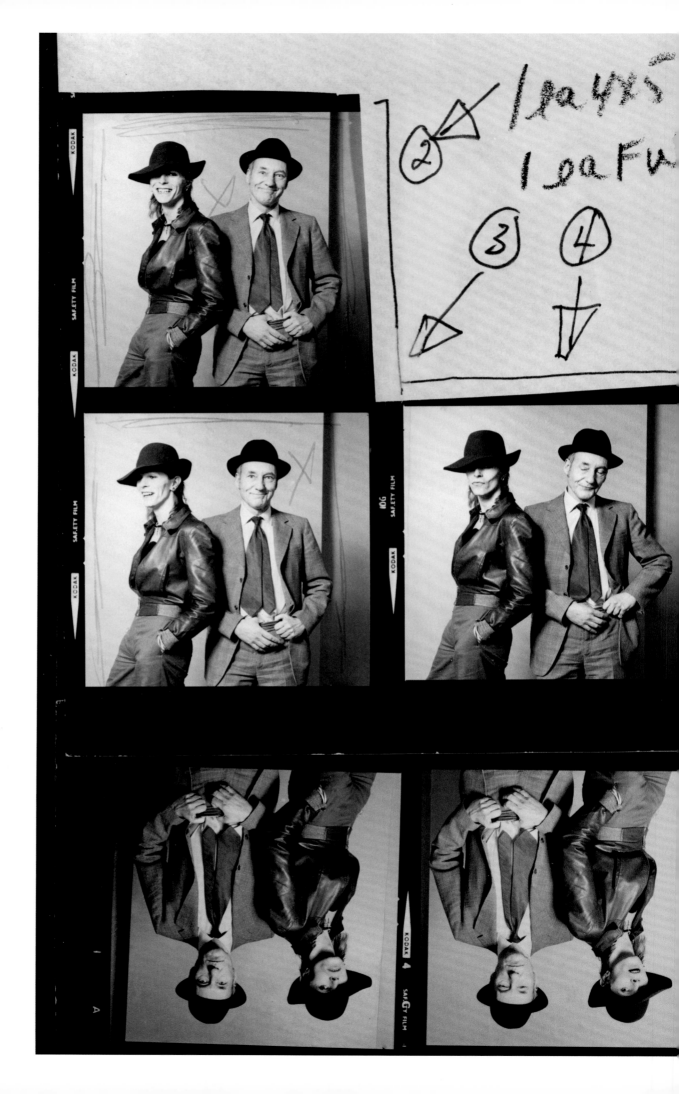

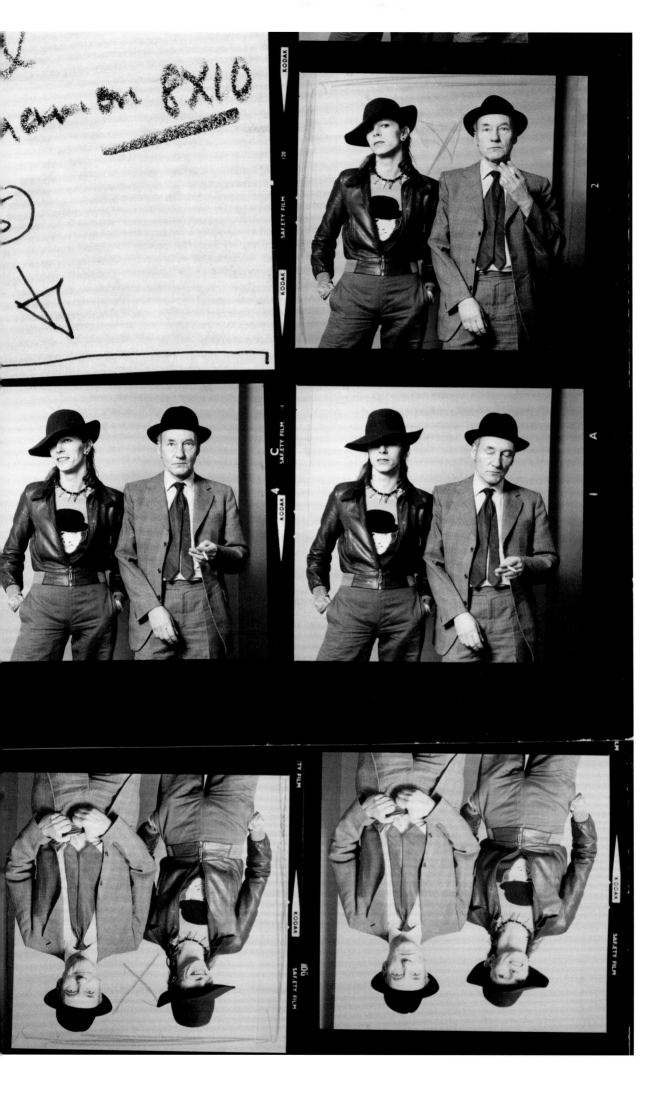

191

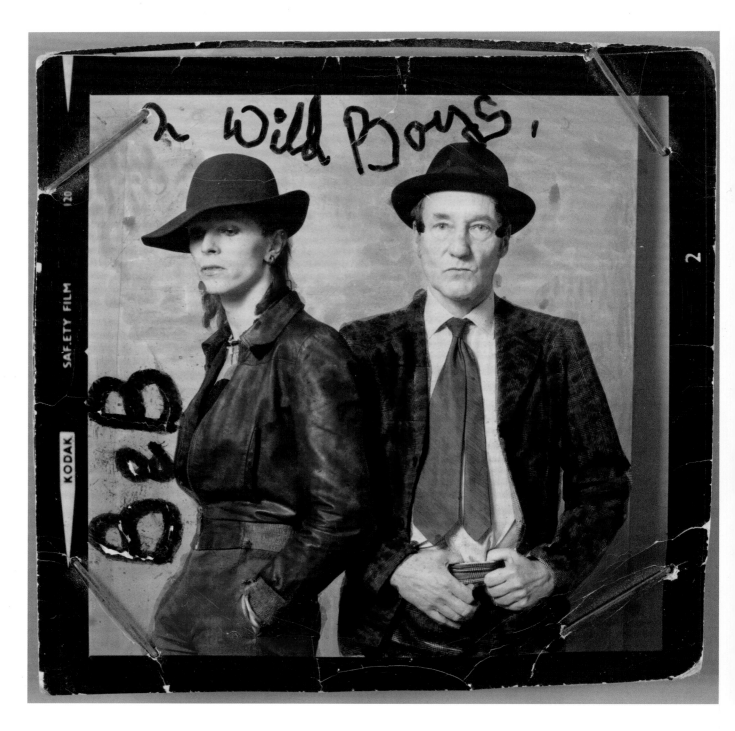

"I gave David one of the Kodak test prints from that shoot. He went back and graffitied the print: colouring the suits, adding some bright orange to his hair. He wrote on top of that image 'Wild Boys' and on the side scribbled 'B&B'. This is the image most people know, because David was very smart. He was not only a genius, but he kept a very extensive archive of his work. The coloured image from that day, that shot, was featured in the V&A's brilliant *David Bowie Is* exhibition and reproduced in their companion book."

Terry O'Neill

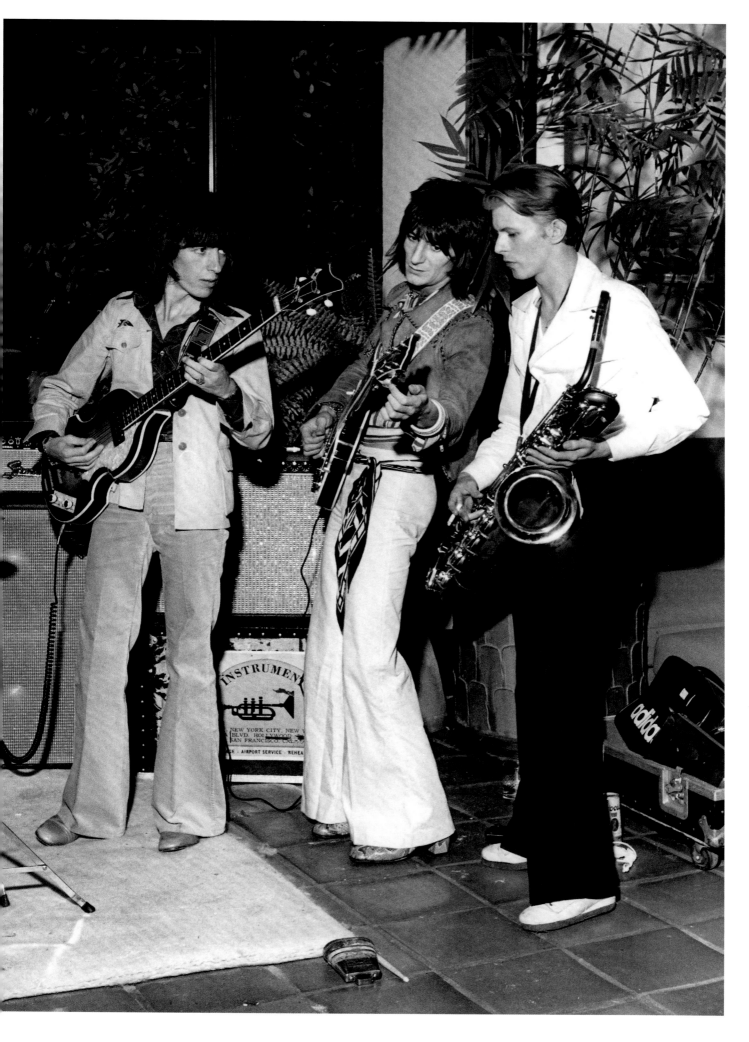

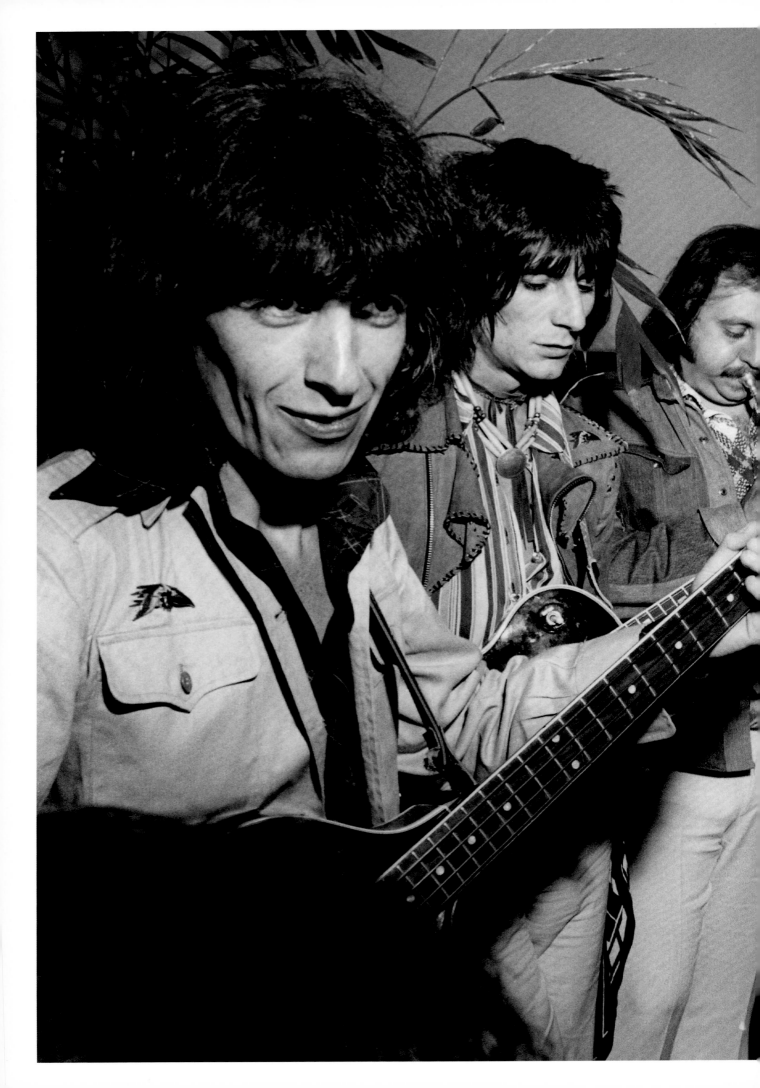

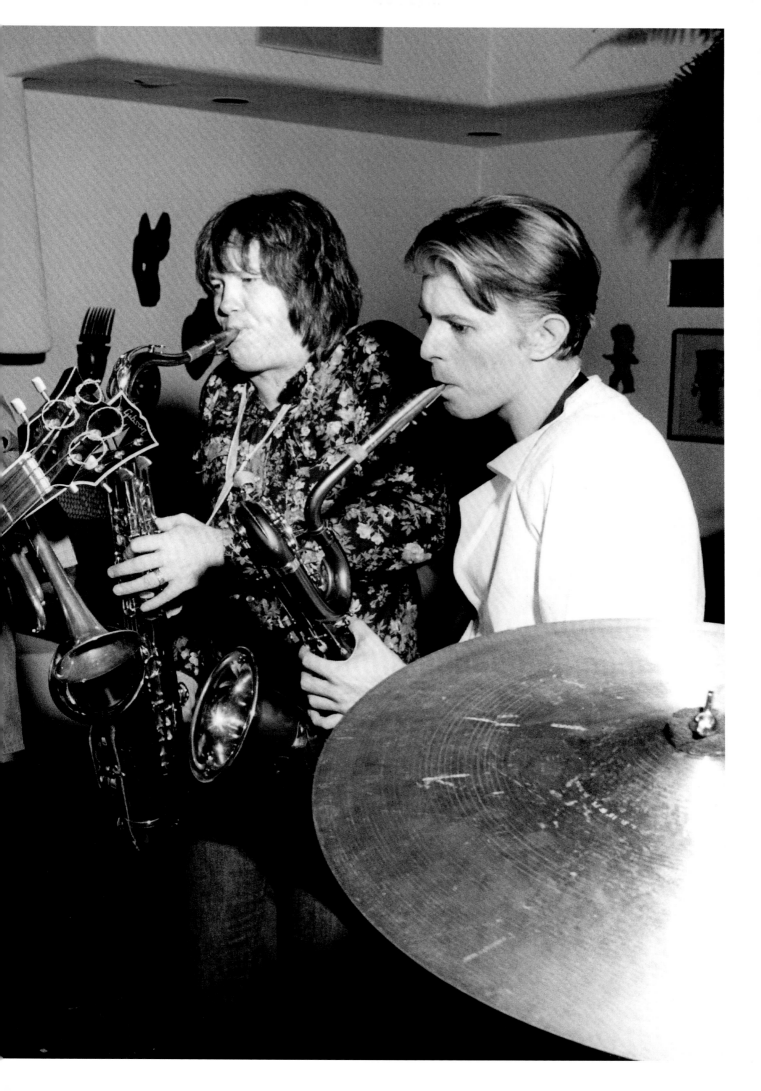

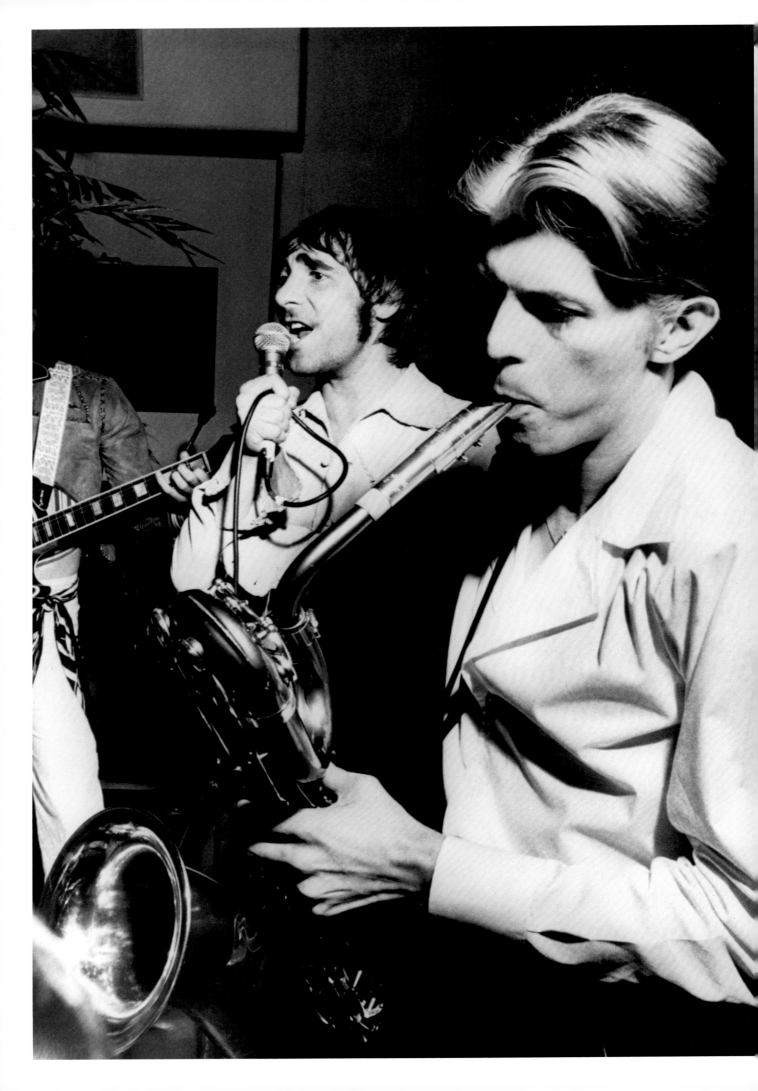

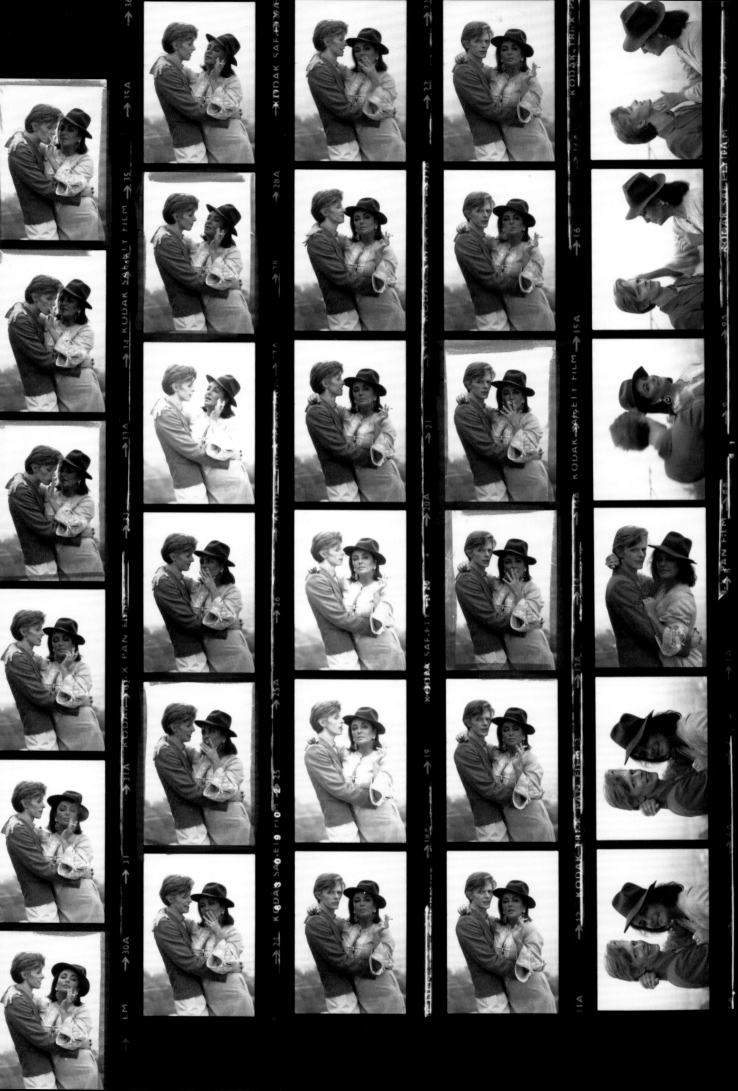

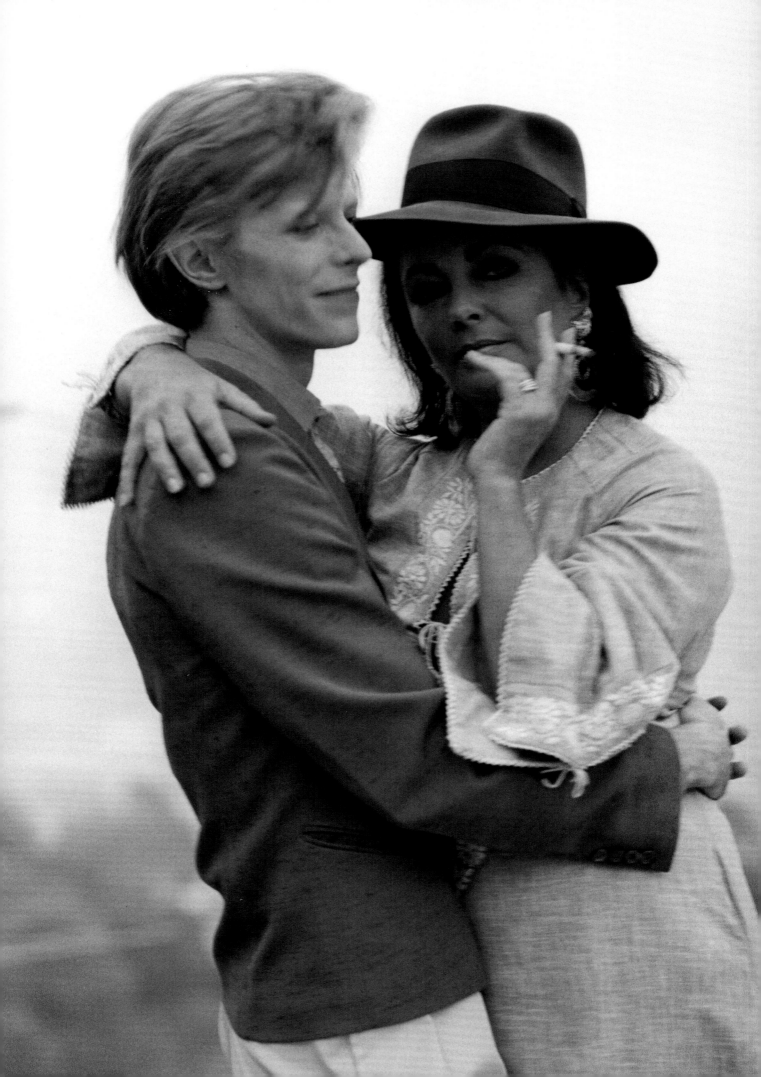

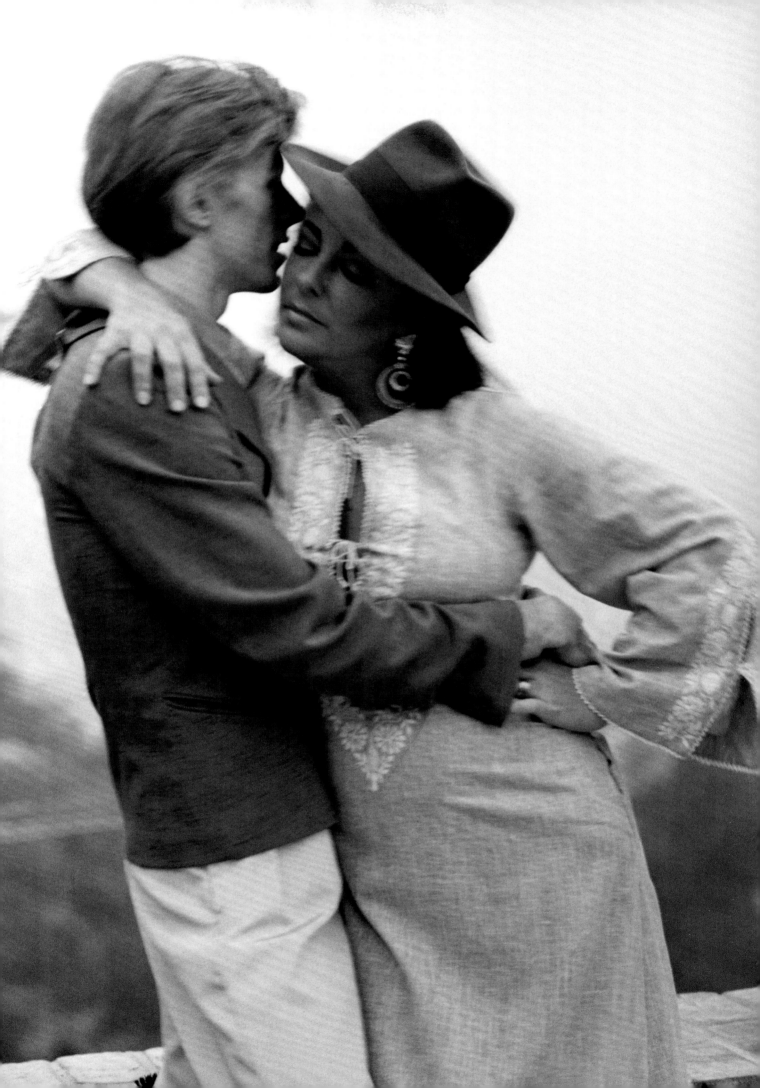

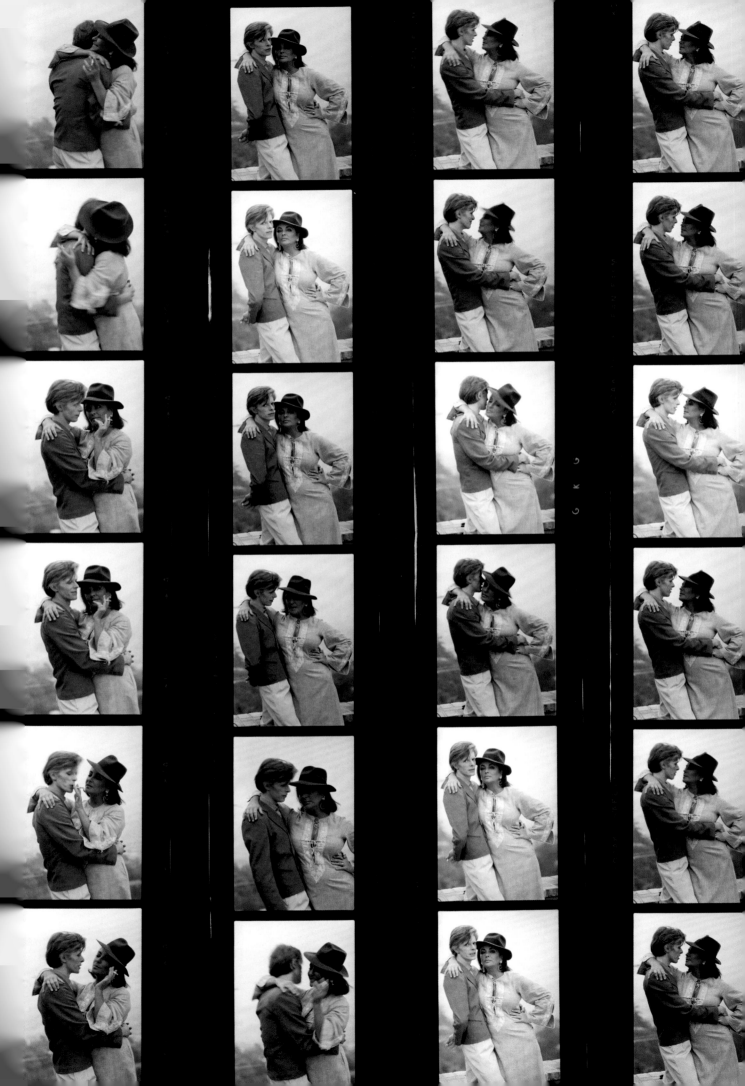

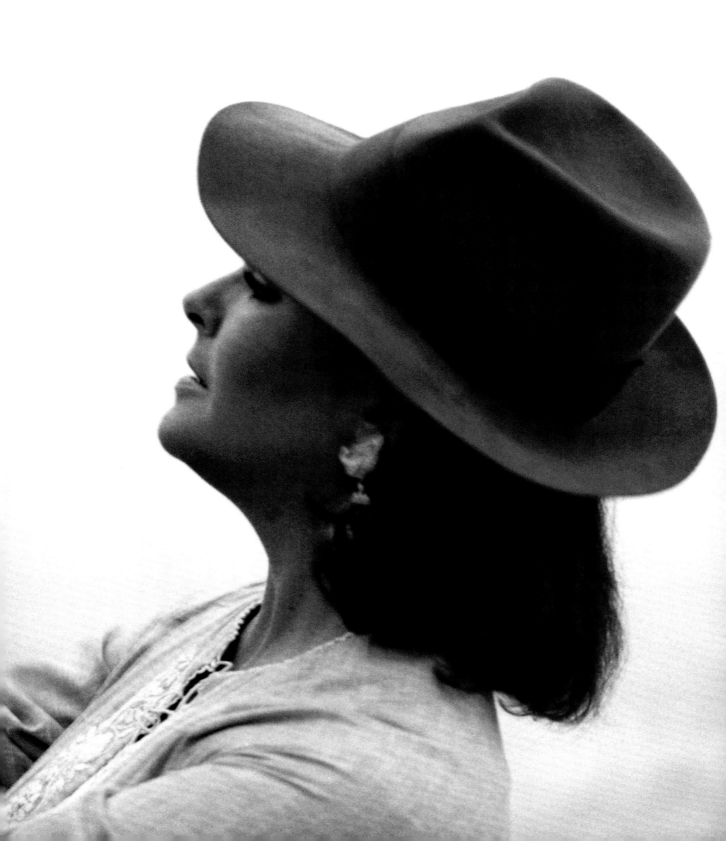

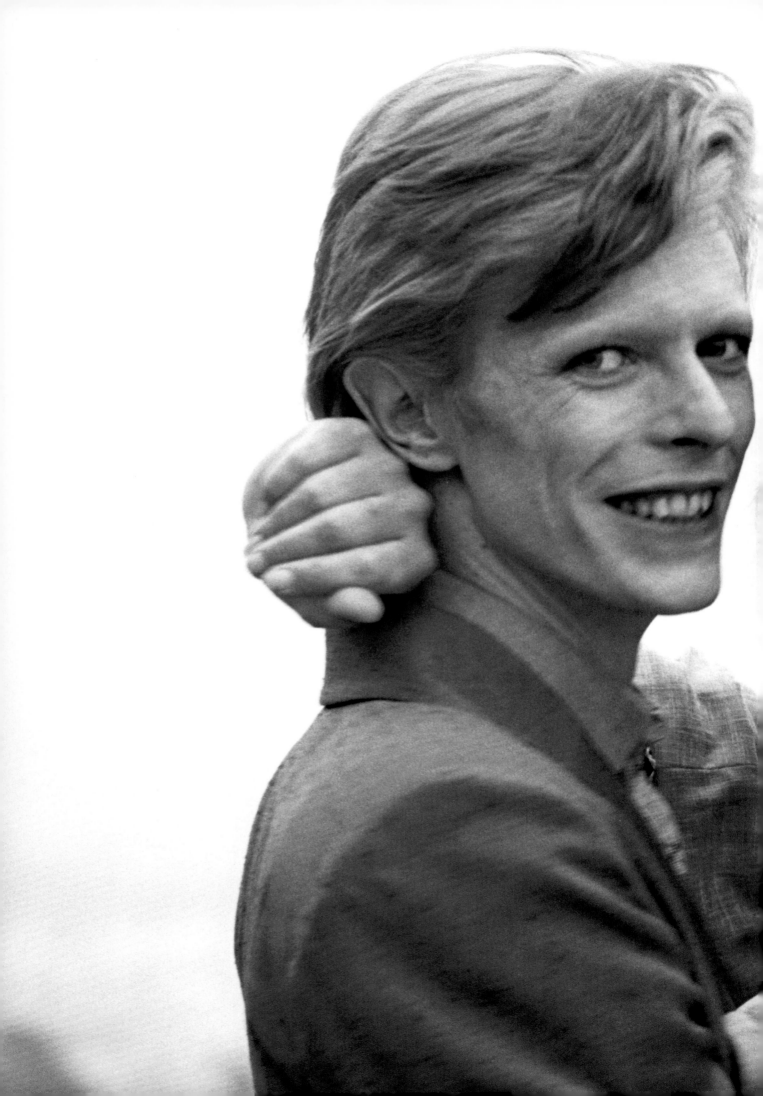

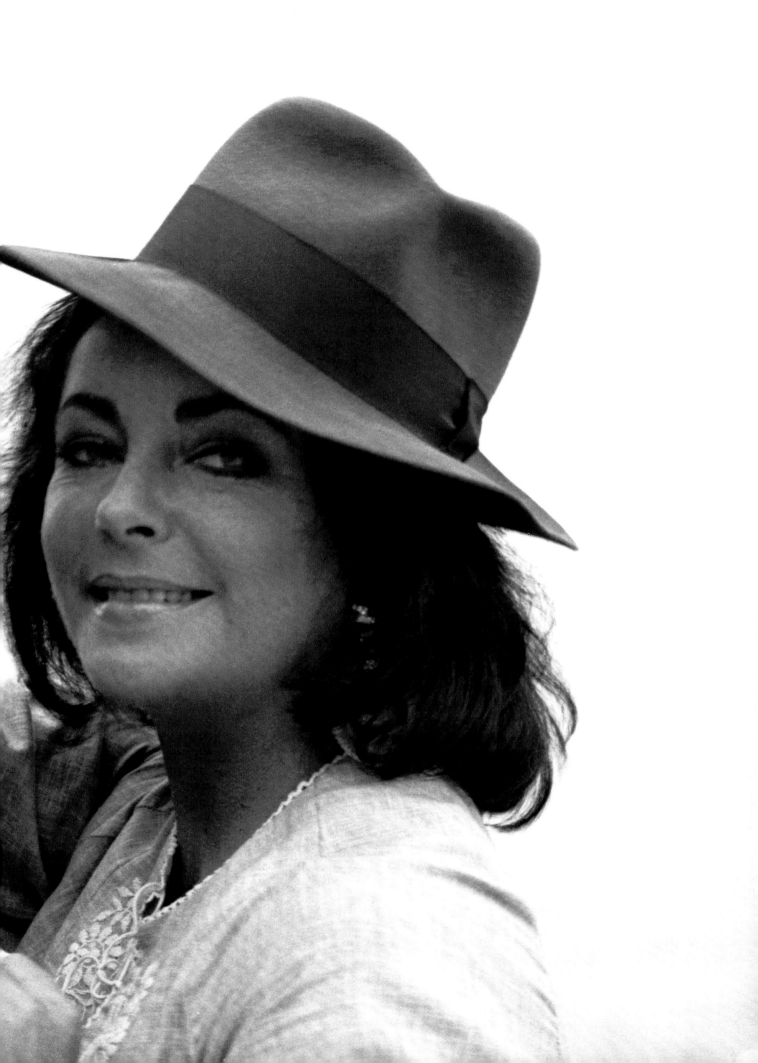

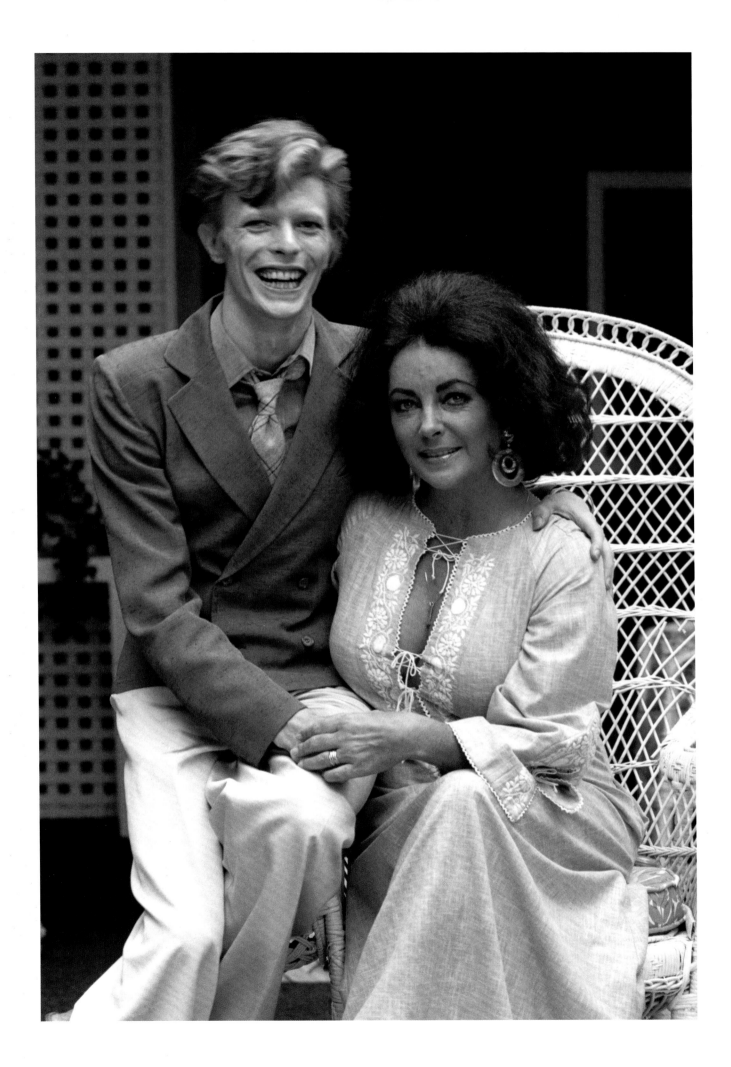

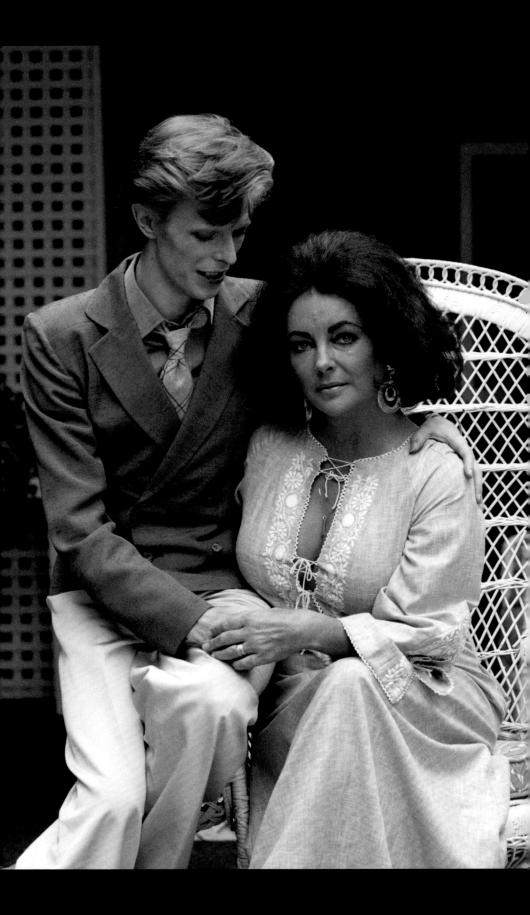

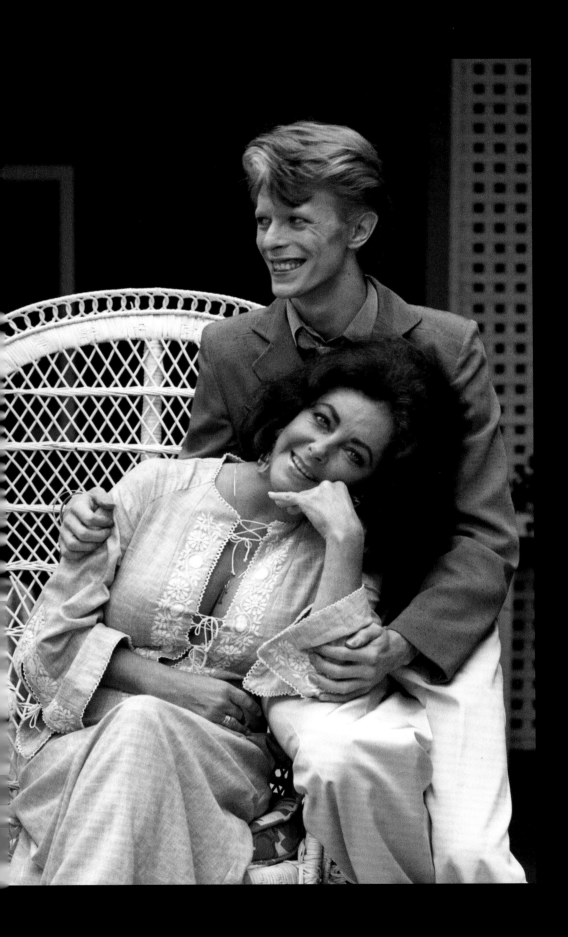

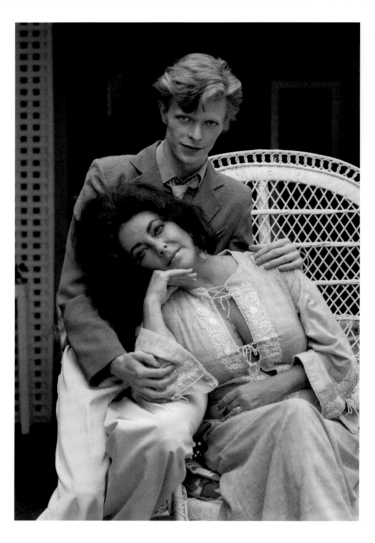
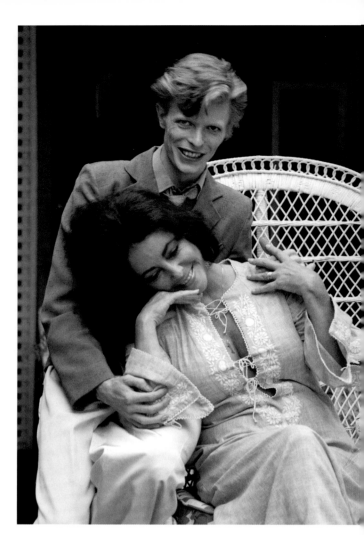
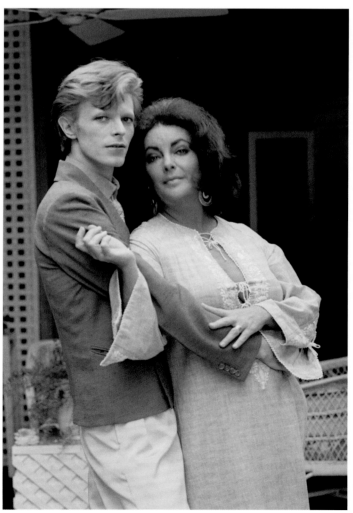
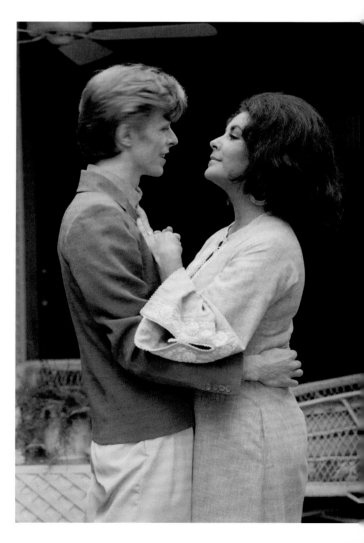

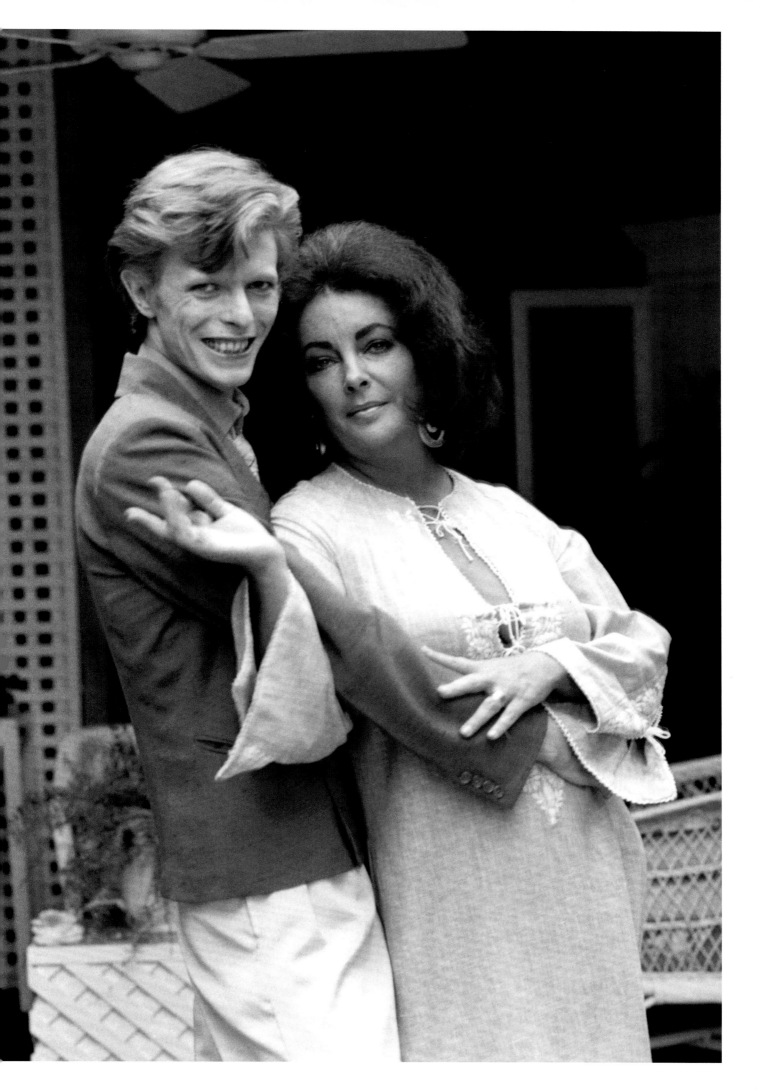

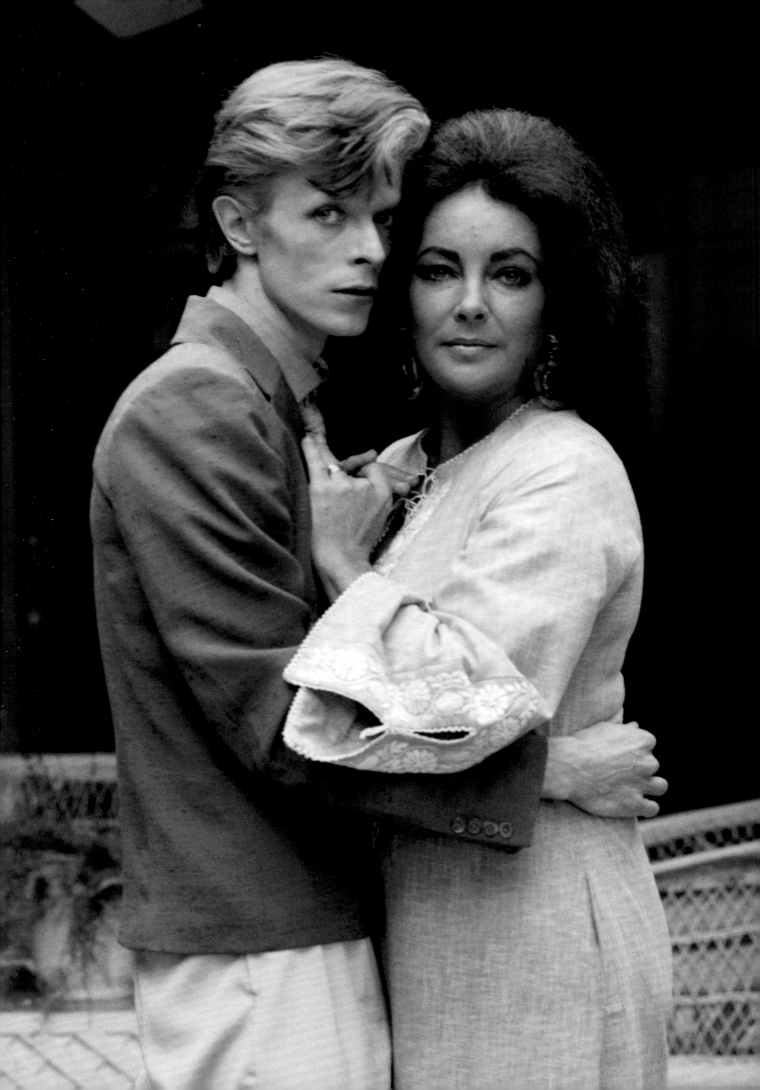

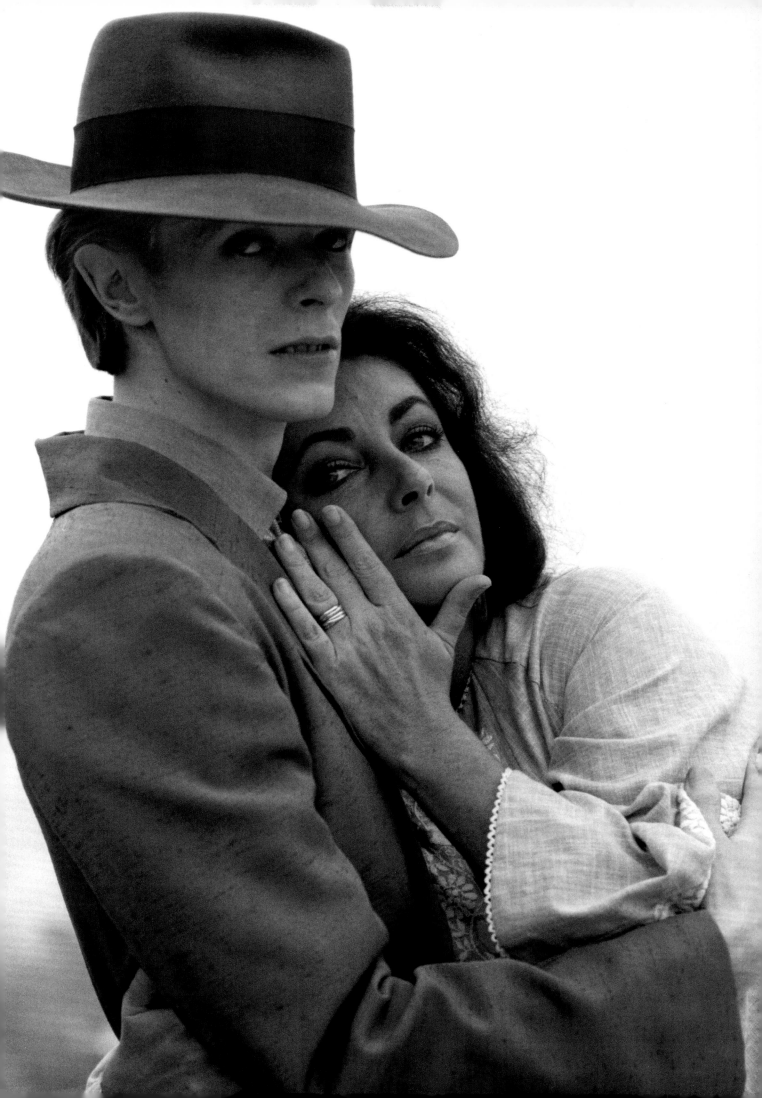

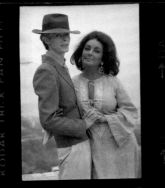
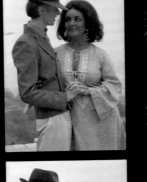
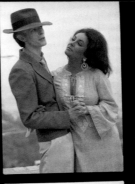

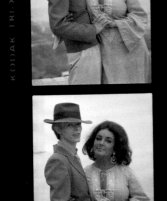
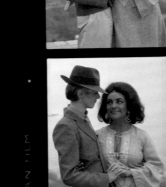
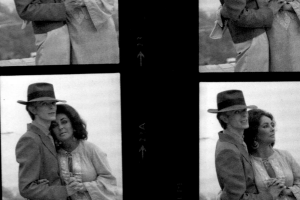
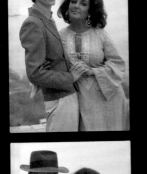
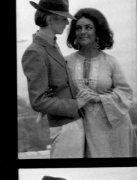
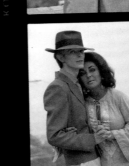
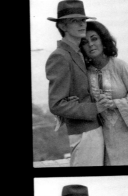
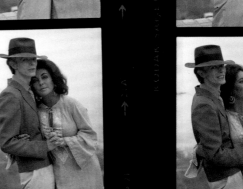
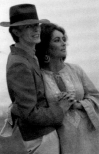
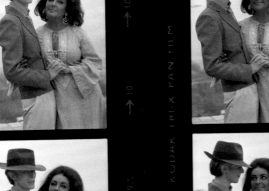
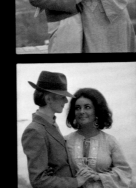
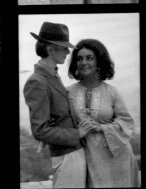
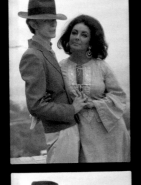
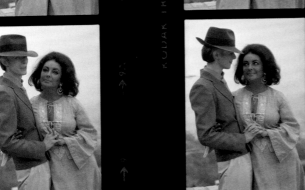
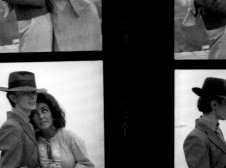
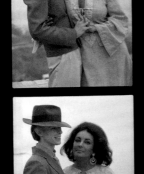
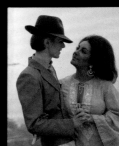
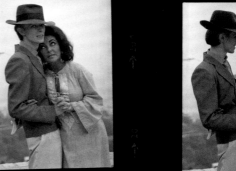
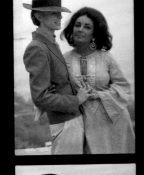

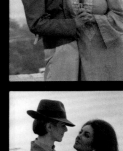

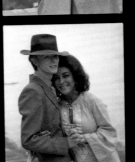
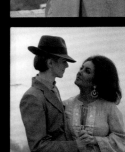
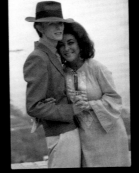
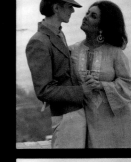

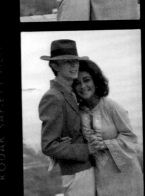
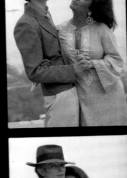
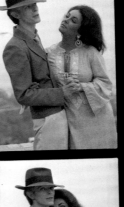
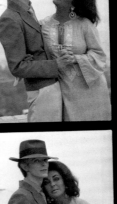

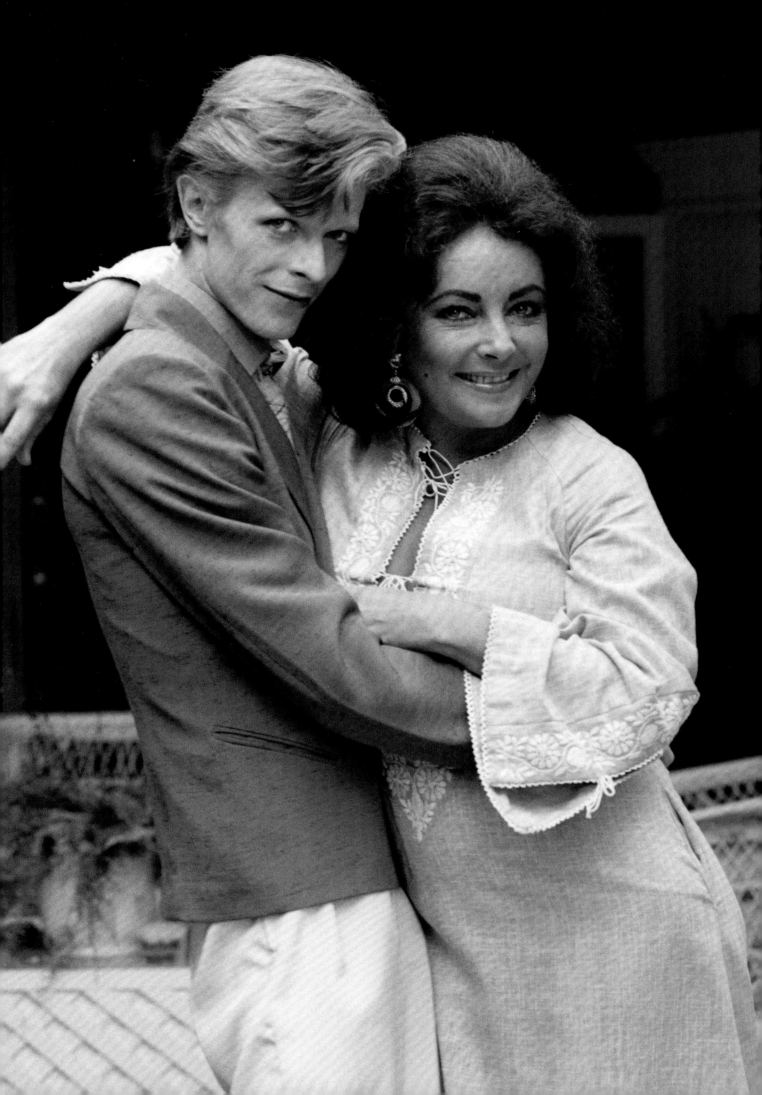

1975

THE MAN WHO
FELL TO EARTH

"There are quite a few science-fiction movies scheduled to come out in the next year or so. We shall be lucky if even one or two are as absorbing and as beautiful as *The Man Who Fell to Earth*." – *The New York Times*

"The skin of
my character in
The Man Who Fell to Earth
was some concoction,
a spermatozoon
of an alien nature
that was obscene and
weird-looking." DB

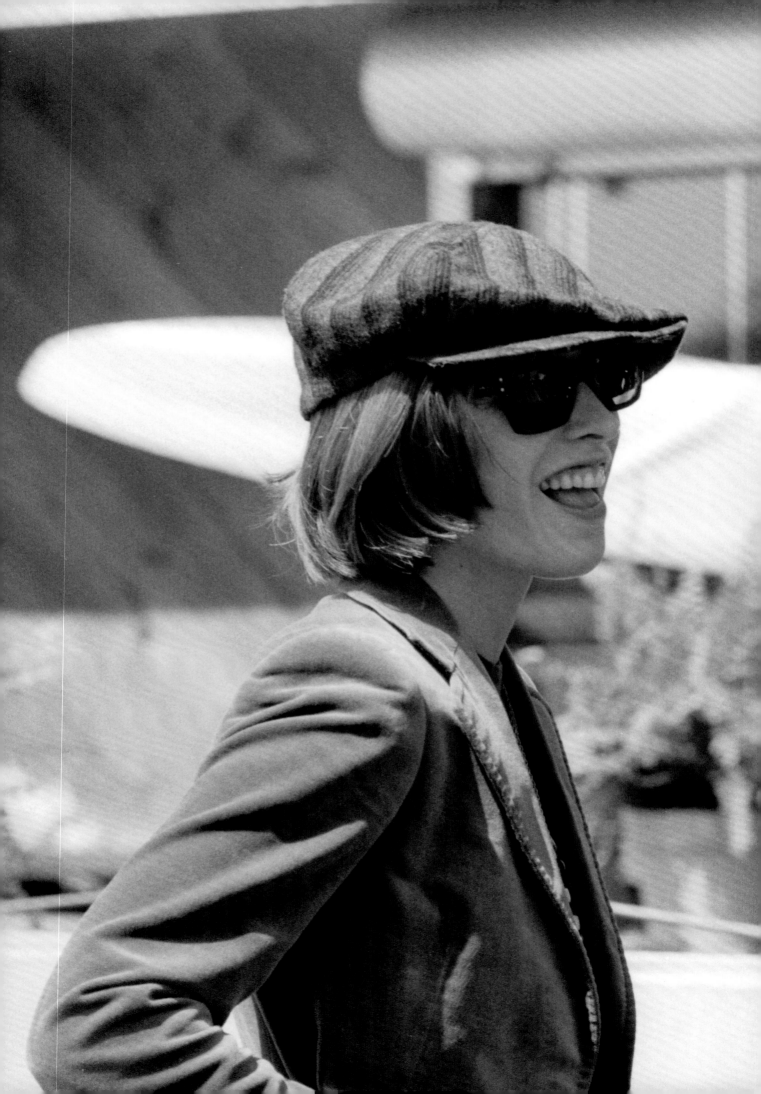

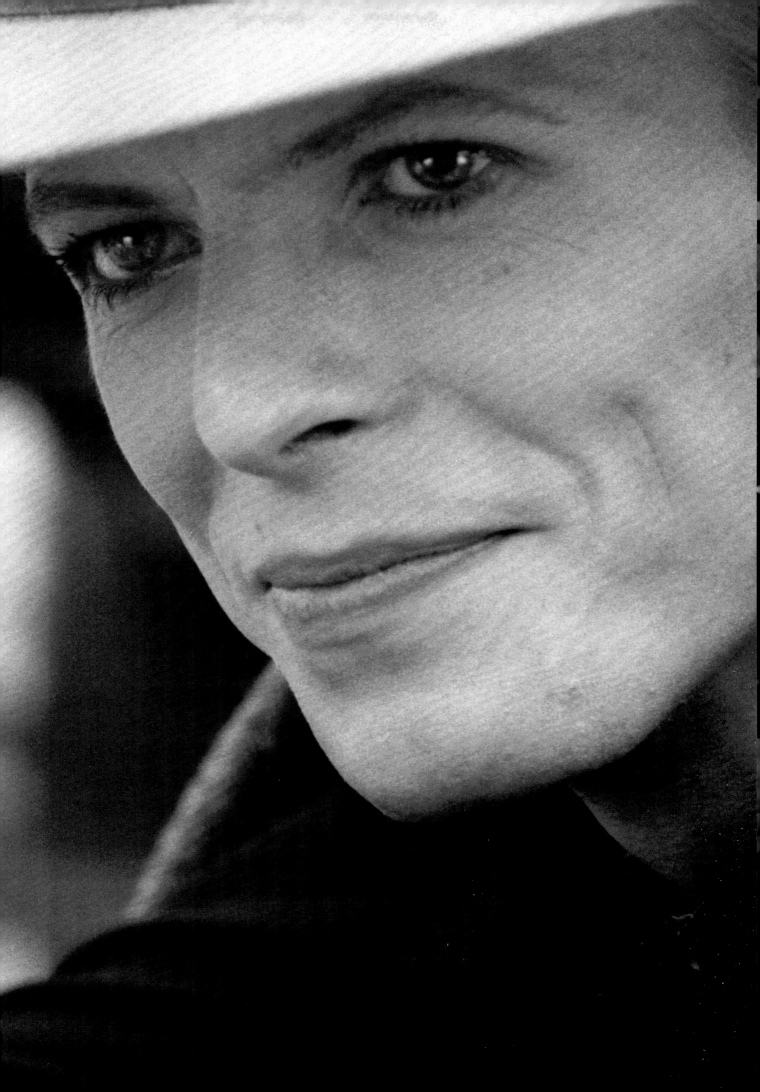

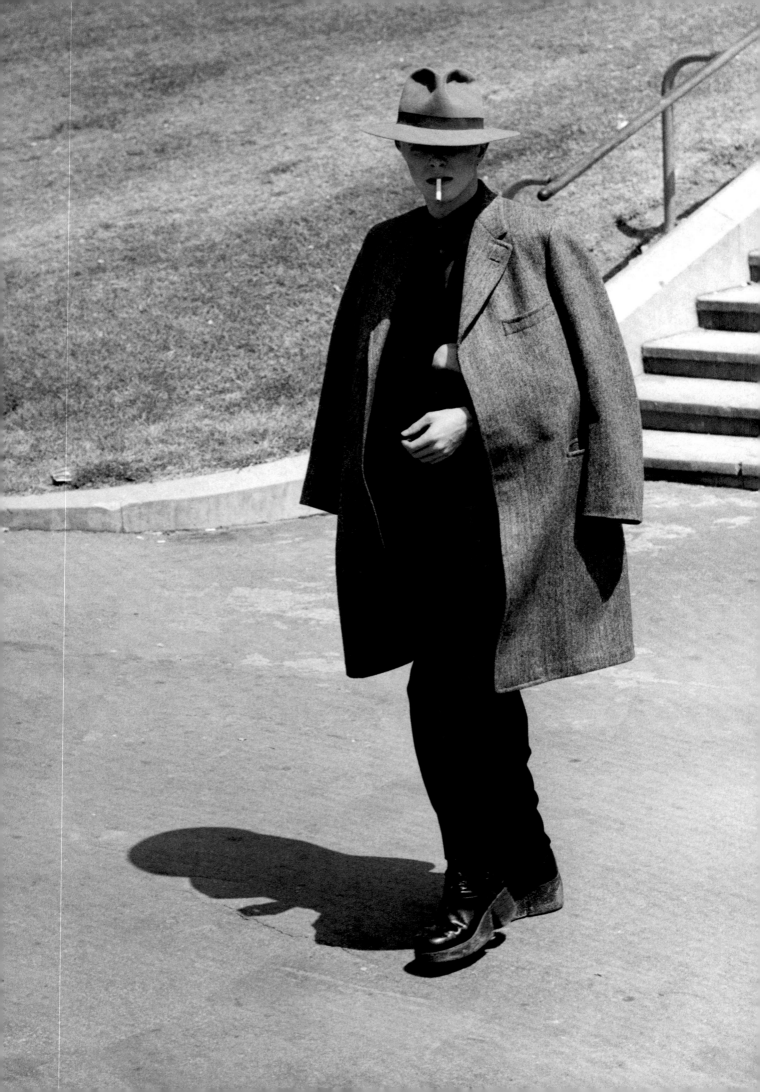

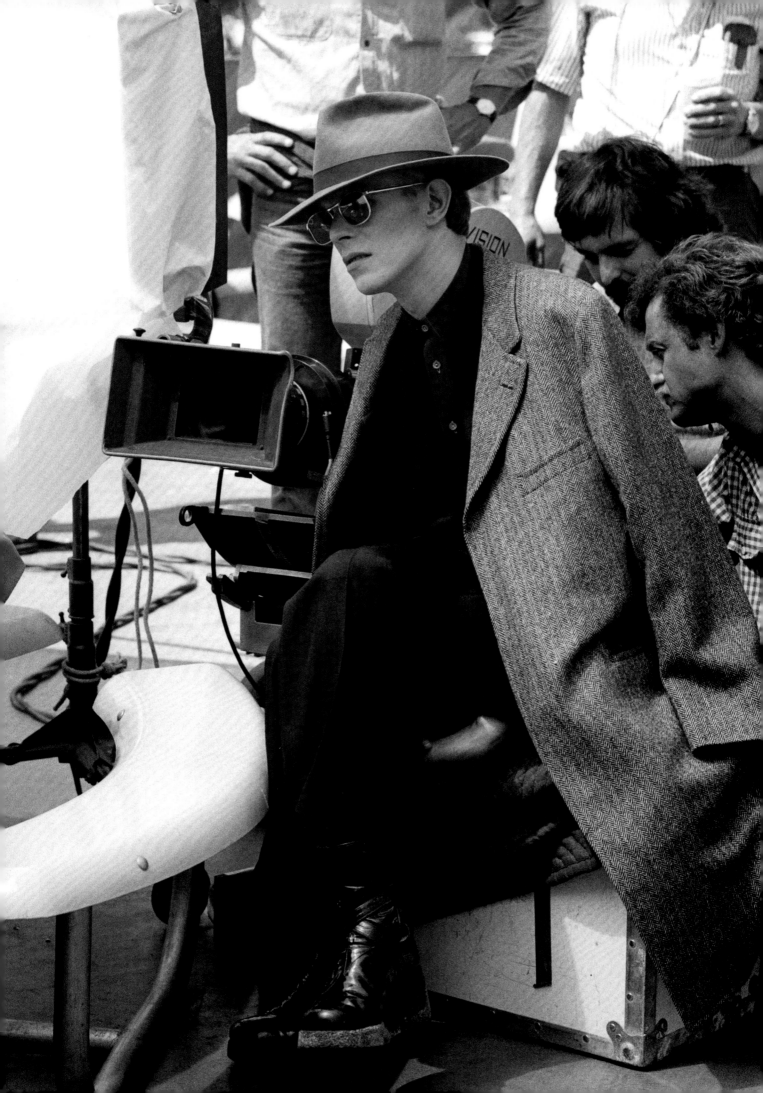

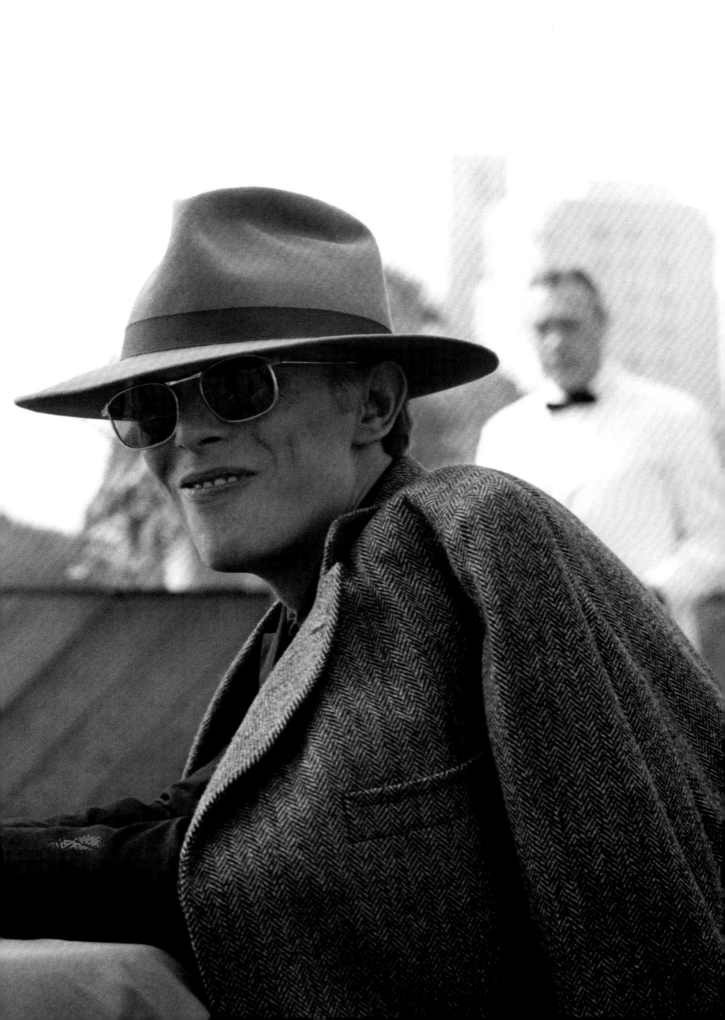

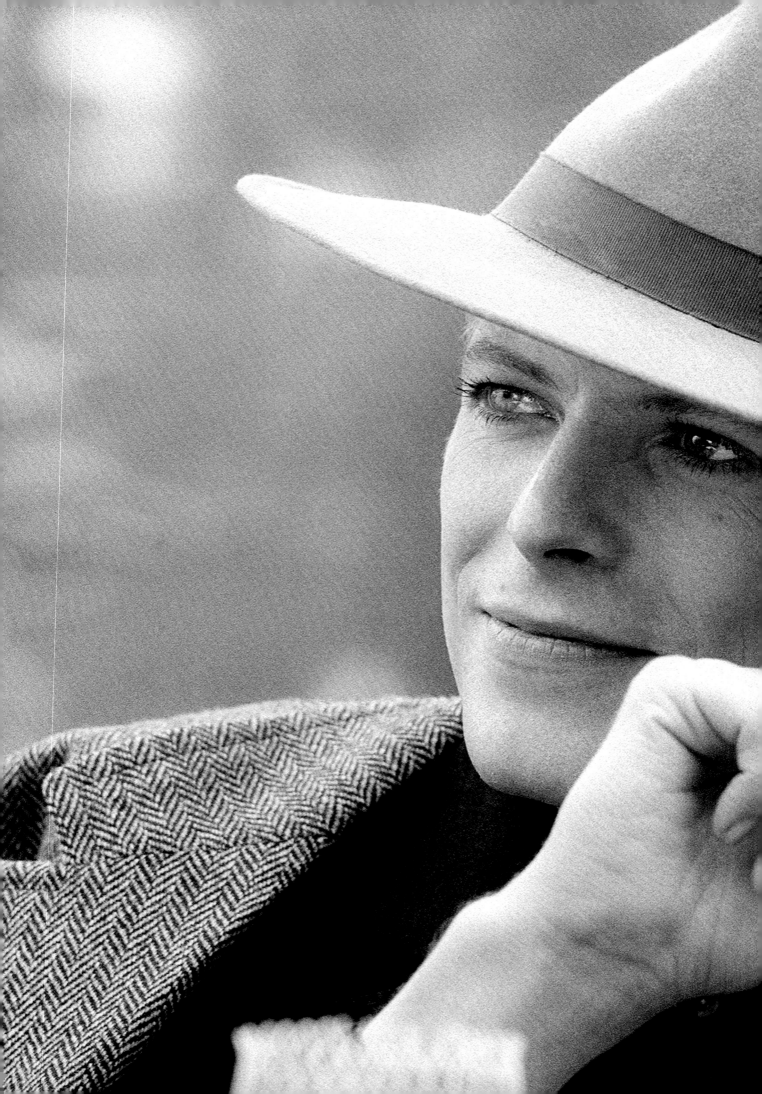

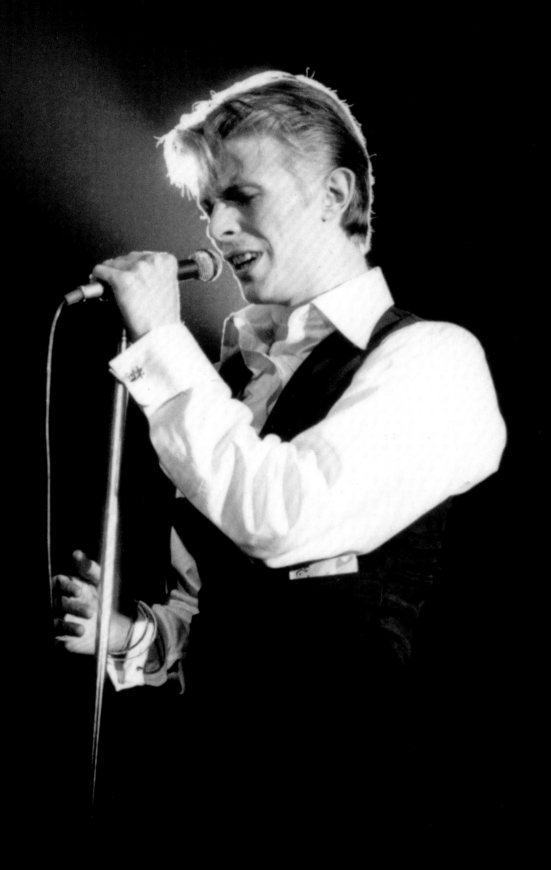

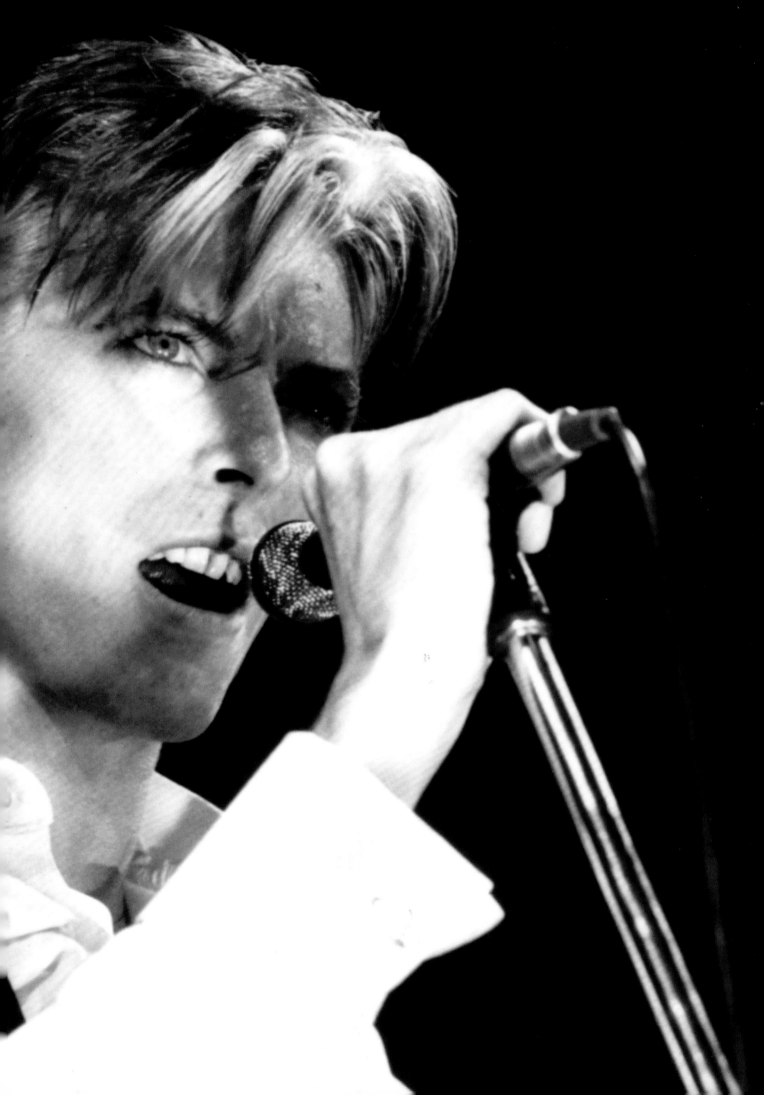

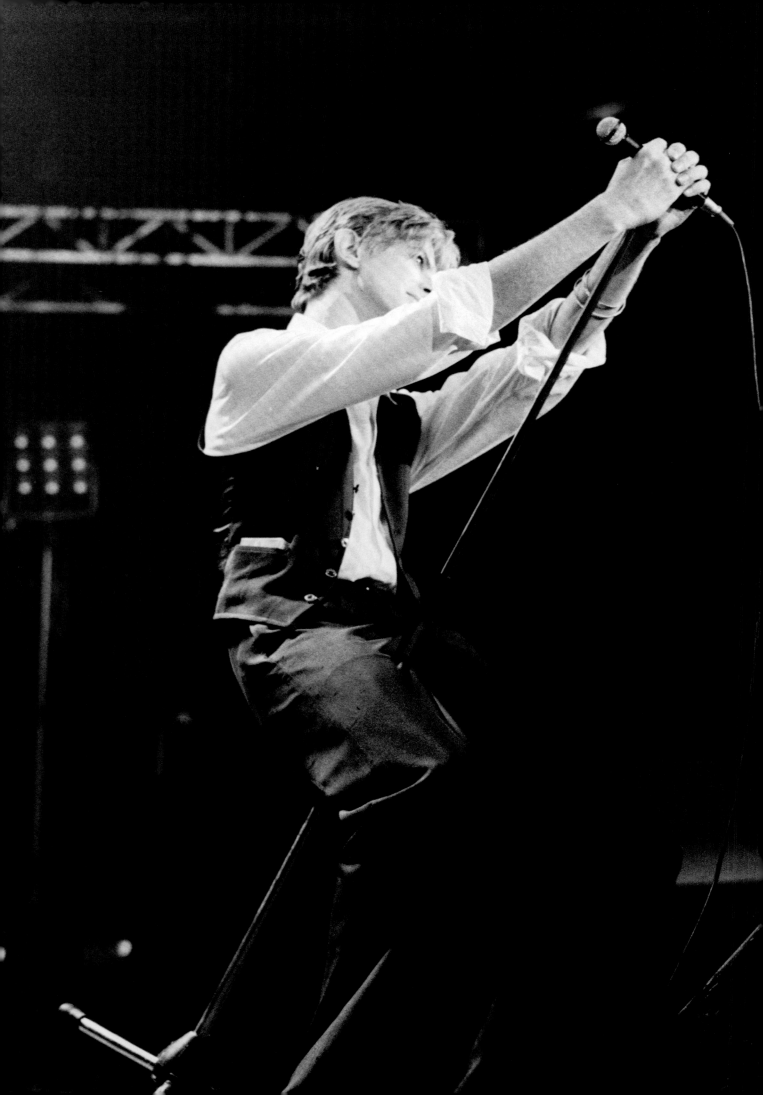

"I shot a lot of performers on stage,
from the Rolling Stones to Elton John,
Led Zeppelin, Frank Sinatra and Elvis Presley.
Bowie was a standout.
His energy, lighting, movements –
the way he controlled the stage
was second to none."

Terry O'Neill

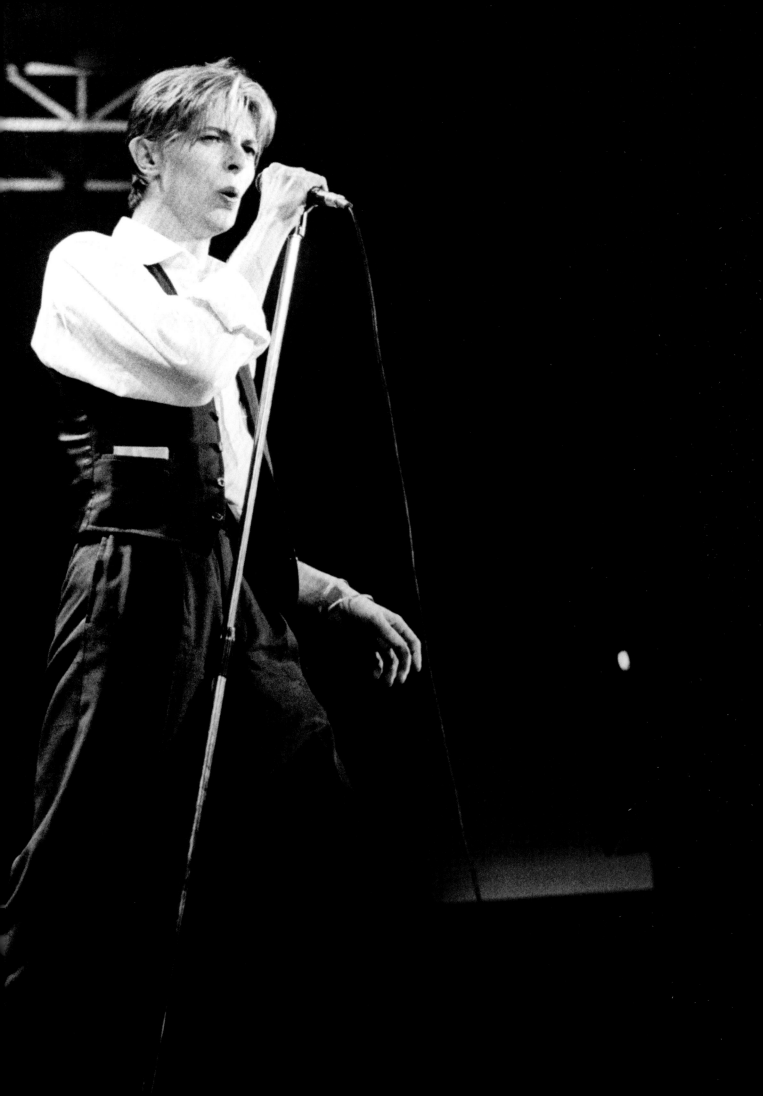

"What I like my music
to do to me is
awaken the ghosts
inside of me.
Not the demons,
you understand,
but the ghosts." DB

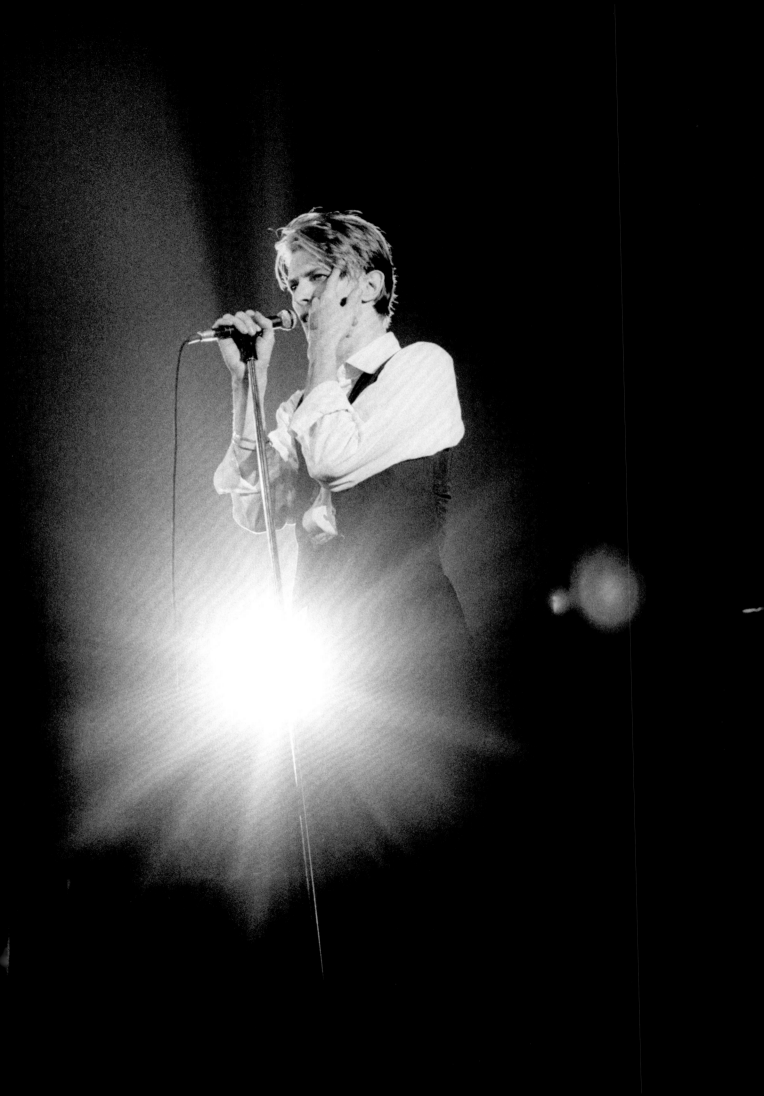

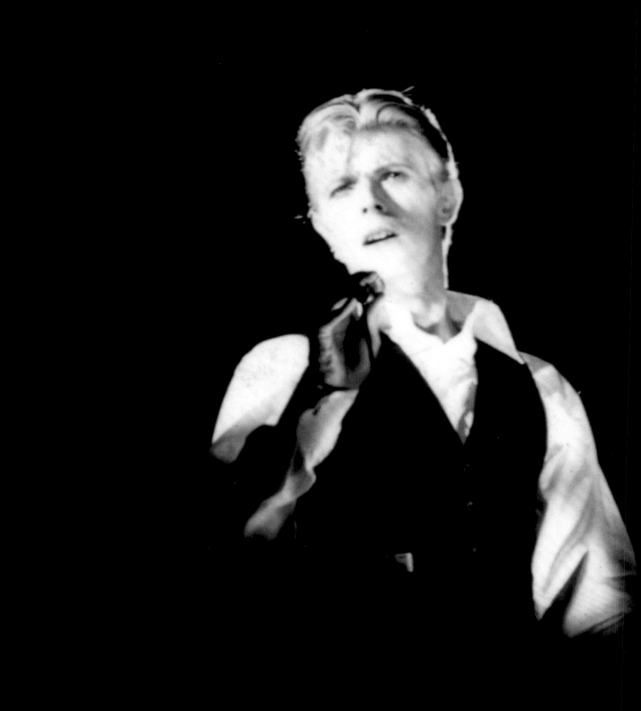

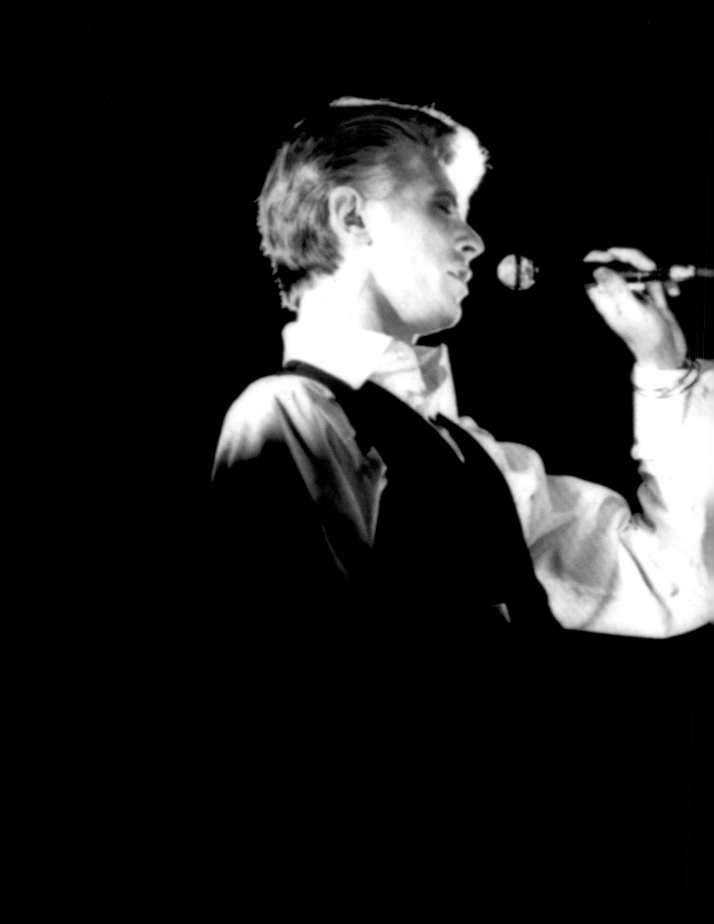

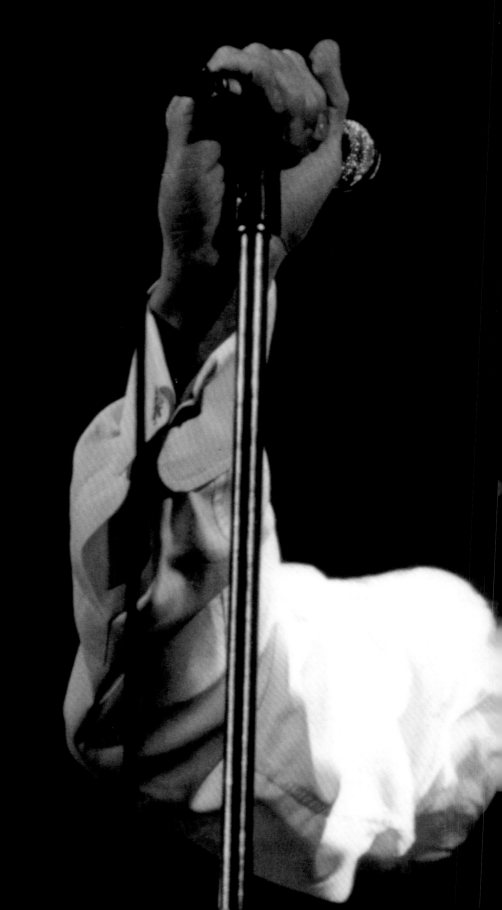

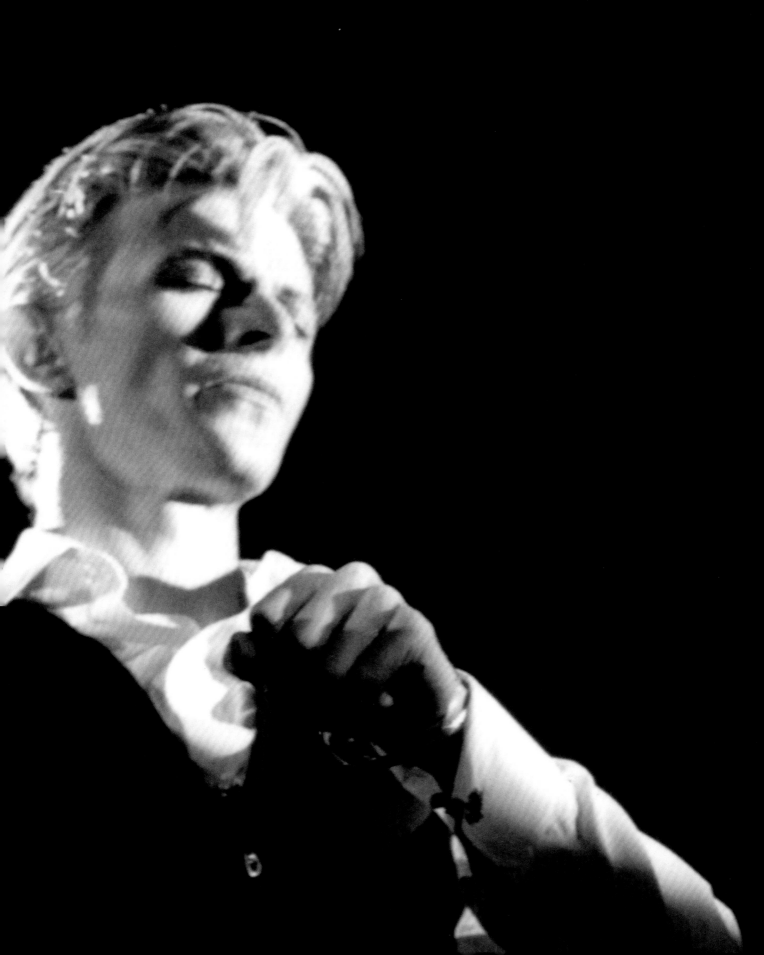

"I had to resign myself,
many years ago,
that I'm not too articulate
when it comes to explaining
how I feel about things.
But my music does it for me,
it really does." DB

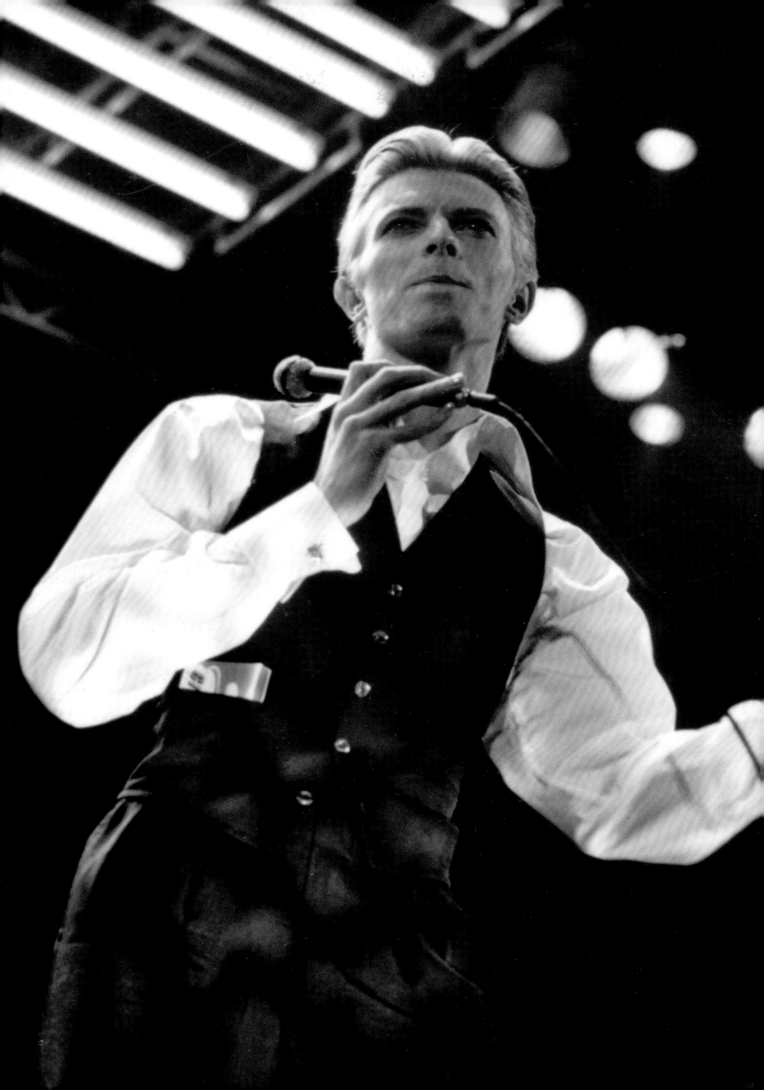

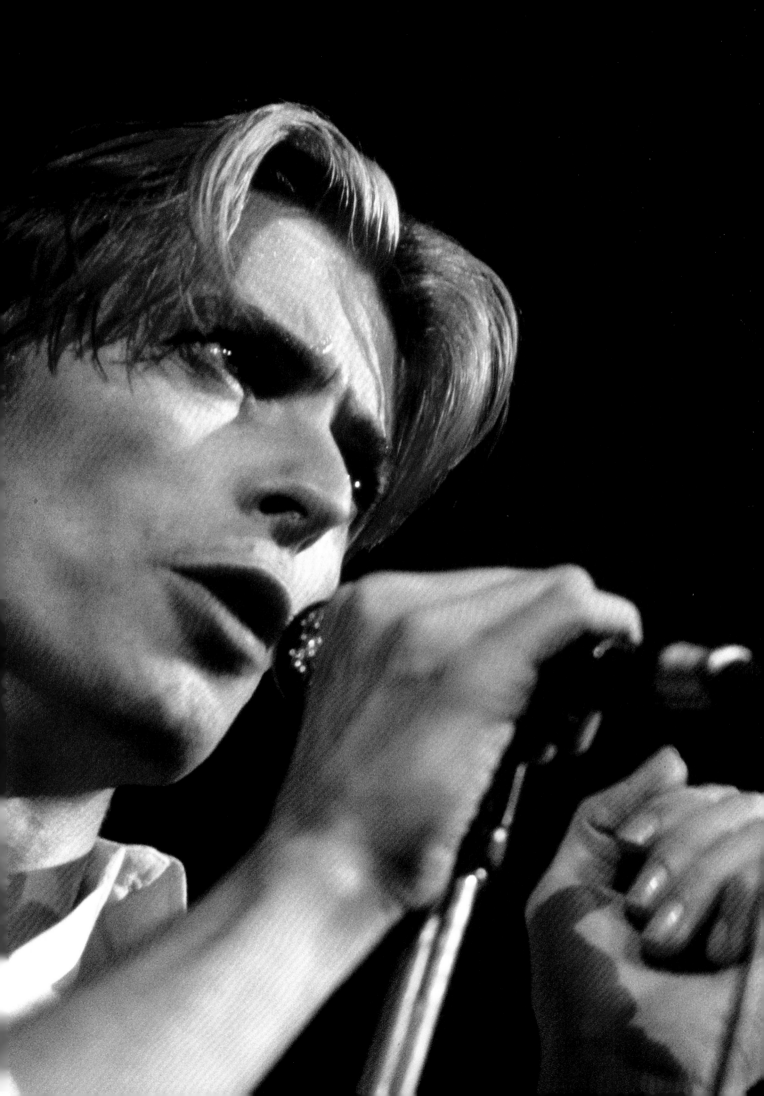

Set list:

Station to Station

Suffragette City

I'm Waiting for the Man
(The Velvet Underground cover)

Sister Midnight
(Iggy Pop cover)

Word on a Wing

Stay

TVC15

Life on Mars?

Five Years

Panic in Detroit

Changes

Fame

The Jean Genie

Rebel Rebel

Diamond Dogs

Queen Bitch

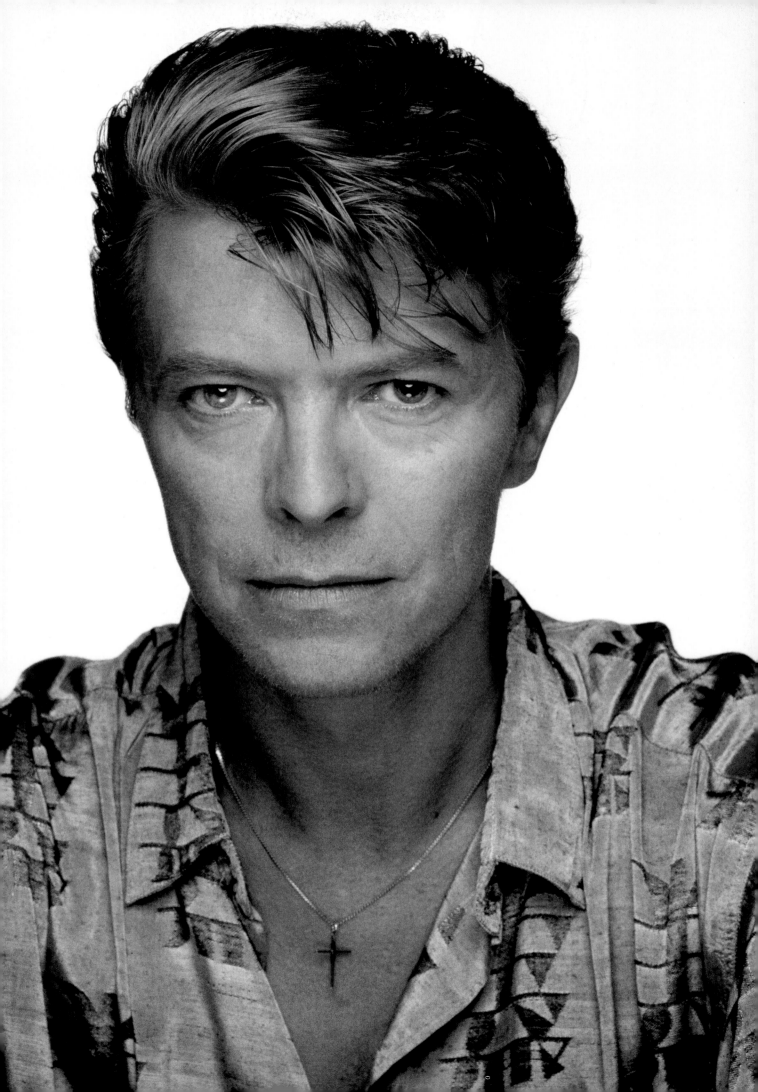

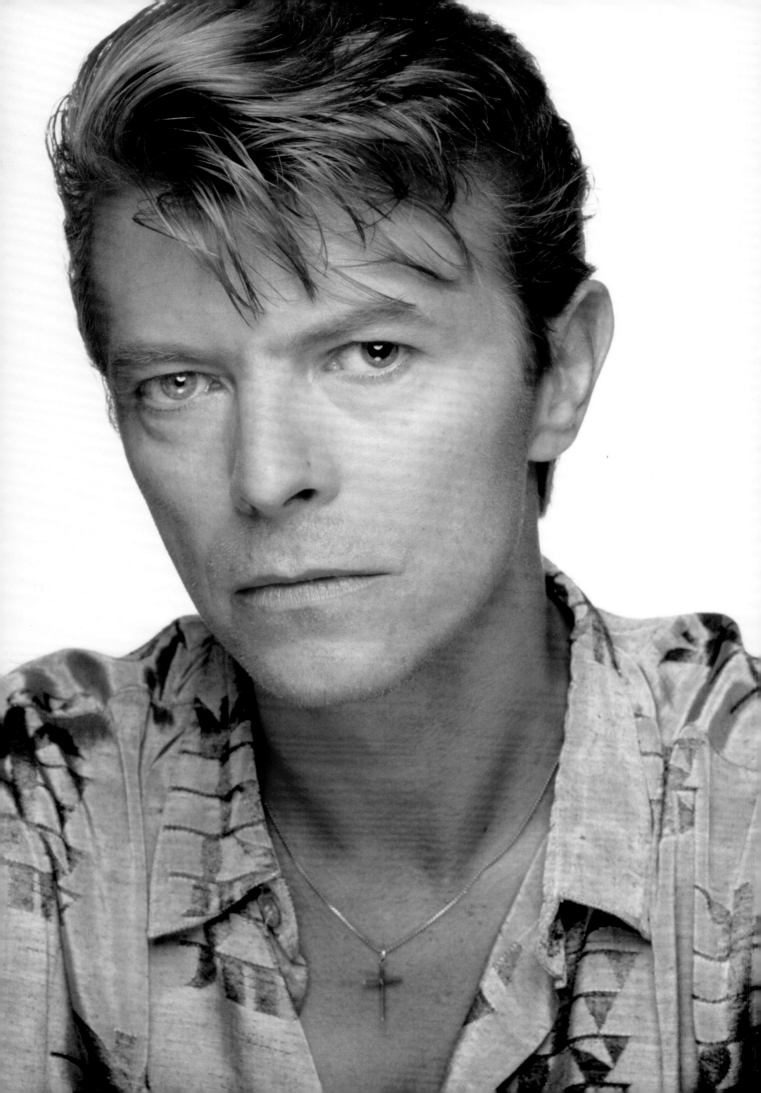

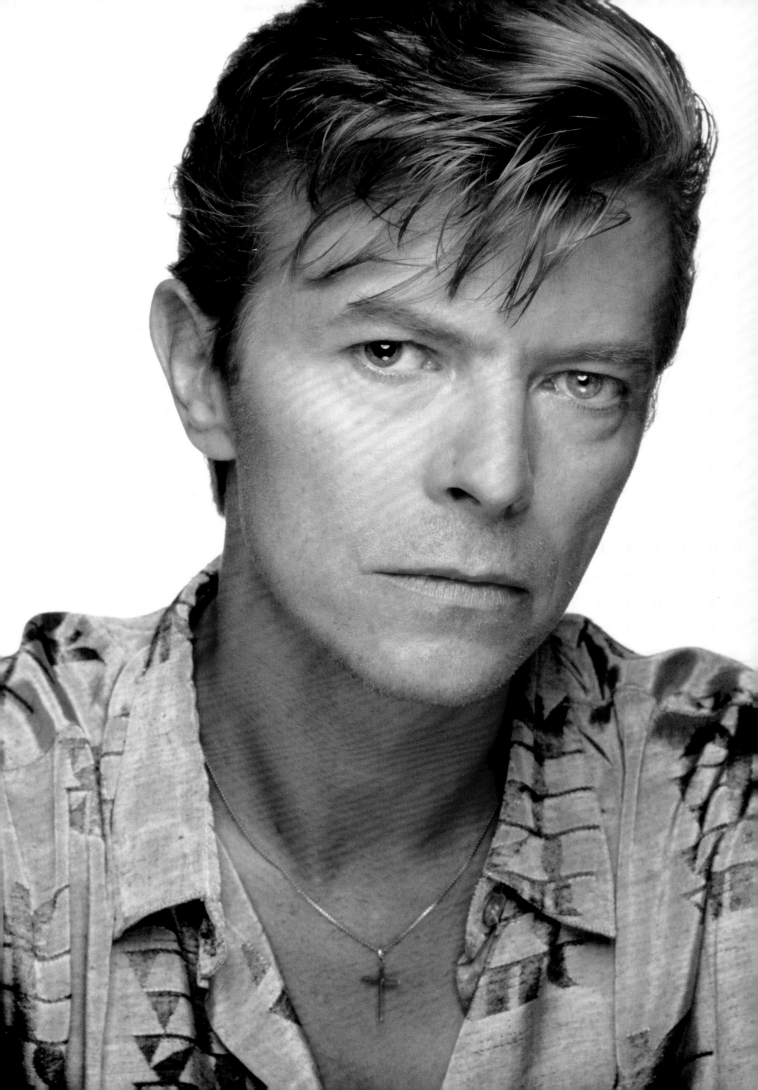

"Religion is for people who are afraid of going to hell, spirituality is for those who've been there." DB

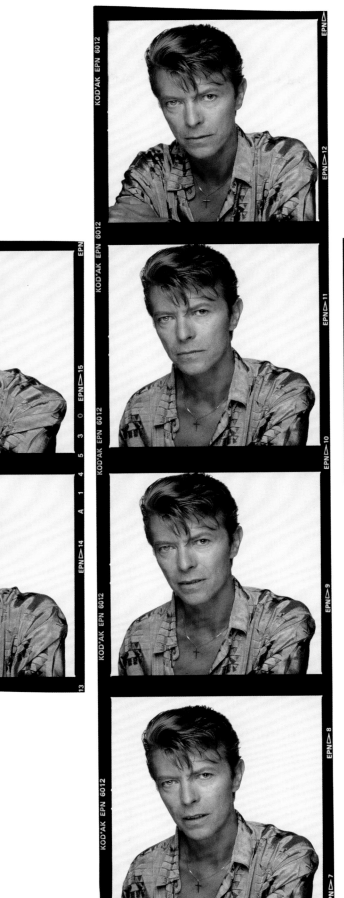
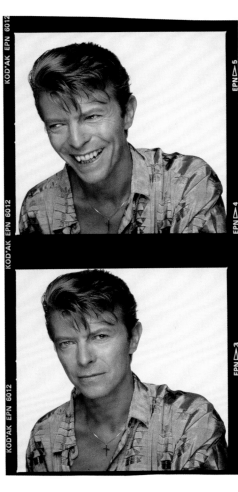

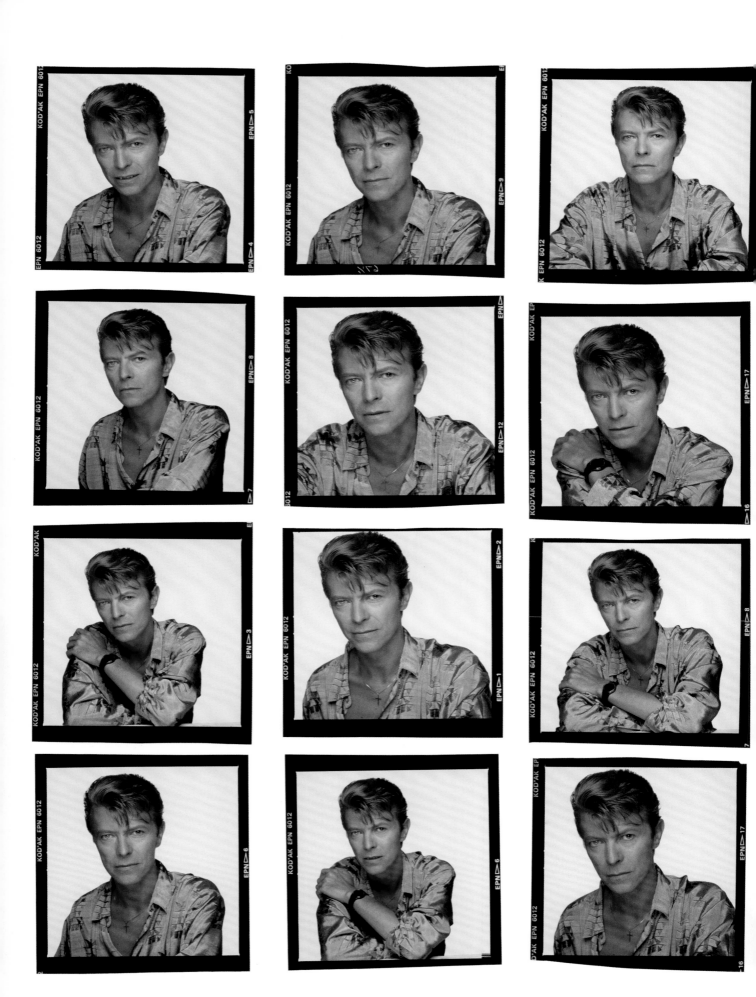

278

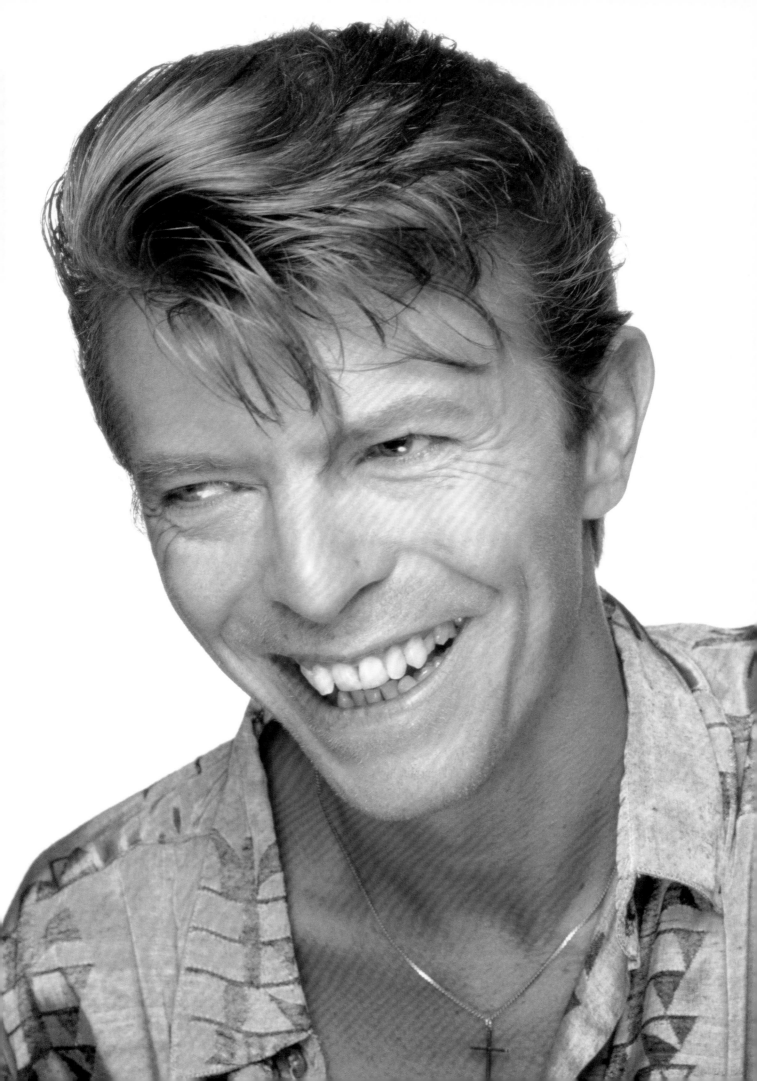

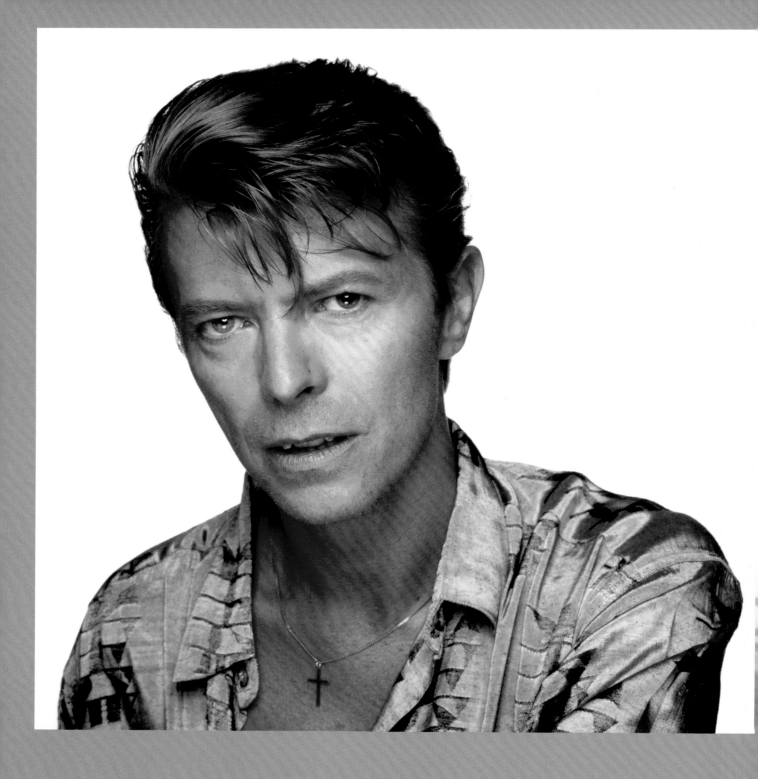

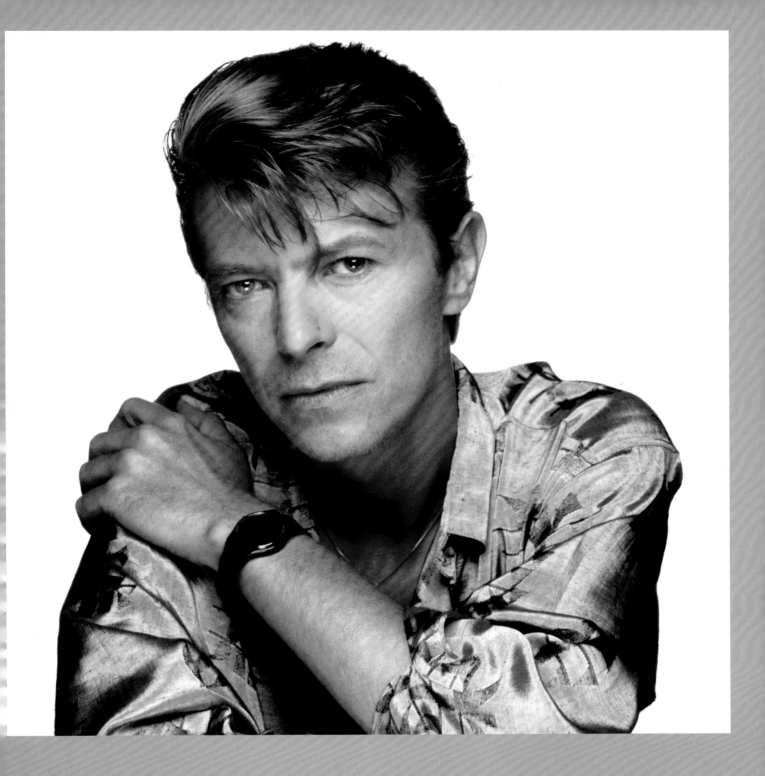

"His loss is going to be felt for a long, long time.
It was impossible to know David Bowie
and not be his friend.
He was a very classy man;
a worthwhile person.
He was always ahead of his time.
There's not going to be anybody else like him.
Thank you, David, for sharing your art with us."

Terry O'Neill

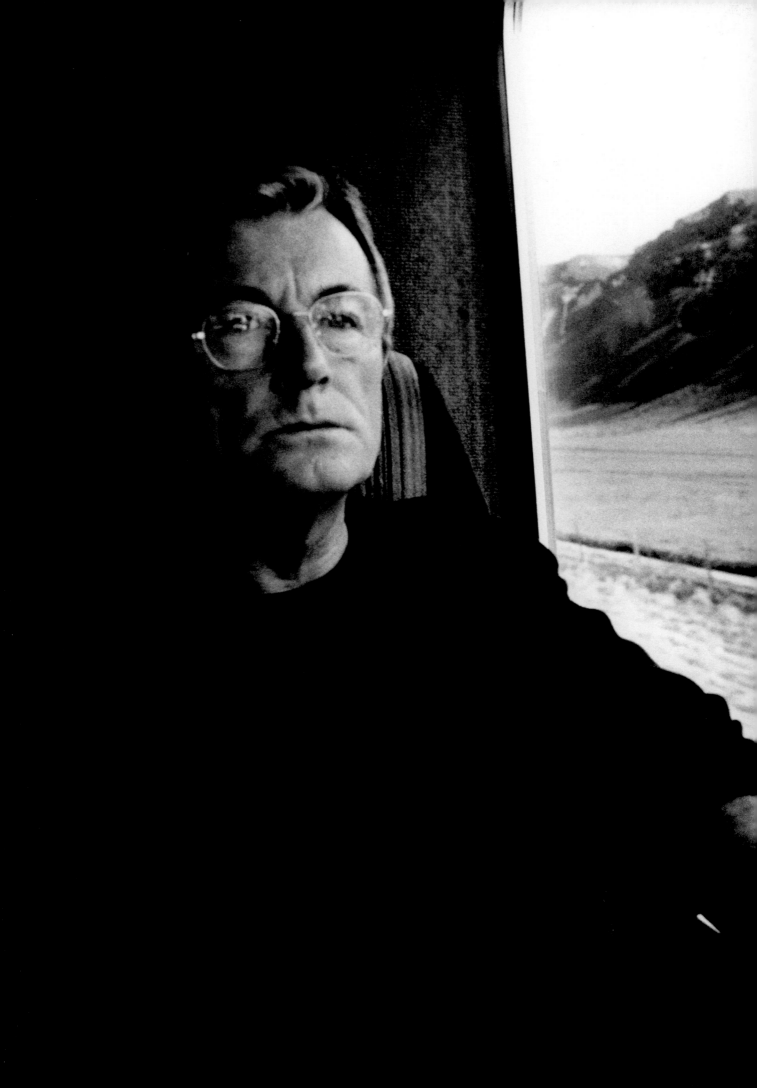

Concept: Mark Bramley © Red Engine Media

Terry O'Neill images reproduced by kind permission © Iconic Images

Art Direction & Design: Desmond Curran © Red Engine Media
Scanning: Mariona Vilaros, Victoria Schofield
Illustration: Ben Godfrey
Creative Colourizing: Johnie at Digital Graffiti © Red Engine Media
Production Coordinaton: Roberto Maggipinto, MD Red Engine Europe
Editor: Carrie Kania
Copy Editor: Alison Bramley

Special thanks to
the following people and publications:

"Bowie's Free For All", 27 October 1973
© Chris Welch

"Bowie Finds His Voice", 14 September 1974
© Robert Hilburn

"Beat Godfather Meets Glitter Mainman: William Burroughs, say hello to David Bowie,"
by Craig Copetas, from *Rolling Stone*, Issue 155, 28 February 1974
© Rolling Stone LLC 1974. All rights reserved. Used by permission

Please visit www.iconicimages.net if you are interested in purchasing fine-art quality
prints from the Terry O'Neill archive

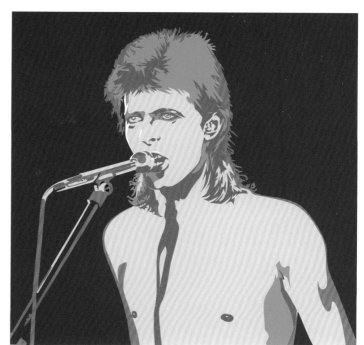

An Hachette UK Company
www.hachette.co.uk

First published in Great Britain in 2016 by Iconic Images and Red Engine Media Ltd

This edition published 2019 by Cassell, an imprint of
Octopus Publishing Group Ltd, Carmelite House
50 Victoria Embankment, London EC4Y 0DZ
www.octopusbooks.co.uk

Distributed in the US by Hachette Book Group
1290 Avenue of the Americas , 4th and 5th Floors
New York, NY 10104

Distributed in Canada by
Canadian Manda Group, 664 Annette St.
Toronto, Ontario, Canada M6S 2C8

ISBN 978-1-78840-101-2

A CIP catalogue record for this book is available from the British Library.

Printed and bound in China

10 9 8 7 6 5 4 3 2 1

For this edition:
Senior Commissioning Editor: Joe Cottington
Assistant Editor: Emily Brickell
Creative Director: Jonathan Christie
Senior Production Manager: Katherine Hockley